UNSEEN
SCOTLAND

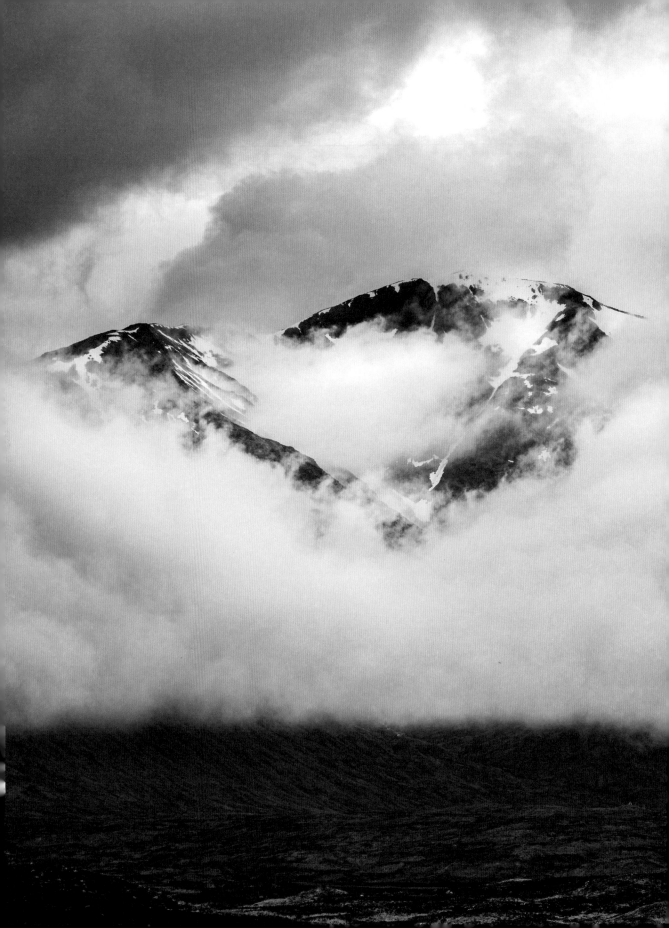

BRYAN MILLAR WALKER

UNSEEN SCOTLAND

The Hidden Places, History and Lore of
the Wild Scottish Landscape

greenfinch

CONTENTS

Introduction 6
The Scottish Outdoor Access Code 8
When to Visit Scotland 10
Flora & Fauna of Scotland 12
Feasts & Holidays 14

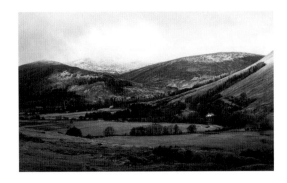
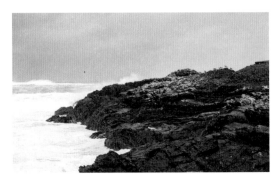

The West Coast

The Whangie 20
The Devil's Pulpit 24
Kilchurn Castle 28
St Conan's Kirk 32
Glen Lyon & Fionn's Rock 34
Glen Etive 38
River Coupall 42
Glencoe 46
Fairy Bridge 52
Steall Falls 56
Castle Tioram 60
Sanna Bay 64

The Hebrides

Luskentyre Beach 72
Nisabost Beach 76
The Temple 78
The Golden Road 80
Calanais Standing Stones 84
Mangersta Beach 88
Gearrannan Blackhouses 92
Shawbost Norse Mill & Kiln 96
Eoropie Beach 100
Butt of Lewis Lighthouse 104
Garry Beach 108

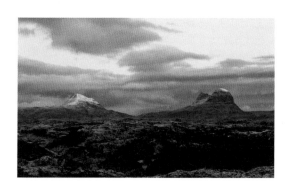

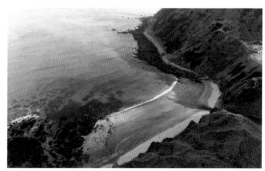

The Highlands

Plodda Falls 116
Glen Affric 120
Corrieshalloch Gorge 124
Suilven 128
Stac Pollaidh 132
Achmelvich 136
Hermit's Castle 140
Clachtoll 144
Allt Chranaidh Falls 148
Golspie Burn & Waterfall 152
Duncansby Stacks 156
Castle Sinclair Girnigoe 160
Castle of Old Wick 166
Whaligoe Steps 170

The East Coast

Uath Lochans 176
Bow Fiddle Rock 180
Cullen 182
Findlater Castle 184
Crovie 188
Pennan 192
Rattray Head Lighthouse 194
Linn of Quoich 198
The Cairngorms 202
Prince Albert's Cairn 206
Craigievar Castle 210
Dunnottar Castle 212
The Hermitage 216

Afterword 220
Index 222

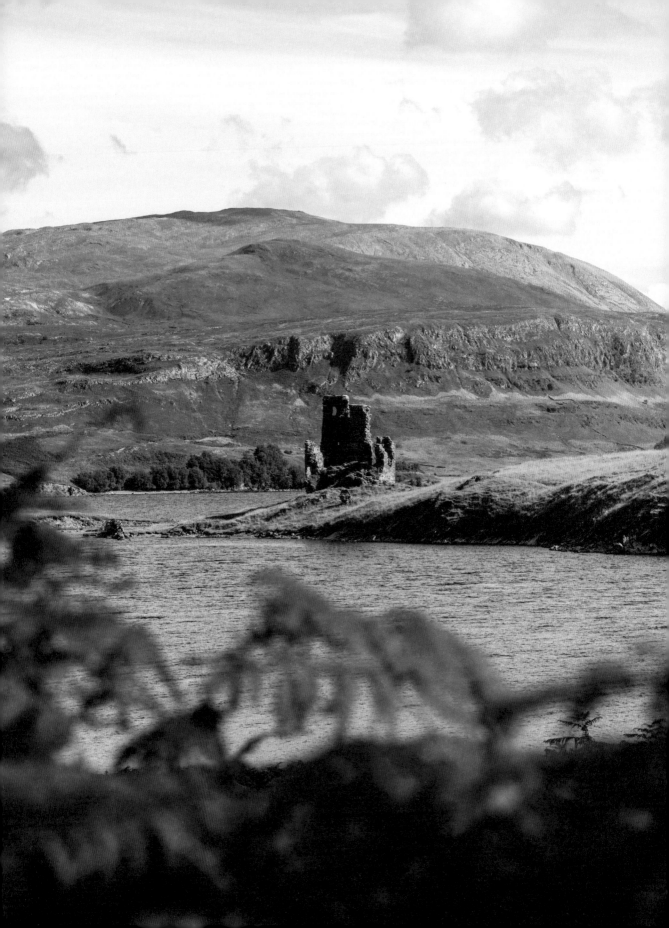

INTRODUCTION

Scotland has not always been considered a desirable location to visit. For centuries the cold, rough mountains and landscapes were viewed as unwelcoming and difficult, but in the 17th century artists ignited our imaginations: painters drew attention to the cloud-scattered mountains and tranquil morning lochs; writers and poets spun tales of fearless giants and mischievous fairies. Suddenly the wet, barren vistas were romanticized into beautiful dreamlands full of potential adventures.

Scots became tourists in their own land. The more word spread of Scotland's wild beauty, the more people flocked to see it for themselves. Infrastructure developed thick and fast, with new railways, roads, ferries and places for travellers to hang their boots for the night and grab a few drams of the now-famous local whisky.

As time went on, the lure of Scotland and its seemingly simple attraction continued to grow. Today, whether looking to take on a mighty Munro, visit the mysteries of Fingal's Cave or spend the day at the beach with the family for a *dook* in the water, the appeal to create your own adventure here is as strong as ever.

With the likes of Instagram and social media at our fingertips you'll likely know somewhat what to expect of the well-trodden streets and world-famous landmarks. But what about the 'unseen' Scotland, the forgotten bits and the places that were once cherished but have perhaps slipped out of favour? What lurks behind the iconic locations, and what hidden gems are there to be discovered? I'll highlight the history, myths and legends that are an integral part of this landscape, so you will learn more of Scottish culture, discover new places and see favourite ones from a different perspective.

This book isn't only about places you may have never seen, but the light in which we view them. It's a journey to places I've visited my whole life, locations I once saw for the first time many years ago and have memories of each and every time thereafter. They are places I know well in a land I call home, so the title to this book is fitting, as it's not mine, it's your *Unseen Scotland*.

Throughout this book you'll find locations, stories, folklore and photos spanning the Highlands, West Coast, East Coast and Hebrides, a considerably small area full to the brim with beauty in every regard. The goal here is to get you dreaming of these places we see over and over again with eyes that never tire of it. And when you do make it here, we know you'll feel the same.

THE SCOTTISH OUTDOOR ACCESS CODE

Scotland's breathtaking landscapes, from rugged mountains to serene lochs, offer boundless opportunities for outdoor adventures. As you embark on your journey to explore this stunning terrain, it's essential to embrace the principles outlined in the Scottish Outdoor Access Code. These are a small and simple set of rules (based on nothing more than common sense) to abide by when enjoying everything the country has to offer. This code serves as a guideline for responsible outdoor áccess, ensuring that everyone can enjoy Scotland's natural beauty while preserving its ecological integrity for generations to come.

KEY PRINCIPLES OF THE SCOTTISH OUTDOOR ACCESS CODE

— **Respect the land:** When venturing into the outdoors, respect the environment and its inhabitants. Treat the land, plants and wildlife with care. Avoid disturbing animals, especially during breeding and nesting seasons, and leave natural habitats undisturbed.

— **Access rights:** You have the right to access most land and inland water, provided you do so responsibly. Respect the rights of landowners and follow any special access rules in certain areas. Always use gates and stiles responsibly, ensuring they remain secure for both livestock and other visitors.

— **Responsible behaviour:** Enjoy outdoor activities responsibly, taking care not to damage or disrupt the environment. Follow designated paths and trails whenever possible, especially in sensitive areas, and avoid trampling on crops or damaging fences.

— **Leave no trace:** Leave the landscape as you found it or even better. Take any litter or waste with you and dispose of it properly. Minimize your impact by carrying away everything you bring with you.

— **Wild camping:** Wild camping is permitted, but it comes with responsibilities. Camp sensibly, ensuring you pitch your tent in a suitable location away from homes and roads. Follow the 'leave no trace' principle.

— **Respect others:** Be considerate of other outdoor users, including landowners, residents and fellow visitors. Keep noise levels low, especially during the evening and at night, to respect the peace and tranquility of the surroundings.

PRACTICAL TIPS FOR RESPONSIBLE OUTDOOR EXPLORATION

— Plan your trip ahead and be aware of any access restrictions or guidelines specific to the area you're visiting.

— Always close gates and use paths and tracks responsibly, especially in agricultural areas or nature reserves.

— Keep your dog under control and on a leash when near livestock or wildlife to prevent disturbances.

— Enjoy outdoor activities such as walking, cycling and picnicking, but be mindful of your impact on the environment.

— Educate yourself about the flora, fauna and local ecosystems to enhance your appreciation of Scotland's natural heritage.

WHEN TO VISIT SCOTLAND

There is no bad time to visit Scotland. No matter the season, Scotland's charm and allure remain ever-present. Each season brings its own distinct beauty and a myriad of activities, allowing visitors to explore and appreciate the country's natural wonders in every hue and shade. Whether you seek colourful blossoms, vibrant foliage or snow-capped peaks, Scotland awaits, offering a unique and enchanting experience in every season.

SPRING (MARCH TO MAY)

As the frost thaws and the land awakens, Scotland comes to life in a burst of colour. Spring paints the countryside with vibrant hues of green, and the landscape is adorned with blossoming flowers, each having their moment of glory on the centre stage before giving way to the next. It's an ideal time for hiking as trails meander through lush meadows and forests, offering glimpses of newborn wildlife. Witness the breathtaking beauty of our gardens scattered all over the land as they bloom with rhododendrons, azaleas and bluebells, to name but a few.

SUMMER (JUNE TO AUGUST)

Summertime in Scotland brings long daylight hours and a lively atmosphere. Once again, it's the perfect season for outdoor adventures, from exploring coastal cliffs to lounging on sandy beaches. The Highland games and various festivals across the country fill the air with music, dance and cultural celebrations. Experience the enchantment of the Scottish islands in the warmer months, where turquoise waters and stunning landscapes await. Just make sure to pack your midge repellent!

AUTUMN (SEPTEMBER TO NOVEMBER)

The landscape is transformed into a tapestry of fiery hues during autumn. The forests blaze with shades of red and orange as the trees shed their leaves and the endless amount of ferns dry and curl into vast seas of gold across every patch of land. It's an excellent time for photographers, with beautiful light glowing throughout the day to capture the stunning vistas across the glens and lochs. Autumn also marks the beginning of the deer rutting season, offering those lucky enough to catch it the chance to see, or at least hear, an impressive spectacle.

WINTER (DECEMBER TO FEBRUARY)

Scotland dons a magical cloak of snow during winter, turning the landscape into a wonderland. Lazy frost-covered mornings lead to a day of long shadows as the sun seems to linger in the air without ever really waking up. Snow-capped mountains sit stiller than usual as the clouds pass over them like a gentle pat on the head. The stillness in the air is mimicked by the hush through the villages, and those willing to brave the cold are often rewarded with the greatest show on earth: the magical hues of green and purple dancing in the night sky – the aurora borealis (also known as the Northern Lights).

FLORA & FAUNA OF SCOTLAND

Scotland is alive with a vibrant array of flora, with iconic species entwined with the nation's history and folklore.

The most famous Scottish flower is the thistle, with its defiant posture and purple crown, which holds a place of honour as the national emblem. It is a symbol born from an ancient nocturnal cry of pain. The story goes that one night, Norse invaders attempted to surprise a Scottish encampment. To move silently, they removed their footwear. However, one invader stepped on a thistle and his shout of surprise alerted the Scots to their presence, giving them time to grab their weapons and take on the invaders head-to-head, leading to the Norsemen's defeat. The thistle has since been an emblem of protection and pride in Scotland, and the thistle flourishing in the wild encapsulates the spirit of Scotland's enduring strength.

In spring, gorse blankets the hillsides in brilliant yellow, a beacon of light that brightens even the most remote landscapes. It becomes a symbol of the Highlands, with every mountain and roadside coated in its bright glow, and an unmistakable smell of fresh coconut filling the air.

The iconic heather, with its delicate hues of purple and pink, transforms the Scottish moors into a painter's palette in summer, a spectacle that captures the imagination and fuels tales of old. It's said that this plant carries the stains of historical battles, a living tapestry of our past, yet it also symbolizes protection and affection in the heart of Scottish lore.

Tucked away in the northern reaches, the Scottish primrose emerges with a subtle grace, its presence a rare delight. Blooming in the cool embrace of spring and then again in summer, it is enveloped in tales of enchantment, offering a glimpse into a world where the veil between the natural and the supernatural is thin. Primroses were thought to be sacred to fairies, and a ring of primroses was believed to offer protection from fairy enchantments or to mark the entrance to their realms.

In comparison to neighbouring countries Scottish wildlife can seem lacklustre at first. The extinction of brown bears, Northern lynx and the killing of the last wolf in Scotland in 1680 has been something we have never recovered from. But in the void left by the apex predators other animals have thrived; majestic deer roam the mountains of the Highlands, giant golden eagles soar between the Western Isles and ever-curious hedgehogs plod along the forest footpaths on their way to take care of very important business.

Whether it's a rare sighting of a magnificent red kite or an elusive wild cat, or watching the adorable ginger Highland cows, pine martens, otters or badgers, the animals of Scotland are cherished by those lucky enough to encounter them. With the continued conservation and rewilding efforts of so many great Scots, we hope they continue to thrive for generations to come.

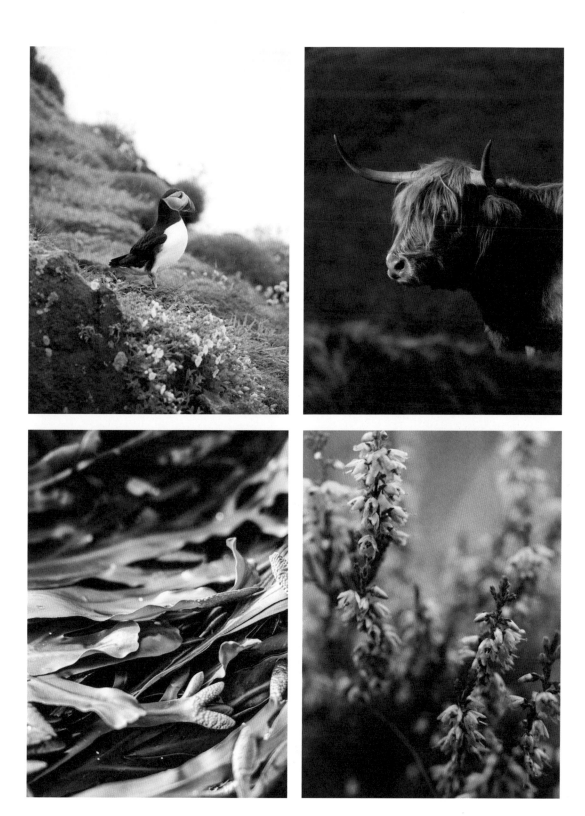

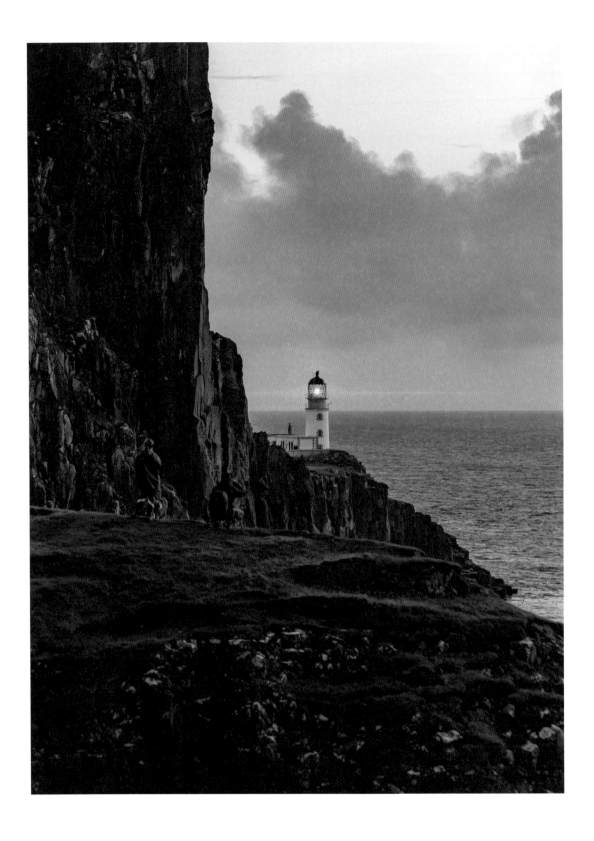

FEASTS & HOLIDAYS

Scotland's cultural heritage is rich with various feasts and holidays that have been observed for centuries. These celebrations thread through the fabric of Scottish culture, capturing the essence of the nation's history, communal beliefs and spirited traditions. Whether in paying tribute to literary legends or heralding the seasons' shift, these traditional Scottish celebrations offer a glimpse into the soulful core of Scotland.

BURNS NIGHT (25 JANUARY)

A heartfelt homage to Robert Burns, Scotland's revered national poet, Burns Night celebrates his life and oeuvre. Initiated by Burns' close friends in 1801, five years after his passing, this tradition involves a convivial supper with haggis, Scotch whisky and recitations of Burns' poetry, symbolizing Scottish pride, creativity and Burns' indelible impact on Scottish letters.

BELTANE (1 MAY)

Celebrating the commencement of the pastoral summer season, Beltane is the joyful counterpart to Samhain. Traditionally, it was a time for lighting bonfires to shield against malevolent spirits and to ensure fertility for the year ahead. Cattle would be herded between these fires before being led to summer grazing fields. In contemporary times, particularly in Edinburgh, Beltane has witnessed a revival, with grand fire festivals and rituals that draw from these ancient practices.

SAMHAIN (31 OCTOBER–1 NOVEMBER)

The precursor to modern Halloween, Samhain is an ancient Celtic festival signalling the end of the harvest and the onset of winter. It was believed that, during Samhain, the veil between the living and the dead thinned, allowing spirits to mingle with the living. Celebrants would light bonfires and don costumes to fend off spirits. Today, Samhain is observed by those keen on preserving Celtic traditions, focusing on themes of reflection, remembrance and the eternal cycle of life and death.

ST ANDREW'S DAY (30 NOVEMBER)

Dedicated to Scotland's patron saint, this day merges feasting with the celebration of Scottish identity. St Andrew has been recognized as the patron saint of Scotland since the 11th century. His feast day has grown into a festivity rich with traditional Scottish fare – music, dance and the flying of the St Andrew's Cross – underscoring a collective pride in Scotland's heritage and history.

HOGMANAY (31 DECEMBER)

Marking the New Year, Hogmanay stands out as one of Scotland's most exuberant traditions, with roots reaching back to Norse winter solstice celebrations and the Gaelic Samhain. Renowned for customs such as first-footing, which aims to bring good fortune to homes, the night is alive with fireworks, torchlight processions and the communal singing of 'Auld Lang Syne' (penned by Robert Burns), creating a vibrant welcome for the year ahead.

UP HELLY AA (JANUARY)

Unique to the Shetland Islands yet emblematic of Scotland's broader Viking ancestry, the Up Helly Aa is a winter festival that celebrates Viking heritage. Highlighted by the dramatic burning of a Viking longship, the festival symbolizes the end of the Viking age while fostering a sense of community and continuity. It's a vivid reminder of Scotland's Norse heritage, celebrating resilience and communal warmth during the deep winter.

THE WEST
COAST

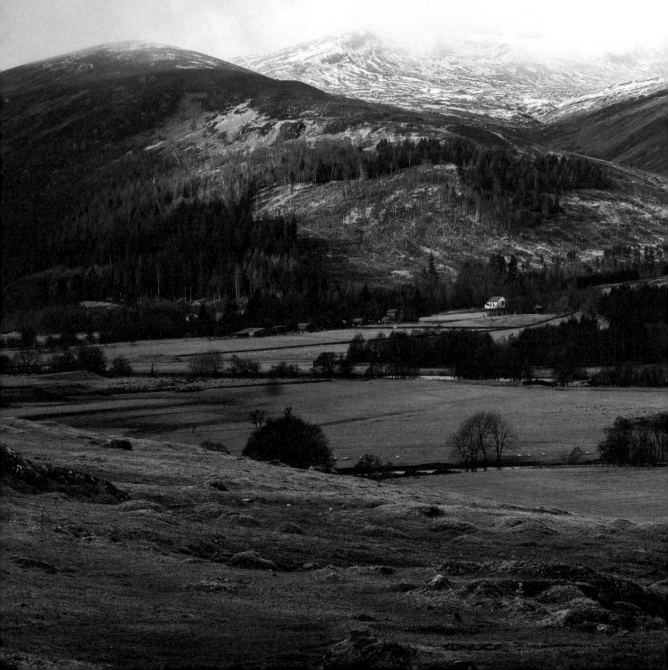

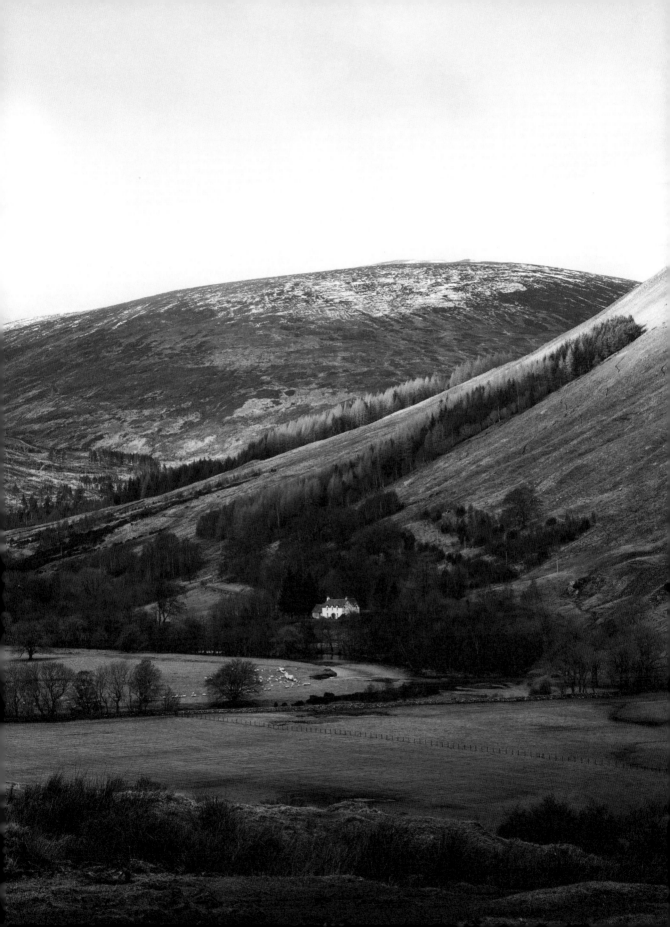

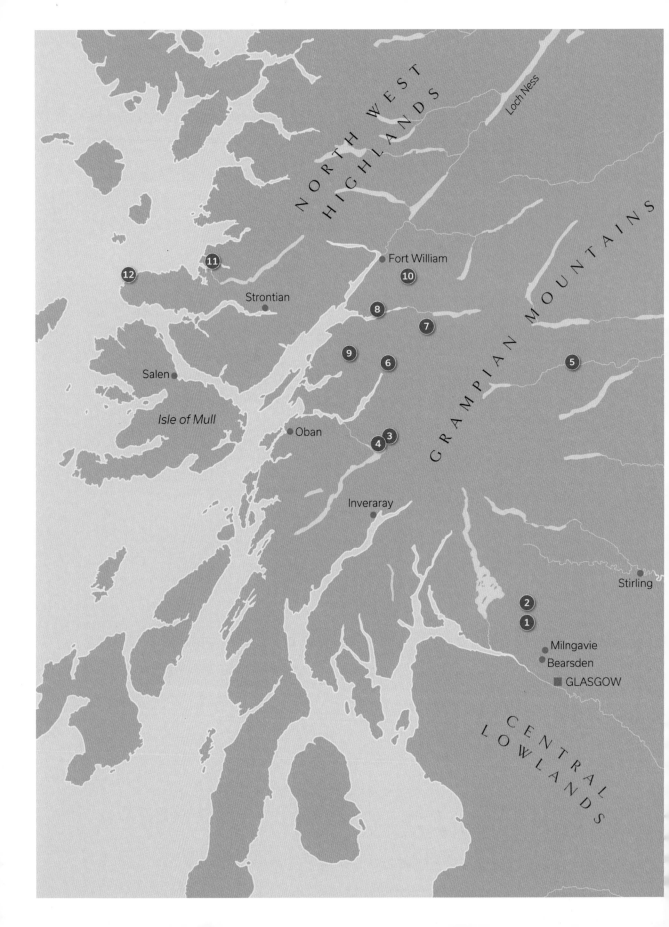

NORTH WEST HIGHLANDS

Loch Ness

GRAMPIAN MOUNTAINS

⑪

⑫

Strontian

Fort William

⑩

⑧

⑦

⑨

⑥

⑤

Salen

Isle of Mull

Oban

④ ③

Inveraray

Stirling

② ①

Milngavie

Bearsden

■ GLASGOW

CENTRAL LOWLANDS

Scotland's West Coast is a region known for its rugged beauty, rich history and timeless charm, stretching from the bustling cities to remote islands.

The West Coast of Scotland is a tapestry of interconnected communities. From bustling ports to secluded villages, the region is united by a shared history of trade, migration and cultural exchange. Centuries-old ferry routes and coastal roads wind their way through the landscape, connecting remote islands and mainland towns alike.

The history of the West Coast is a tale of resilience, endurance and adaptation. From the ancient Celts to foreign invaders who left their mark on the landscape, the region bears the scars of countless battles, migrations and cultural shifts. Historic castles, standing stones and ruins serve as reminders of the region's turbulent past, while traditional crofting communities and fishing villages offer glimpses into a way of life shaped by nature.

The West Coast is never low on stories of folklore and mythology, with popular tales of fairies, mermaids and sea monsters woven into the fabric of daily life. Traditional crafts such as weaving, knitting and boat building are passed down through generations, preserving a sense of continuity and connection.

From rugged coastlines and windswept moors to tranquil lochs and seemingly impassable mountains, the West Coast offers endless opportunities for outdoor adventure. Visitors can hike along scenic trails, sail on pristine waters or simply soak in the tranquility of the natural surroundings.

1 The Whangie **2** The Devil's Pulpit **3** Kilchurn Castle **4** St Conan's Kirk **5** Glen Lyon and Fionn's Rock **6** Glen Etive **7** River Coupall **8** Glencoe **9** Fairy Bridge **10** Steall Falls **11** Castle Tioram **12** Sanna Bay

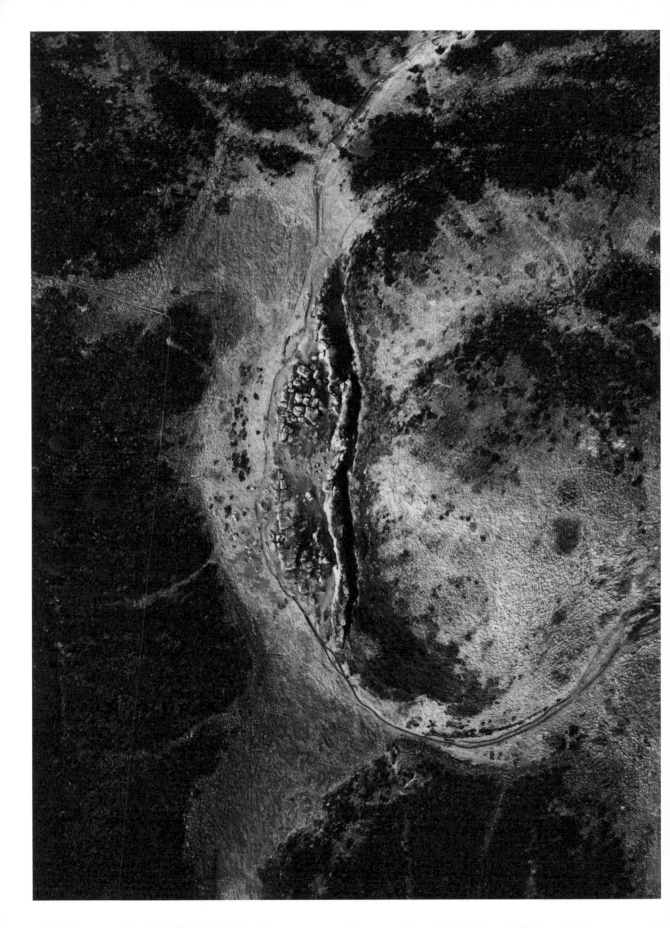

THE WHANGIE

Nearby Town: Bearsden

Just a stone's throw away from Scotland's largest city, Glasgow, lies a geological marvel known as the Whangie. Resting on the outskirts of the Trossachs and set amid the stunning landscape of the Kilpatrick Hills, the Whangie is a natural rock formation that has intrigued and inspired local families, dog walkers, hikers, explorers and visitors for generations.

Carved by ancient volcanic activity, the Whangie is a remarkable fissure in the sandstone rock face. It's a striking and unique cleft, resembling a gigantic crevice, with walls stretching up to 30m (100ft) high in places. The word 'whangie' itself originates from the Scots word 'whang', meaning a slice or a large cut-off piece, but local legend has a much more fun interpretation.

A local coven, the Witches of Kilpatrick, were awaiting a meeting with the devil himself, and began to get restless and rattled as he ran late. Suddenly appearing, he imposed his presence on the startled witches, whipping his tail against the earth, scarring it indefinitely and creating the now famous Whangie.

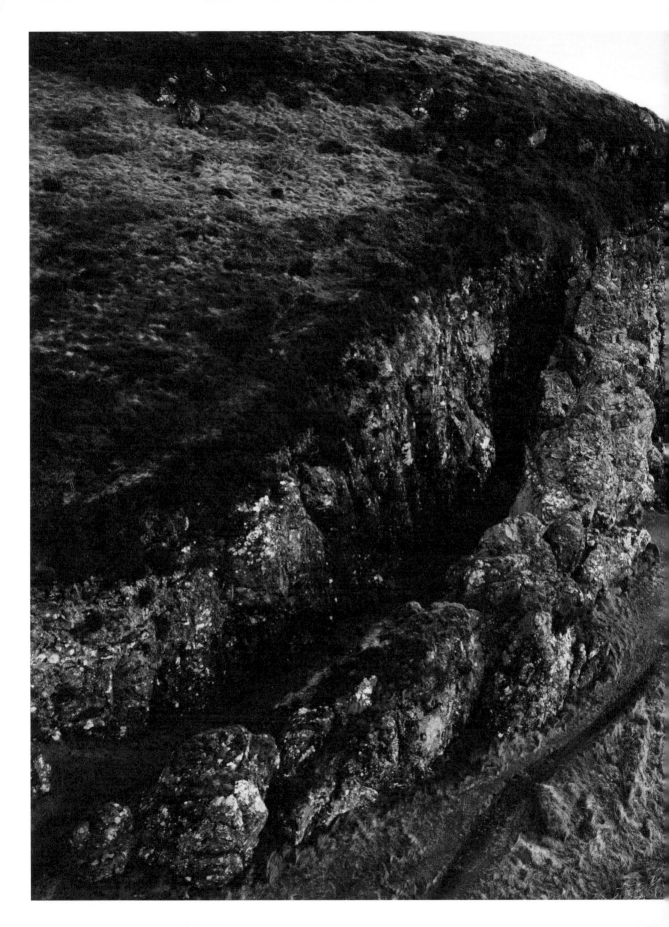

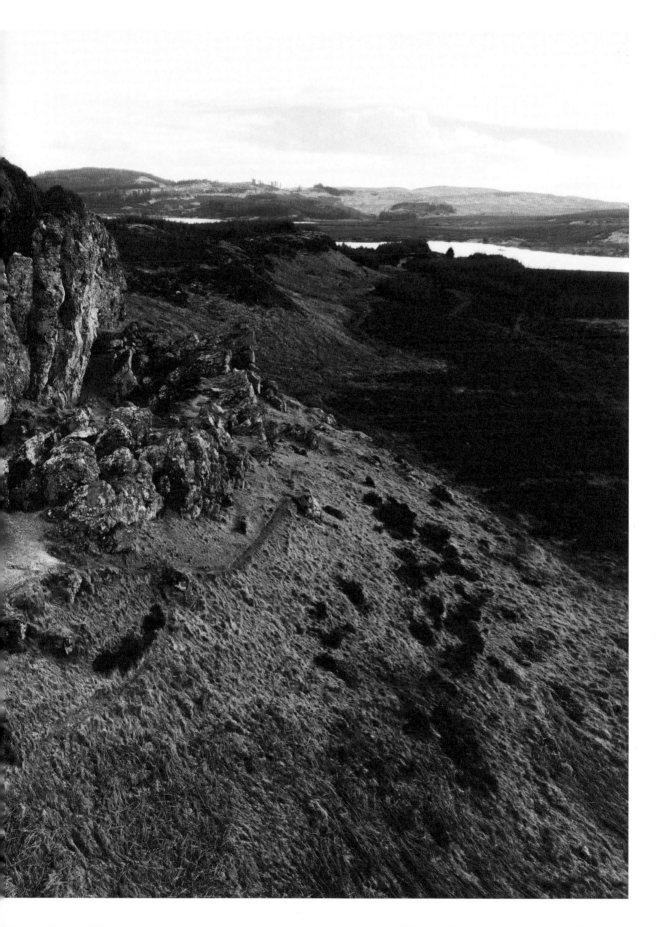

THE DEVIL'S PULPIT

Nearby Town: Milngavie

The Devil's Pulpit, tucked within the captivating depths of Finnich Glen, is a place that seems plucked from the pages of a dark and mysterious tale. This otherworldly gorge, with its towering red sandstone walls and emerald waters, conjures a sense of both awe and intrigue among those who venture into its depths.

The name itself hints at the whispers of folklore that swirl around this enigmatic site. Legend has it that the pulpit was a place where the devil preached to his followers, the vibrant red rock resembling the fiery depths of the underworld.

Stepping into the glen feels like entering a hidden realm – a place where time moves differently and the outside world fades into nothing. The descent into the gorge is an adventure in itself, navigating steep stairs and narrow pathways that lead deeper into the heart of this natural wonder.

Upon reaching the bottom, visitors are greeted by the sight of the moss-covered walls towering above, creating an almost cathedral-like atmosphere. The vibrant green waters of the Carnock Burn wind through the gorge, adding an ethereal touch to the already mesmerizing landscape.

The Devil's Pulpit, a natural rock formation jutting out above the water, stands as a focal point within the glen. Some say it resembles an ancient pulpit, while others see it as a mysterious altar from a forgotten time.

Despite its eerie name and haunting beauty, the allure of the Devil's Pulpit is undeniable. Adventurers, photographers and nature enthusiasts alike are drawn to its mystical ambiance, finding solace and wonder amidst the whispers of ancient legends that permeate the very essence of this hidden gem within the Scottish countryside.

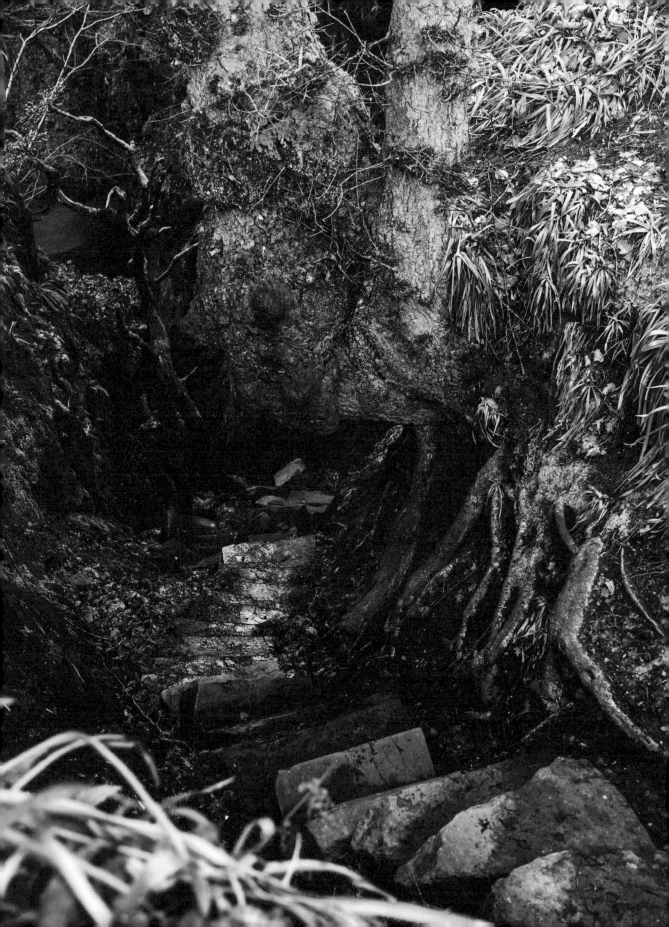

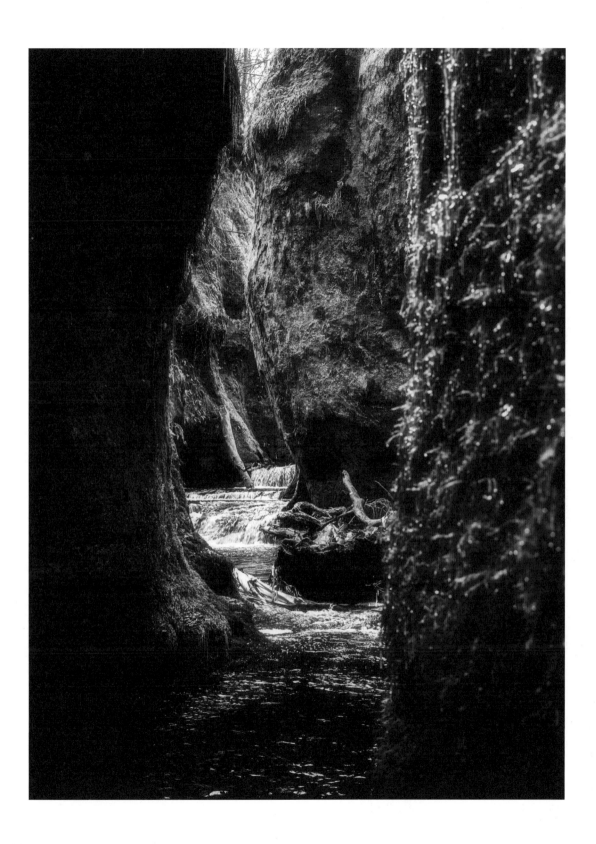

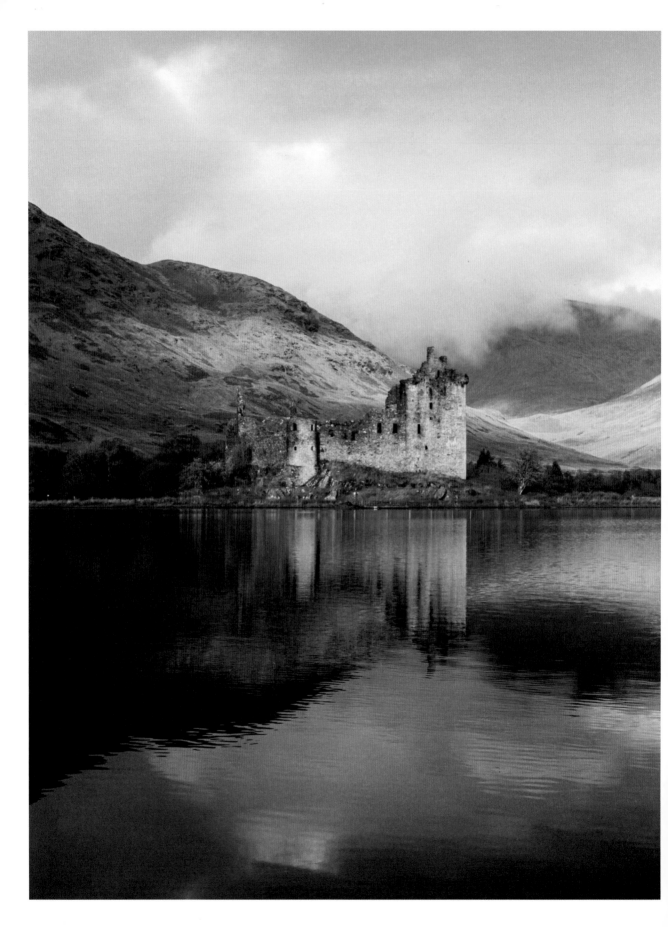

KILCHURN CASTLE

Nearby Town: Inveraray

The criteria for an iconic castle are quite simple: beautiful surroundings are a given, but it needs to tell a story the instant you see it. Kilchurn (pronounced Kill-who'rn) may not have a roof, complete walls or anything more than a basic shape and a couple of fully intact chimneys remaining, but every cracked wall, wee window and blackened stone tells the story of a castle that has played countless parts in a history we look back on in wonder.

It may now sit in ruin off the forever-lapping banks of Loch Awe, never to be returned to its glory days, but every single person that takes the long path up to the front gate, or the boggy mud walkway from the small farmland just across the water, will gawk in wonder at the stature of what remains and imagine how it must have felt to see it in its prime.

In the 15th century, Kilchurn was built as the first of many castles by the Campbells of Glenorchy, a powerful branch of the Campbell Clan, and played a key role in asserting their dominance over the area. The Campbells attempted, unsuccessfully, to sell the castle to the government after they moved, in 1740, to the reconstructed Taymouth Castle.

Kilchurn was renovated frequently, being converted into a barracks capable of housing over 200 troops, then being used as a government garrison during the 1745 Jacobite rising. Eventually the castle was abandoned following a devastating lightning strike that left a turret tower stuck upside down in the main courtyard – where it remains to this day.

On a still day the reflections of the castle bounce off the water creating an ethereal vision of the landscape. Early mornings will see beautiful light on the mountains in the background, and a lucky few will witness inverted clouds pass through the region during early mornings.

As iconic castles go, Kilchurn is worthy of any list.

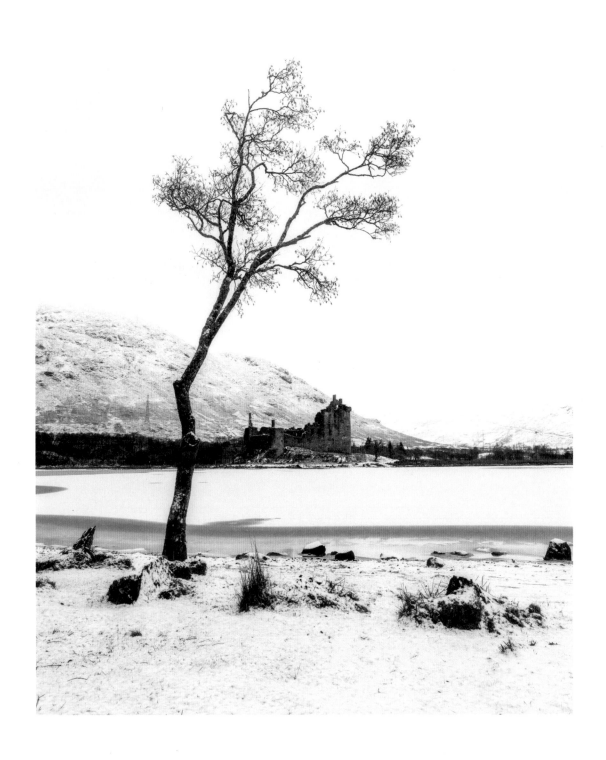

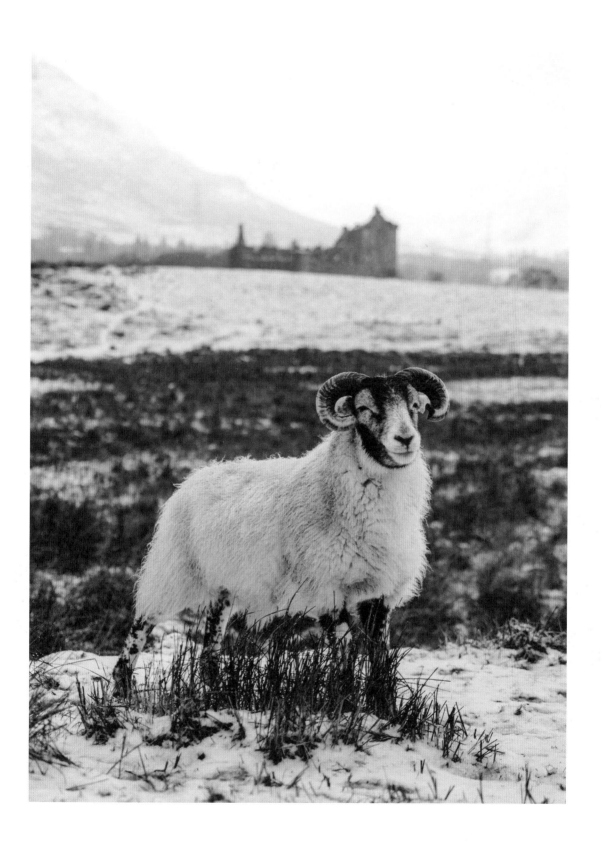

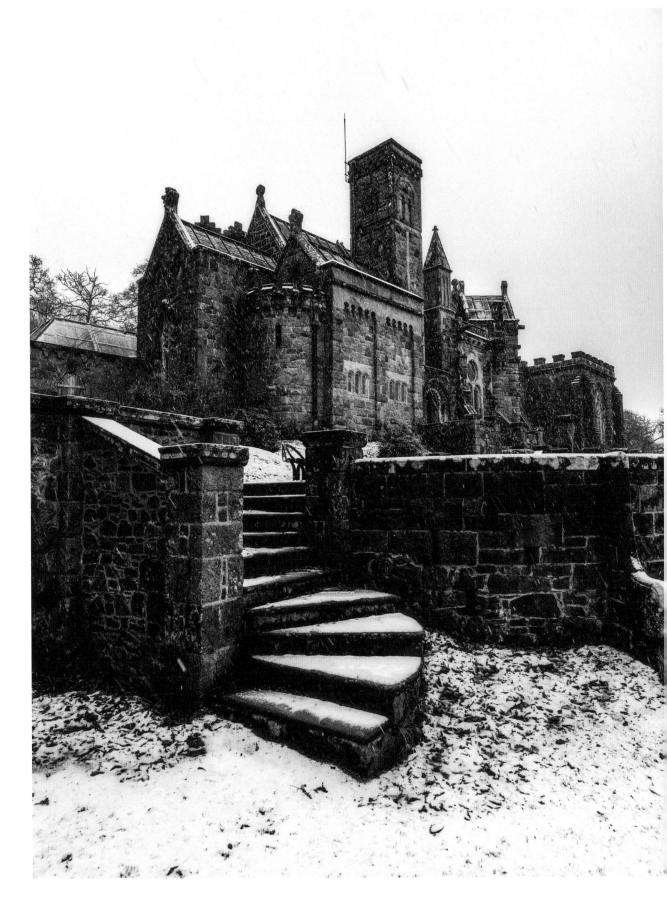

ST CONAN'S KIRK

Nearby Town: Oban

St Conan's Kirk stands proudly on the shores of Loch Awe, a testament to both architectural brilliance and spiritual reverence. The captivating church is a symphony of history, craftsmanship and profound beauty.

A marvel born from the vision of one man, Walter Douglas Campbell, St Conan's Kirk is an architectural ode to Scotland's rich heritage. Its construction began in the late 19th century and continued to evolve, weaving together various styles – Gothic, Romanesque and Byzantine – in a harmonious tapestry.

Approaching the kirk, you are greeted by a facade that seems plucked from the pages of a fairy tale. Towering spires and intricate stonework evoke a sense of grandeur, while the doorways embellished with ornate carvings invite exploration in the sanctum within.

Once inside, you are enveloped by a sense of serenity and awe that only these ancient religious structures can provide. Sunlight filters through stained-glass windows, casting kaleidoscopic patterns upon the polished wooden pews. The air hums with a quiet spirituality, enhanced by the beauty of the interior adorned with intricate details and craftsmanship.

What truly sets St Conan's Kirk apart is its melding of history and legend. Each stone, each archway, whispers tales of ancient lore and the timeless devotion of those who crafted this masterpiece. The church's unique design seems to transcend mere architecture, inviting visitors on a journey through time and spirituality.

Surrounded by the picturesque landscape of Loch Awe and the looming presence of Ben Cruachan, St Conan's Kirk stands as a beacon of tranquility. It's a place where the echoes of the past resonate with the beauty of the present, inviting all who visit to pause, reflect and embrace the enduring spirit of Scotland's cultural heritage.

GLEN LYON & FIONN'S ROCK

Nearby Town: Stirling

Referred to as Scotland's 'longest, loneliest and loveliest glen' by Sir Walter Scott, Glen Lyon winds through the heart of Perthshire, boasting breathtaking landscapes filled with historical importance. The secluded glen stretches for over 55km (34miles), flanked by rugged hillsides, age-old forests and the tranquil River Lyon.

Nestled within the glen lies the legendary Fionn's Rock, believed to be named after the mythical Gaelic hero, Fingal, after he split the rock with an arrow due to his incredible strength. Others say the rock was thrown by Fingal in a dramatic display of strength, which may suit his character profile if the other tales of legend are true.

Fingal is a character in the Ossianic poems, a collection of epic poems written by the 18th-century Scottish poet James Macpherson, who appears often in Scottish and Irish folklore. In the Ossianic poems, Fingal is portrayed as a mighty hero, a warrior and leader of the Fingalians, a legendary warrior band. The character became popular in the Romantic era and inspired various other works of art and literature. The poems were claimed to be translations of ancient Gaelic works, but their authenticity has been widely debated.

The walks around Glen Lyon are plentiful but the facilities scarce. However, the scenic drive through the glen is a must for anyone in the area. It can be frustrating at times not being able to park and enjoy the scenes that pass you by but, much like life itself, watching it come and go in peace and happiness is what you're here for, so enjoy the ride.

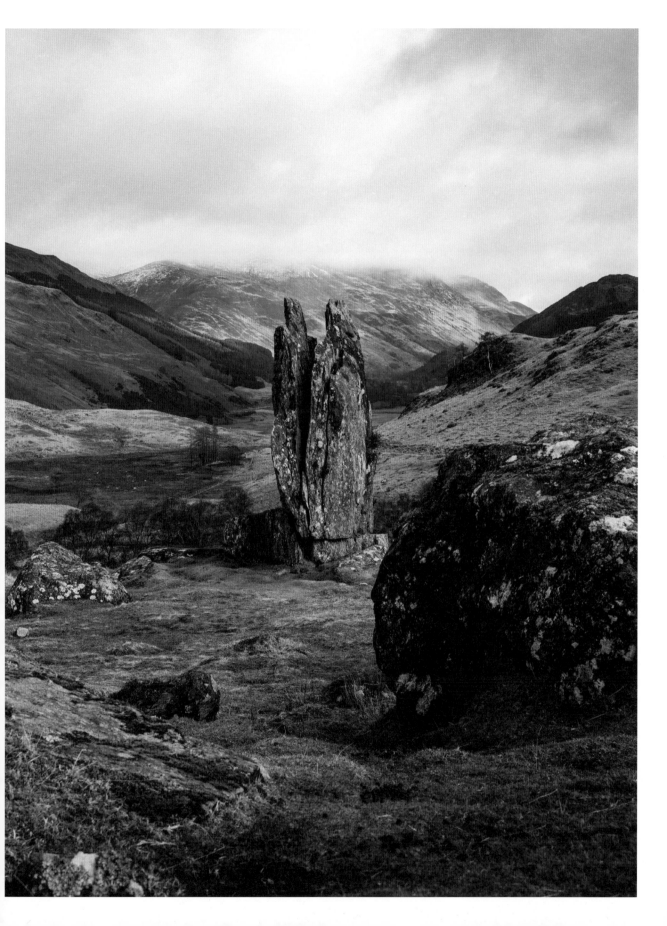

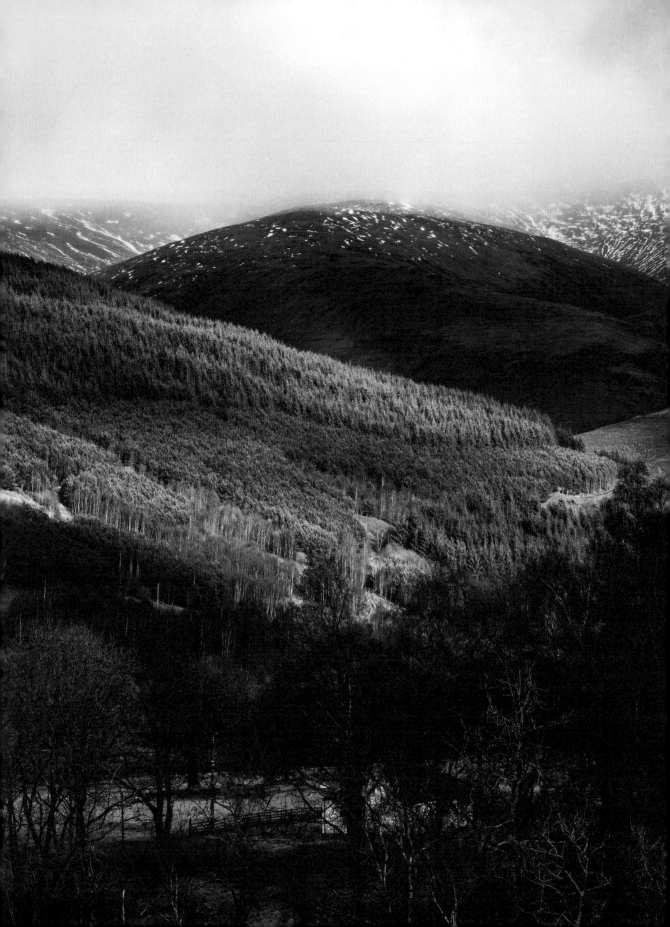

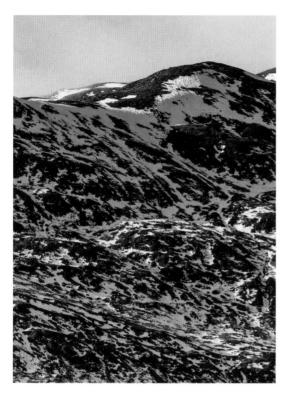

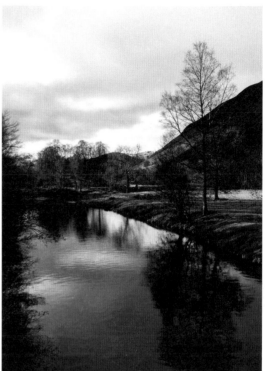

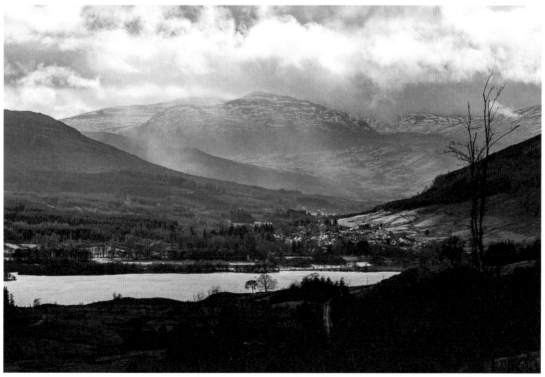

GLEN ETIVE

Nearby Town: Glencoe

Those that continue along the single-track road running down Glen Etive will be treated to a wondrous show of rugged and raw nature. The iconic glen stretches for approximately 20km (12miles) from the northern shores of Loch Etive, near the village of Dalness, to the remote and stunning Rannoch Moor, and every twist and turn has another breathtaking photo opportunity not to be missed. The roads here are good but definitely off the beaten track, so be well prepared for off-road conditions.

The valley is flanked by prominent peaks, including the famous Buachaille Etive Mòr and Buachaille Etive Beag, which dominate the skyline and contribute to the glen's dramatic allure – it set the scene for a meeting with James Bond and 'M' in the movie *Skyfall* (2012).

A wildlife haven and photographer's delight, the glen's ever-changing scenery and varied light conditions make it a paradise for both. From sunrise to sunset, the interplay of light and shadow on the mountains, the reflection of the landscape on Loch Etive's calm waters and the vibrant colours of the changing seasons, create captivating compositions from tip to toe.

Red deer graze on the valley floor while golden eagles soar overhead. Otters can be spotted along the riverbanks and, if you're lucky, you might catch a glimpse of the elusive Scottish wildcat or pine martens that call this region home.

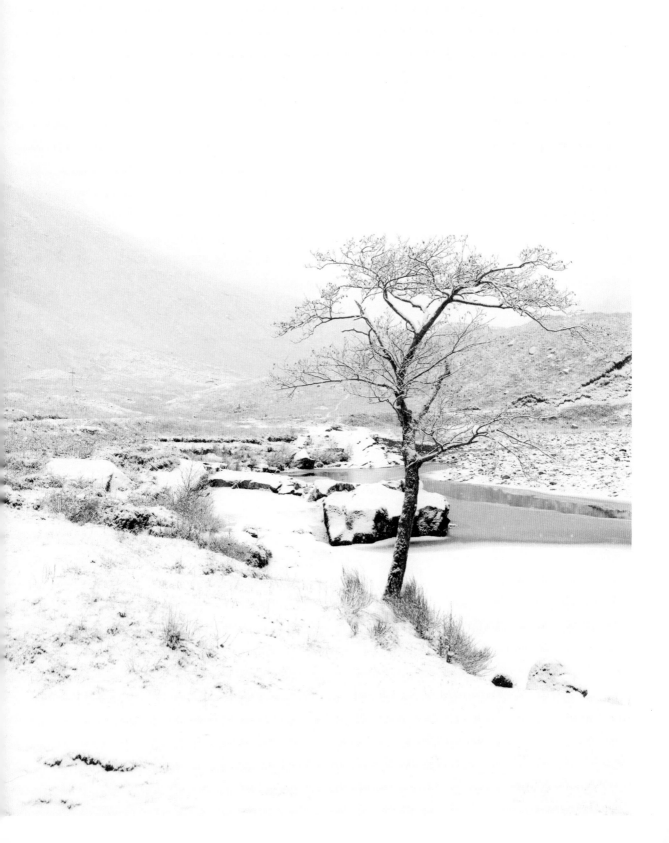

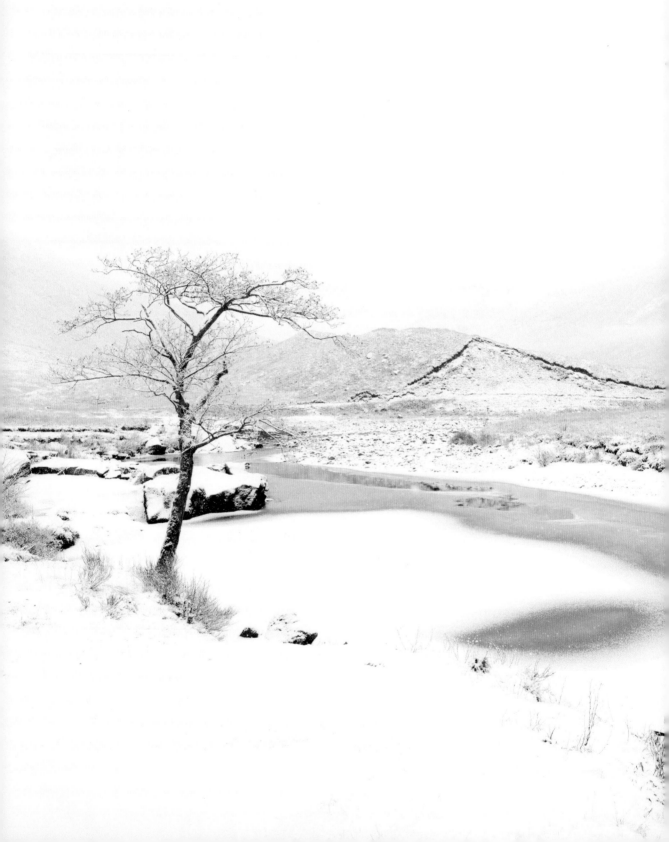

A wildlife haven and photographer's delight, the glen's ever-changing scenery and varied light conditions make it a paradise for both.

BIG EARS CAT

In the rich history of Scottish folklore, there exists a whimsical tale of another wildcat – a creature known as the Big Ears Cat. This charming figure, with ears as large as sails and a mischievous gleam in its eye, has captured the imaginations of Scots for generations.

According to legend, the Big Ears Cat is a playful and cunning creature, known for its ability to outwit even the cleverest of humans. With a coat as dark as the midnight sky and eyes that sparkle like stars, it roams the countryside under the cover of darkness, its ears twitching with curiosity and mischief.

Though its origins are shrouded in mystery, the Big Ears Cat is said to possess magical powers, granting it the ability to understand the secret language of the animals and commune with the spirits of the land. Some even whisper that it has the power to grant wishes to those who are pure of heart and deserving of its favour.

Yet despite its magical abilities, the Big Ears Cat is not without its faults. Like all creatures of the night, it can be capricious and unpredictable, leading travellers astray with its beguiling songs and playful antics. It is said that those who encounter the Big Ears Cat must tread carefully, lest they find themselves caught in its web of enchantment.

But for those who show kindness and respect to the natural world, the Big Ears Cat can be a loyal and steadfast companion. Tales abound of travellers who, lost in the wilderness, have been guided to safety by the gentle purring, its ears twitching with each step as it leads them home.

As the moon rises over the Scottish countryside and the stars twinkle in the night sky, the legend of the Big Ears Cat continues to draw our attention, reminding all who hear its tale of the magic that lies beyond.

RIVER COUPALL

Nearby Town: Glencoe

Flowing from the foothills of the iconic Buachaille Etive Mòr, the River Coupall meanders its way through the iconic Glencoe, its icy waters falling over the rocky terrain. Along its course, the river creates gentle rapids and sparkling pools that are perfect for a little private swim in the warmer months.

Surrounded by the majestic peaks of the Western Highlands, the River Coupall offers a symphony of sights and sounds. The glint of sunlight dancing on the water's surface, the soothing drone of its flowing currents and the backdrop of rugged mountains paint a picture that captures the essence of Scotland's natural allure.

Making your way down the small road at Glen Etive as you begin to circle the Buckle (an easier-to-say pet name for Buachaille Etive Mòr), a small unsuspecting car park seems to lead nowhere in particular. Cross the road and pop through the small line of trees, over the muddy footpath, following the ever-increasing sound of gushing water, and you'll soon reach a perfectly framed picture that could have been painted by a master.

Majestic falls rush from the River Coupall, surrounded by silver birch, as the rolling hills across the water lead your eye to the almost incomprehensible Buachaille. Every spiked rock, smoothed surface and bulbous boulder creating its unique silhouette seems within reach.

And while the mountain is hard to miss, the vein of life that flows through the ancient glen provides for the abundant wildlife that calls Glencoe home. Otters playfully navigate its currents and you'll often find herons and dippers gracefully fishing along its banks. The surrounding flora, from wildflowers to ancient woodlands, finds sustenance in its pure waters.

The short walk can be very boggy at times, and in wet seasons waterproof footwear is essential. The route is also rife with midges in the summer. A little bit of insect repellant might buy you some time, but wearing a midge hat is recommended!

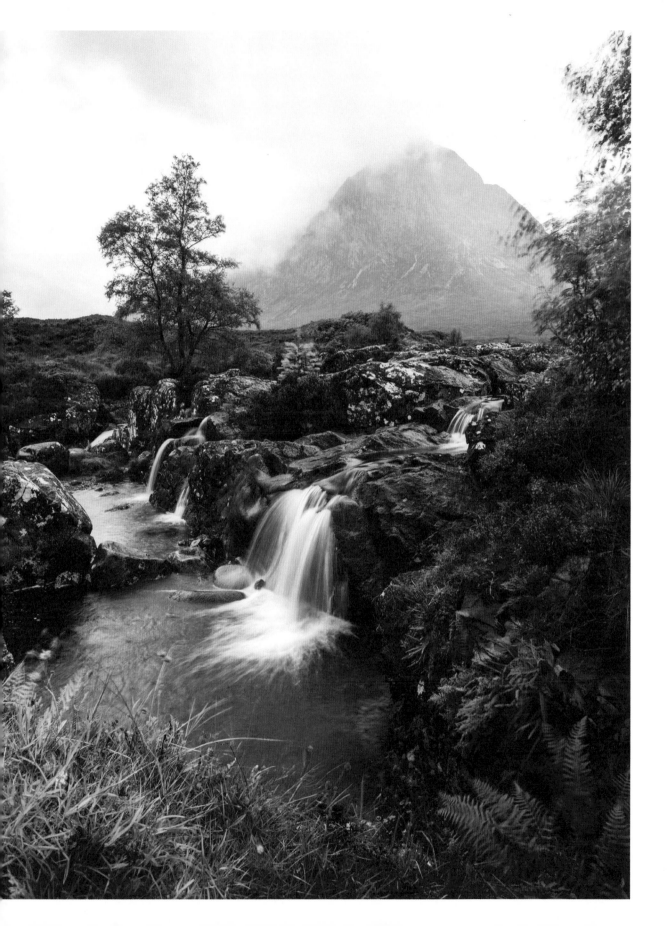

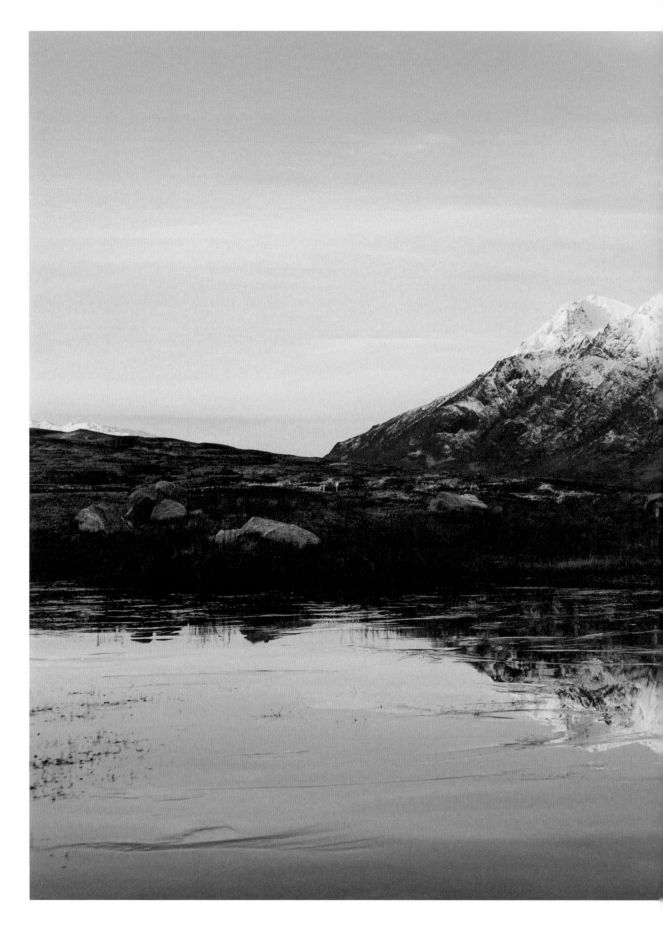

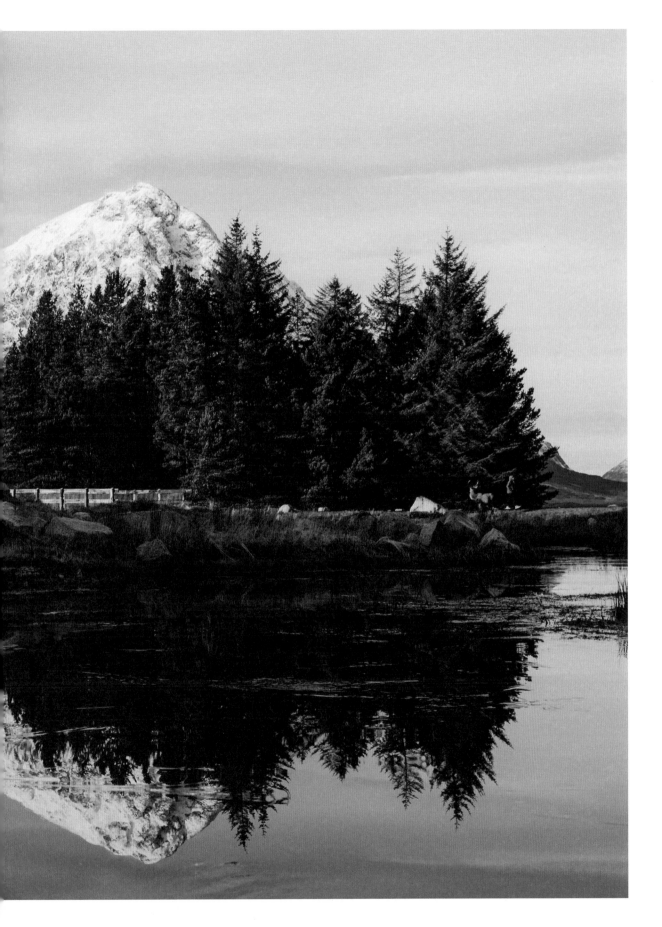

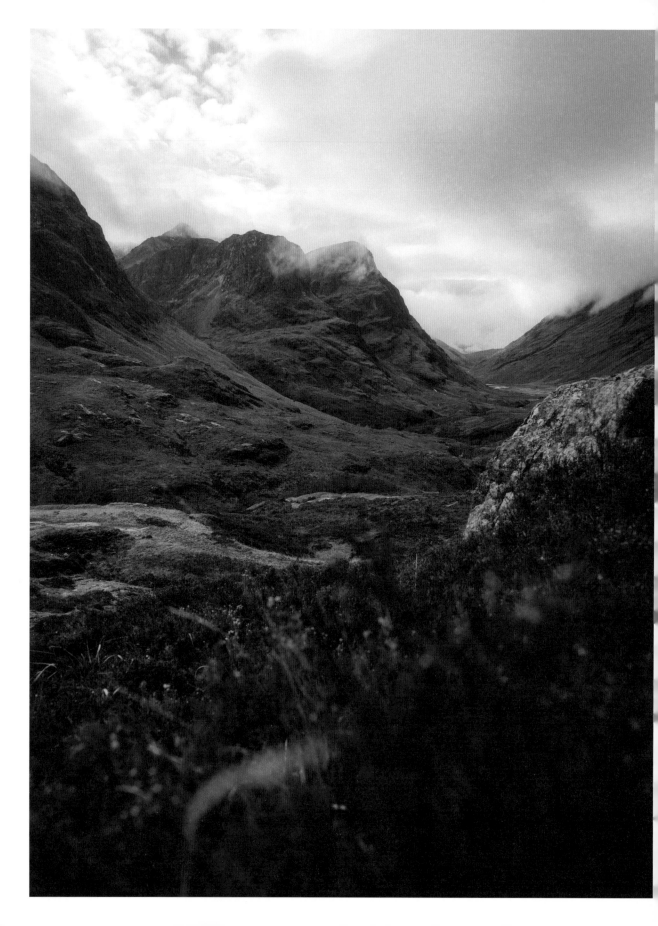

GLENCOE

Nearby Town: Glencoe

Many of Scotland's most iconic sites are nestled within the short space of Glencoe. The second you turn the bend into the glen, you can instantly sense something is different. The mountains are bigger; the landscape has transformed. The small structures dotted around the distance blend in with the patches of trees; rivers pop up out of nowhere and vanish before you can catch a glimpse of them. Look carefully and the tiny paths etched out on the sides of mountains become visible as small florescent-clad dots make their way up and down the sides of the resting behemoths.

In the early morning, the sun rises at one end of the long, tunnel-like valley and, in the evening, it sets at the other. And should you find yourself at the top of one of the many mountains at this auspicious time, you will feel like the last person on earth watching the spectacle for the very first time.

Glencoe is a haven for hikers, climbers, explorers and adventurers, all keen to take in the incredible views from countless vantage points. At centre stage, Buachaille Etive Mòr stands encircled by his brothers and sisters, each offering a new take on a view famous across the world.

GLENCOE MASSACRE

However, beneath the breathtaking views of Glencoe lies a haunting piece of history, the infamous Glencoe Massacre of 1692. This dark episode in Scottish history left an indelible mark on the glen, adding a layer of solemnity to its majestic landscapes.

The Glencoe Massacre unfolded against the backdrop of political turmoil and clan rivalries. In the late 17th century, the Highlands of Scotland were marked by tensions between the supporters of William of Orange, who had recently ascended to the English throne, and the Jacobites, loyal to the deposed James VII of Scotland and II of England.

In a ruthless act, the government forces, under the command of Captain Robert Campbell, were quartered among the MacDonalds, a clan traditionally associated with the Jacobites, in a seemingly friendly gesture. However, this hospitality was a facade.

On the fateful night of 13 February 1692, the Campbells turned on their hosts. In the early hours of the morning, the soldiers attacked the unsuspecting MacDonalds. The massacre resulted in the death of around 38 clan members, with more succumbing to the harsh winter elements as they fled into the mountains.

The Glencoe Massacre left an enduring scar on the Scottish conscience. Yet, Glencoe perseveres as a testament to the resilience of both nature and the human spirit. It invites modern-day explorers to not only appreciate its grandeur but to reflect on the layered history that has shaped its character.

CLOSE BY: THE DEVIL'S STAIRCASE

In the shadow of the towering peaks near Glencoe, there winds a path both feared and revered by those who dare to tread its course. Known as the Devil's Staircase, its steep inclines and perilous twists have earnt it a reputation as one of the most challenging routes in the region.

Legend has it that the name of the Devil's Staircase is no coincidence, but rather a testament to its sinister origins. According to local folklore, the path was forged by none other than the devil himself, who sought to ensnare unsuspecting travellers and lead them astray amidst the mist-shrouded peaks.

Yet despite the devil's best efforts, there were those who refused to be swayed by his dark intentions. Brave souls who dared to traverse the Devil's Staircase would emerge triumphant, their spirits unbroken and their resolve unwavering in the face of adversity.

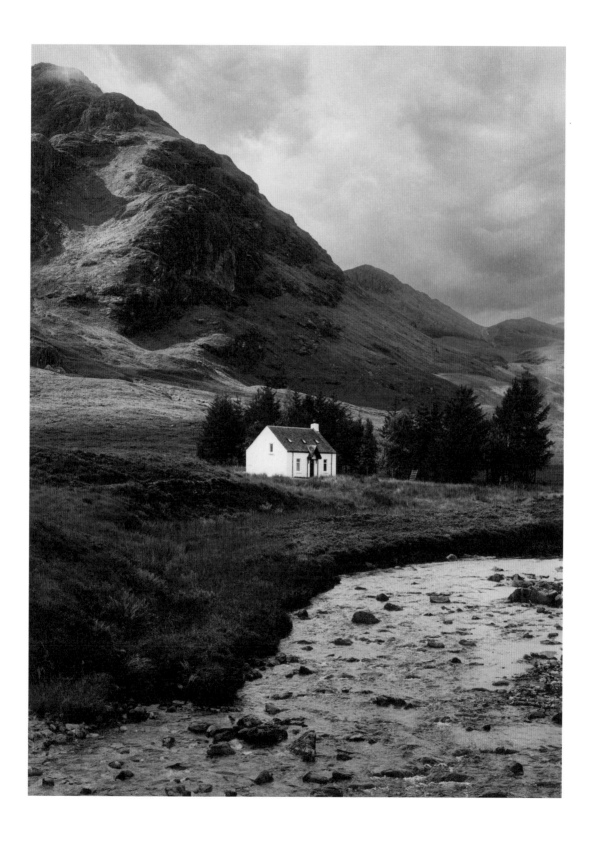

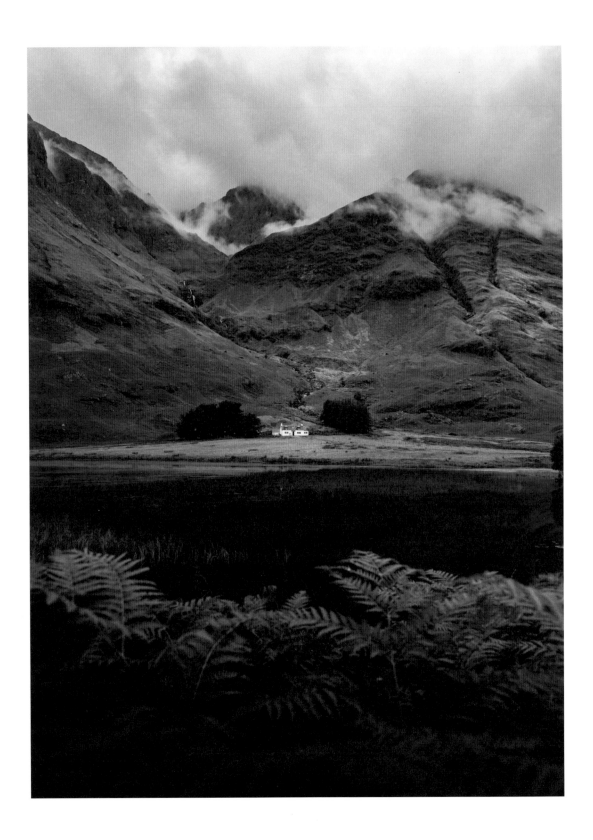

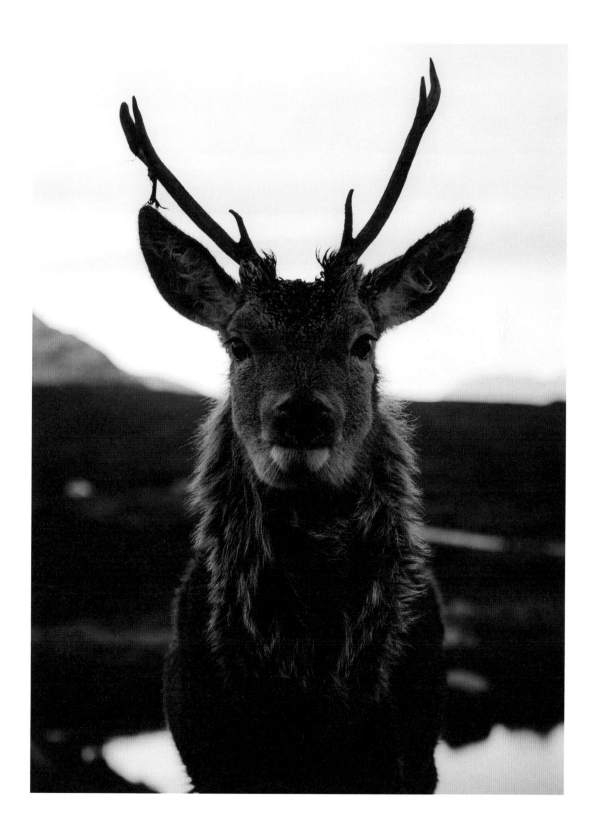

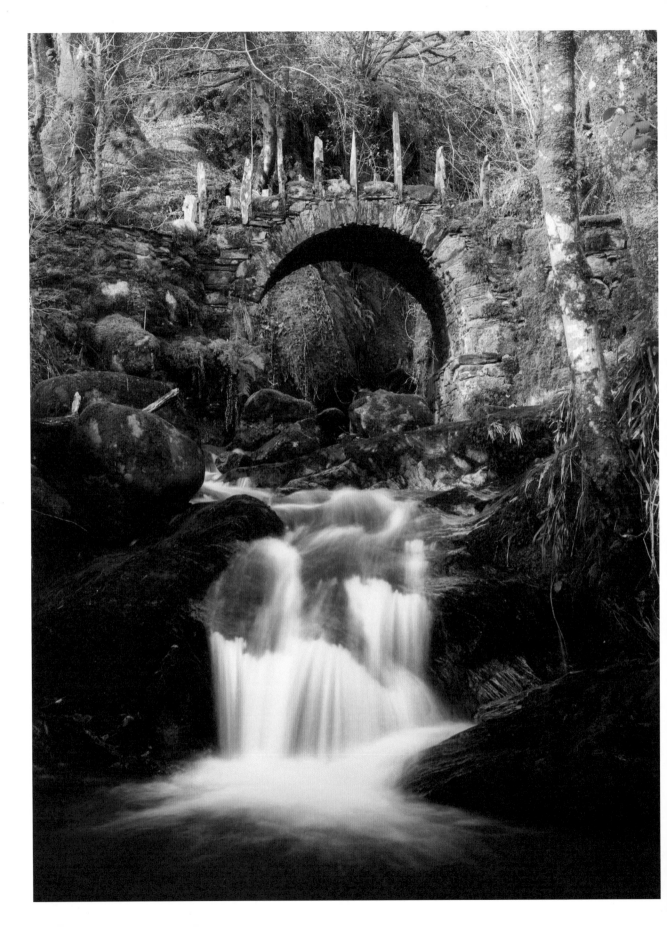

FAIRY BRIDGE

Nearby Town: Oban

The Fairy Bridge sits within the enchanting Glen Creran and spins a tale that blurs the lines between folklore and fact. This picturesque stone arch, draped in foliage holds a mystical allure that has captivated travellers through the ages.

Legend has it that the Fairy Bridge serves as a portal between the mortal realm and the ethereal world of the fay. Stories, passed down through generations, speak of those who have crossed its ancient threshold, finding themselves momentarily transported into a realm where time dances to a different melody than our own.

Stepping onto the worn stones of the bridge, visitors can almost feel the tingling sensation of magic in the air. Moss-covered rocks flank the arch, seemingly preserving the secrets of countless centuries within their silent embrace. The babbling brook beneath adds a melodic undertone to the whispers of the glen, as if inviting those who listen closely to hear the laughter of unseen beings.

Surrounded by the lush greenery of Glen Creran, the Fairy Bridge becomes a focal point of wonder amidst nature's splendour. The archway frames the landscape like a doorway to another world, inviting the curious and the dreamers to step closer and embrace the mystery that shrouds this beguiling place.

Whether you believe in the tales spun around this ancient bridge or simply seek solace in nature, the Fairy Bridge remains a testament to the rich Scottish tapestry of folklore. It stands, not just as a structure of stone and mortar, but as a bridge that connects the realms of imagination and reality, inviting all who encounter it to believe in the magic that dwells within the heart of the Scottish Highlands.

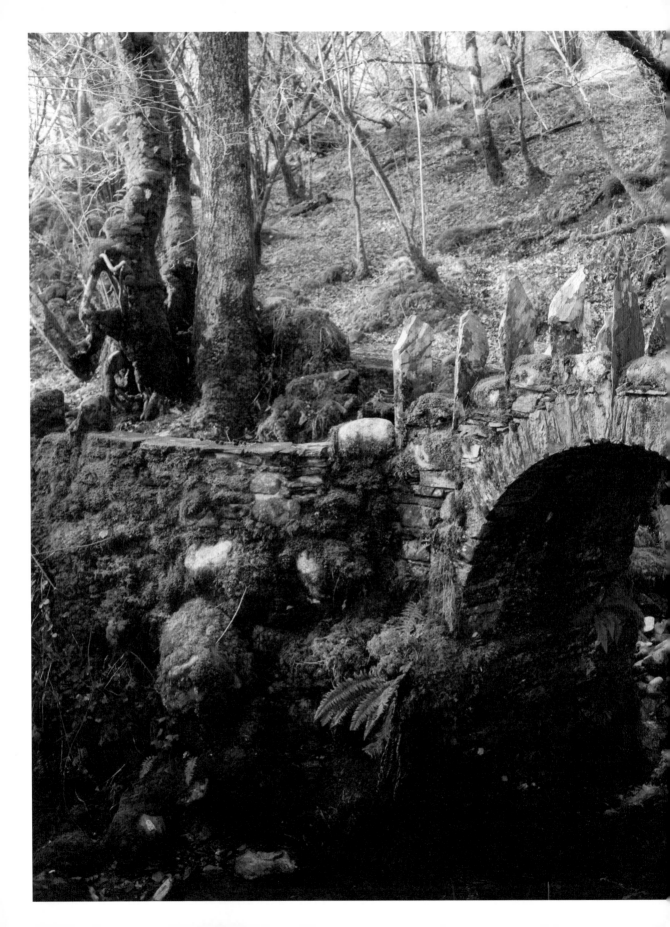

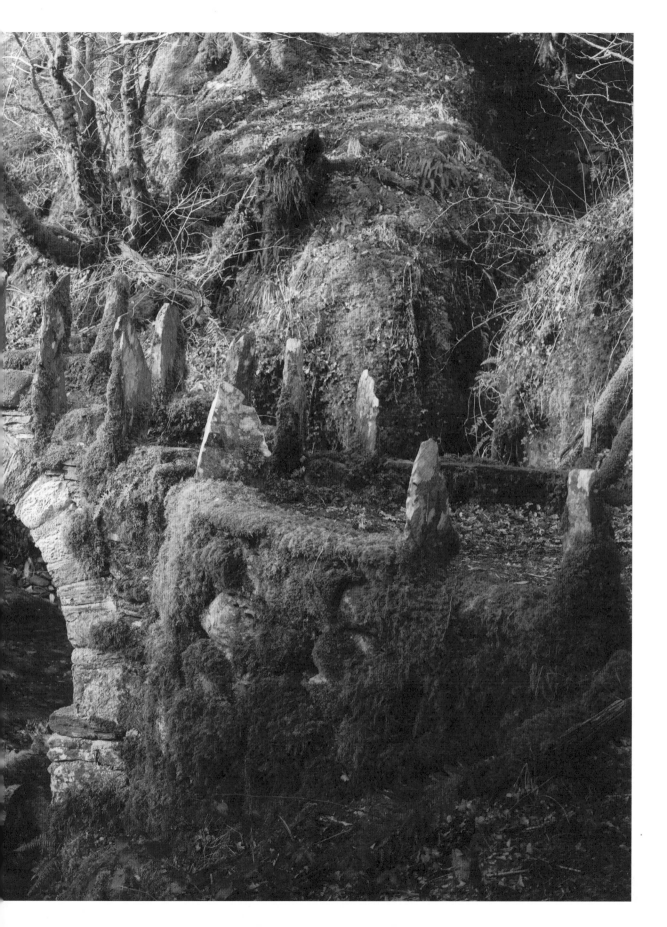

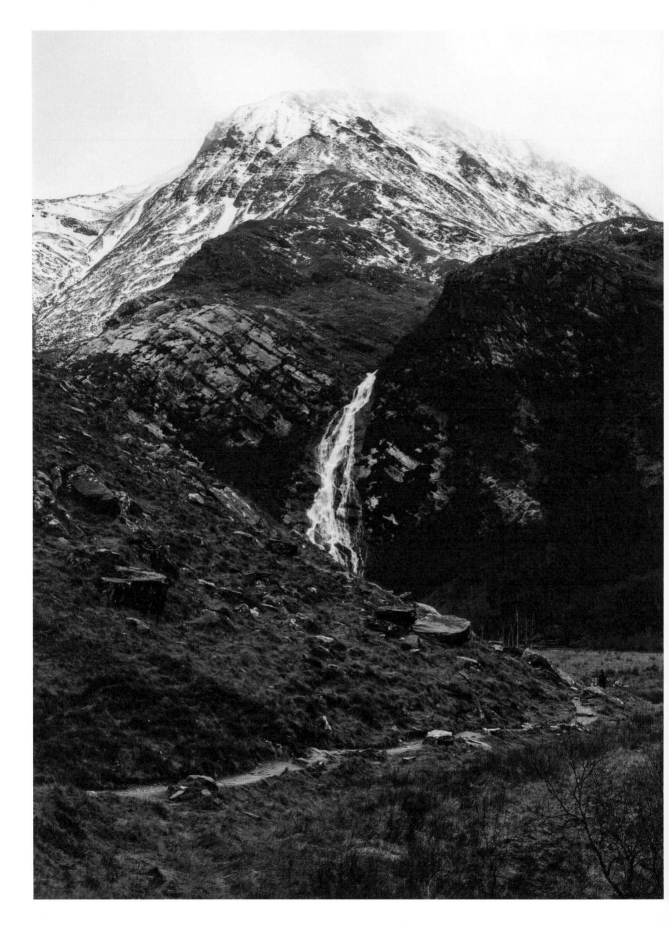

STEALL FALLS

Nearby Town: Fort William

Ben Nevis is the United Kingdom's highest mountain and at 1,345m (4,413ft) it dominates the area surrounding Fort William and beyond. But that's not who we're here to see today.

Twisting around the base of the mountain is Glen Nevis, dense with fascinating trees, meandering rivers and rock formations that don't seem to make sense. There is a path that leads in, up and around the glen, vaguely heading in every direction – climbing stairs, crossing bridges and hopping waterfalls – as it makes its way up and above the trees.

The reward for your valiant efforts is soon apparent as you turn the final corner and leap over the last boulder in your way. In the distance, Steall Falls seems to operate in slow motion as the water falls 18m (60ft) from top to bottom, crashing into the stone and forest below.

A casual walk further takes you to the final hurdle of your journey, and one that many have failed at! A wire rope bridge crossing the fast-flowing river is the only way across without getting your feet wet. It can be tough, especially in wet weather, and there's always going to be a little shaking as you make your way across, but a couple of minutes is all it takes, and then you'll be on your way to the foot of the falls.

In an area famous for its hikes, climbs and walks, the journey to Steall Falls will always be a favourite of those who make it. Following the path through the dense forest clinging to the side of the mountain with the ever-present white noise of the fast-flowing river below creates a fantastically beautiful ambience for a short hike to a very special location.

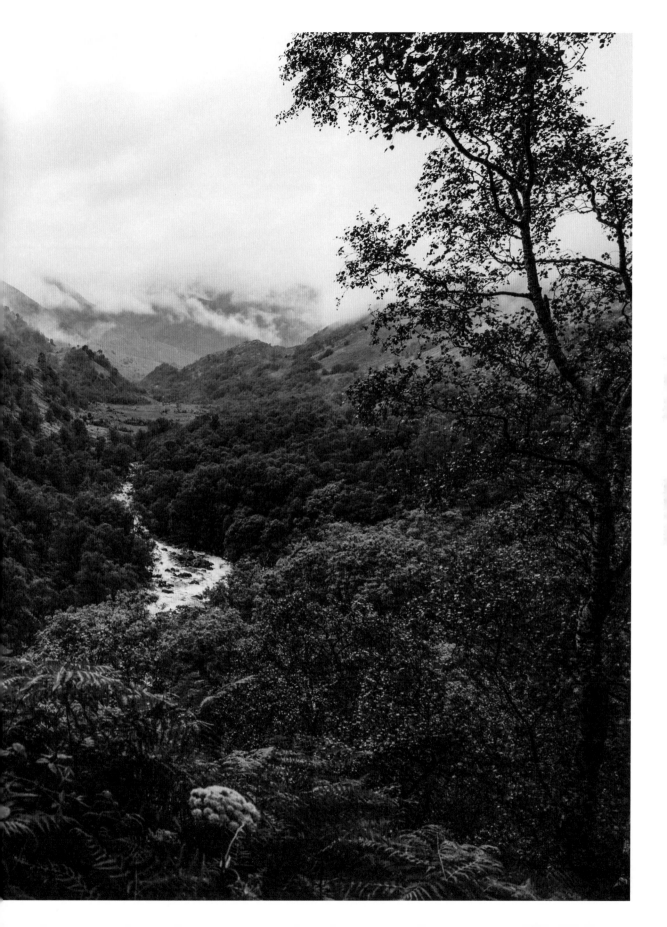

CASTLE TIORAM

Nearby Town: Strontian

Castle Tioram, a weathered sentinel standing strong amidst the serene landscape of the Highlands, stands as evidence of centuries of history and untold tales. This ancient stronghold, perched majestically on a tidal island at the confluence of Loch Moidart and the River Shiel, whispers echoes of a bygone era.

Approaching Castle Tioram, you're greeted by the haunting silhouette of its ruins against the backdrop of the tranquil loch. With a history dating back to the 13th century, Castle Tioram was once a mighty fortress, a strategic stronghold guarding the western shores of Scotland. Its walls have witnessed the ebb and flow of power, changing allegiances and the clash of clans vying for control over these ancient lands.

The castle's rugged beauty is accentuated by the surrounding natural splendour – the shimmering waters of the loch, the green hillsides and the ever-changing skies that paint a mesmerizing backdrop. During low tide, a causeway reveals itself, offering a fleeting passage to the island and the castle ruins, should the tide be in when you arrive, feel free to roll up your trouser legs and venture forth.

Exploring the remnants of Castle Tioram is a journey through time. Stone staircases lead to vantage points that offer panoramic views of the surrounding wilderness, evoking a sense of both isolation and grandeur. The crumbling walls, though weathered by time, exude an aura of stoic resilience, each stone preserving the secrets of the past.

Yet, despite its weathered state, Castle Tioram retains an air of mystique and allure. It remains a pilgrimage site for history enthusiasts, a canvas for artists seeking inspiration and a poignant reminder of Scotland's rich cultural heritage.

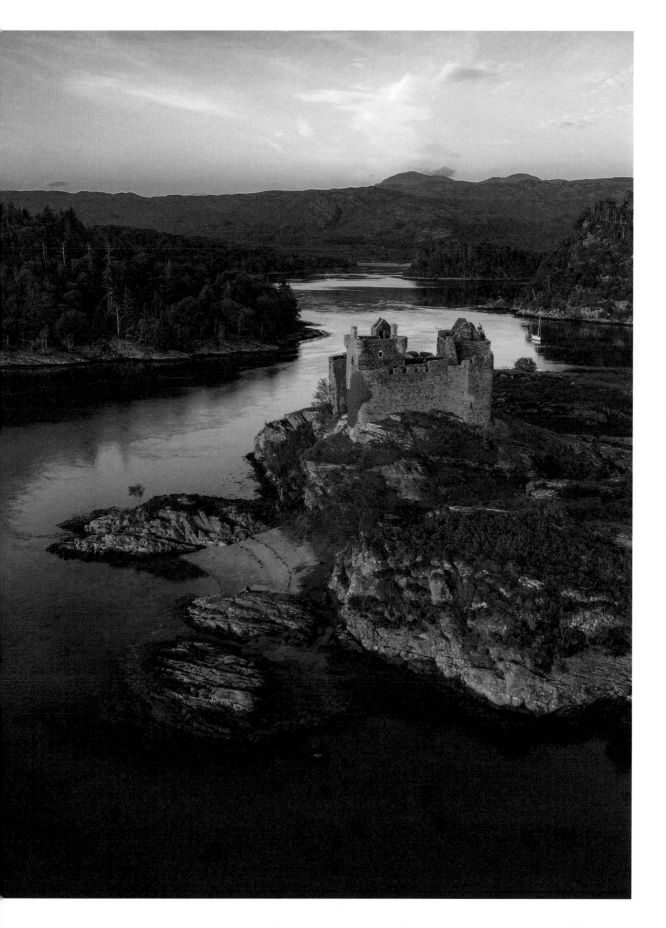

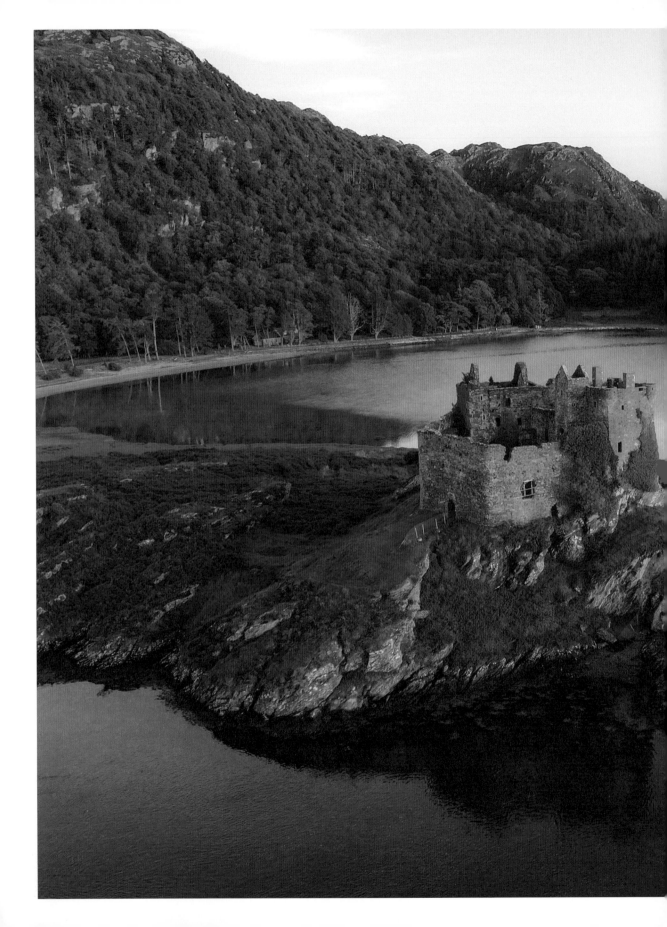

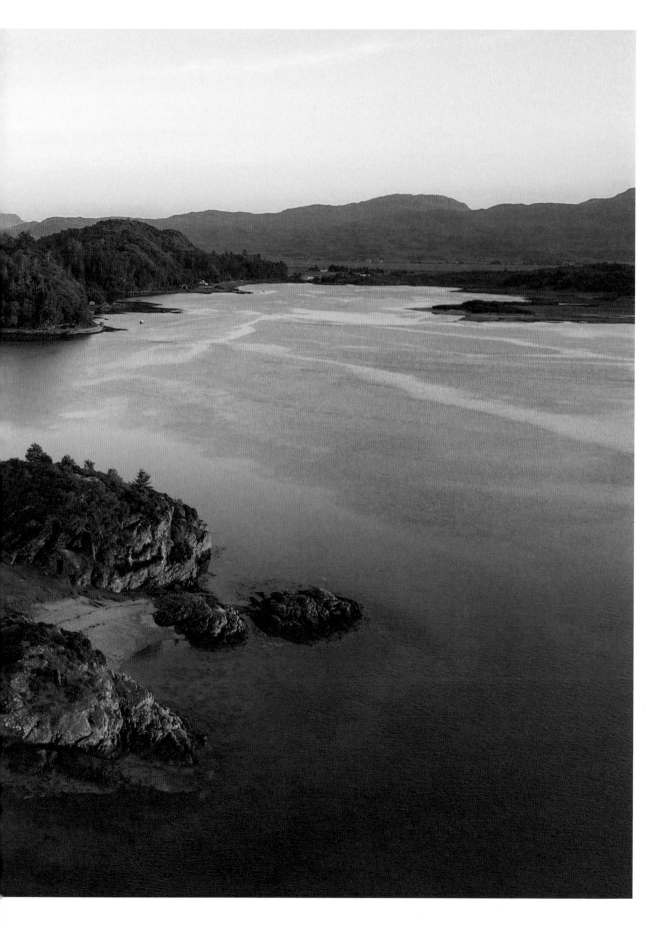

SANNA BAY

Nearby Town: Salen

Lying close to the most westerly point on the mainland, Sanna Bay delivers everything you might expect from a Scottish beach. Rugged stone pushes its way out of the earth and grassy dunes eventually make way for pristine white sands leading down to the turquoise blue and green waters. But the one thing that stands out the most is that there is no one here.

The small roads of Ardnamurchan keep a large portion of visitors away and the peninsula's position makes it seemingly easy to score off the list in favour of heading north to the Isle of Skye or Torridon. But this isolation may also be what keeps the area so fascinatingly beautiful.

The history of the bay whispers tales of ancient settlements and a heritage intertwined with the sea. Fishermen and sailors once sought refuge in these sheltered coves, braving the tempestuous waters for their livelihoods.

Exploring the bay unveils its treasures – a mosaic of tidal pools teeming with marine life, hidden caves carved into the cliffs and an array of seabirds dotting the skies above. The tranquility of the bay, punctuated by the sound of crashing waves and the cry of seabirds, creates a serene ambiance for those who venture here.

The roads in this part wind and twist their way through ancient forests, past brutal coasts and up, over and around bends, like nowhere else in the country. Being able to take your time and enjoy the journey is the key to a successful trip.

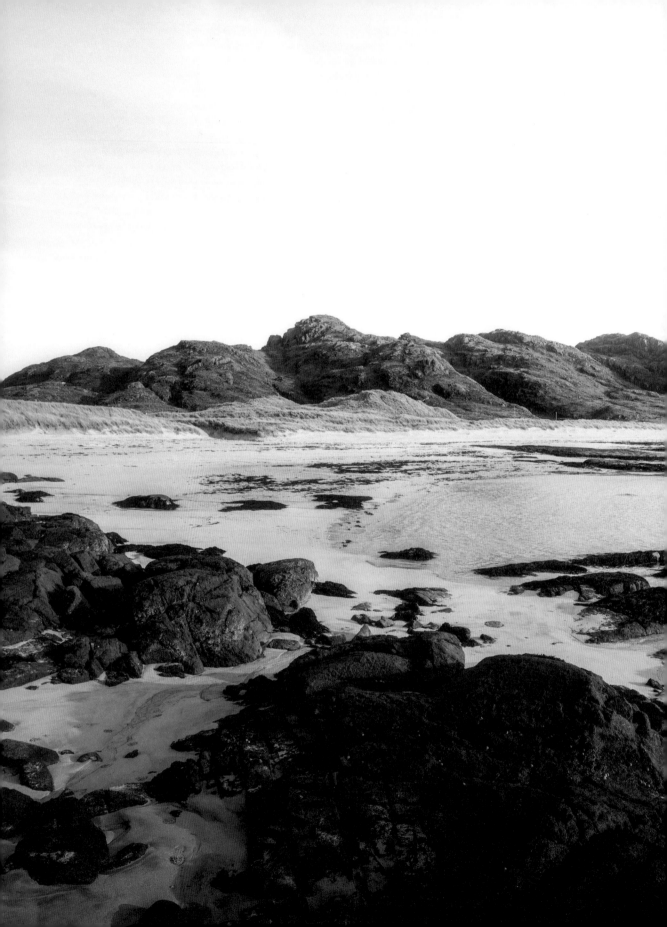

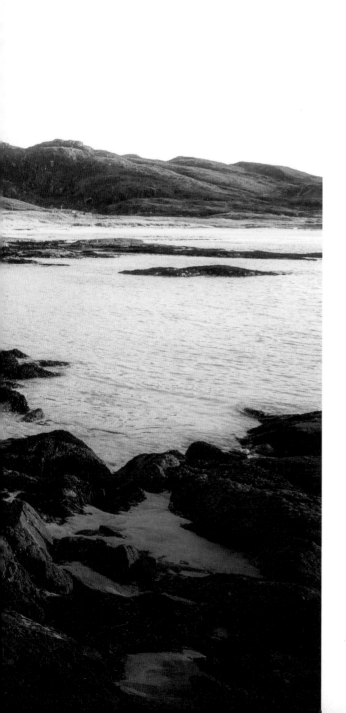

CLOSE BY: TOBERMORY

During the warmer months, around late March until late September, a small ferry from the tiny village of Kilchoan runs to the iconic fishing village of Tobermory on the Isle of Mull, a thriving community with a rich maritime heritage that dates back centuries. From its humble beginnings as a fishing port to its role as a bustling hub for trade and commerce, the village has always been intimately connected to the sea.

Wander along the cobbled streets and you'll discover a treasure trove of local shops, cozy cafes and welcoming pubs, each offering a taste of the unique culture and hospitality that defines life in Scotland.

For outdoor enthusiasts, Tobermory is a paradise waiting to be explored. Hike along the rough coastline and discover hidden coves and sandy beaches, or venture into the surrounding hills for breathtaking views of the landscape. For those looking to experience the rich marine life that thrives in the waters off the coast of Mull, there are plenty of opportunities for fishing, wildlife watching and boat tours to the incredible islands that rise up all over the western coast.

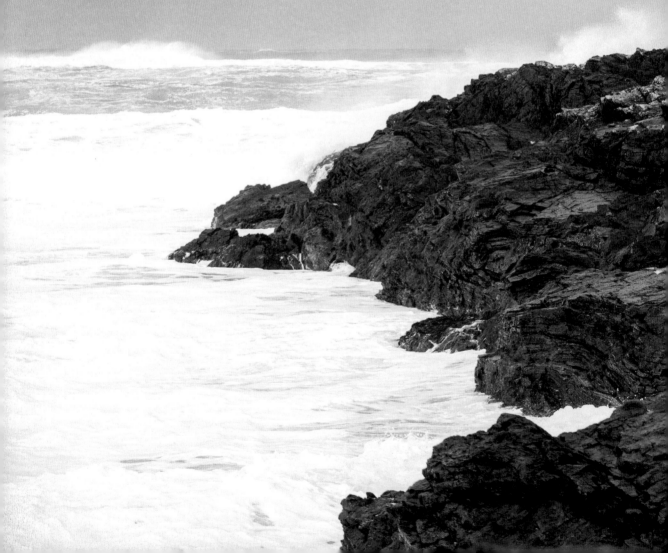

THE
HEBRIDES

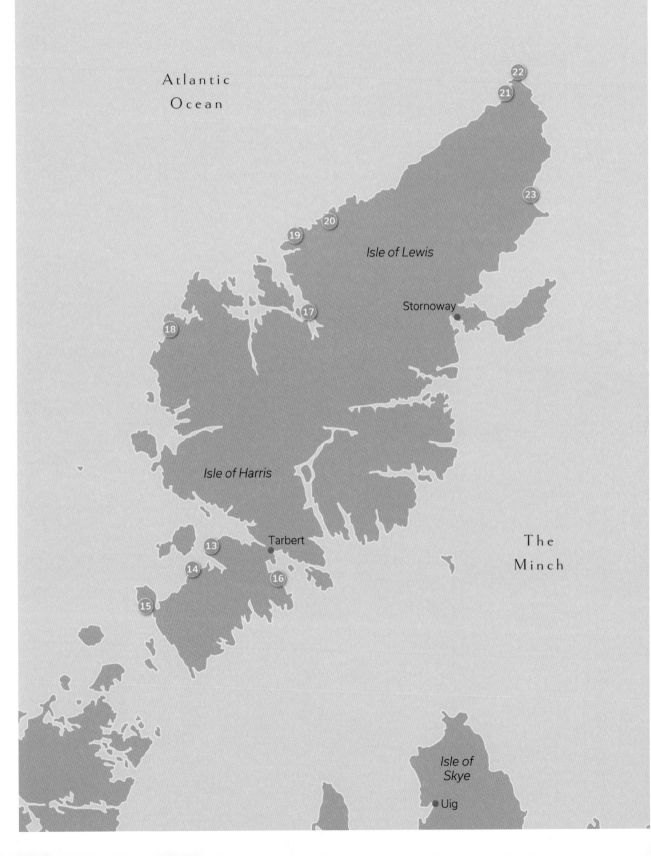

Atlantic
Ocean

Isle of Lewis

Stornoway

Isle of Harris

Tarbert

The
Minch

Isle of
Skye

Uig

Off the northwest coast of Scotland, the Outer Hebrides stand as a testament to both the relentless force of nature and the unwavering resilience of its people.

The islands' history is as deep and varied as the landscapes themselves, with human traces dating back to the Mesolithic era. Their past is woven with the threads of Celtic tribes, Norse invaders and Scottish clans, each leaving a very distinct imprint on the culture and archaeological legacy that endures to this day.

Inhabitants of the Outer Hebrides, or 'islanders', are celebrated for their hospitality, community spirit and adherence to traditions that have been the cornerstone of their identity for generations. From the Scots Gaelic language to the melodies of traditional music and the artistry of Harris Tweed weaving, these customs are the lifeblood of the community. Fishing and crofting continue to be as important as ever, sustaining many families and preserving a way of life that is in harmony with their surroundings.

Stories of fairies, sea monsters and ethereal entities are deeply interwoven into the islanders' way of life. These tales, along with traditions such as saining (blessing, protecting or consecrating) and community ceilidhs (gathering or party with lots of singing and dancing), underscore a profound connection to the mystical aspects of land and sea, enriching the social fabric of the islands.

The natural beauty of the Outer Hebrides is unrivaled, boasting landscapes that range from stark coastlines and desolate moors, to beaches of such pristine beauty they seem otherworldly. A journey to these remote islands is an indelible experience, leaving lasting memories in the hearts of all who explore them.

13 Luskentyre Beach **14** Nisabost Beach **15** The Temple **16** The Golden Road **17** Calanais Standing Stones **18** Mangersta Beach **19** Gearrannan Blackhouses **20** Shawbost Norse Mill and Kiln **21** Eoropie Beach **22** Butt of Lewis Lighthouse **23** Garry Beach

LUSKENTYRE BEACH

Island: Isle of Harris

On the western coast of the Isle of Harris, after making your way past stunning beaches, green glowing waters, and idyllic crofts, houses and graveyards, Luskentyre Beach sits waiting like a prized jewel in a crown of diamonds. A brief walk over uneven ground and scattered grains of white sand leads you to a miniature jungle of beautiful tall grass. Pushing your way through the leaves while they sway to the gentle breeze; experiencing the unique curve of the delicate sand, gleaming crystal-like waters and expansive view that seems to go on forever – it is like stepping into your favourite book. It's easy to see why this very spot makes it into almost every 'top ten beaches of the world' list ever made.

Luskentyre Beach boasts breathtaking sights that stretch as far as the eye can see, with the waters of the Atlantic Ocean meeting the golden sands against a backdrop of rough rolling hills and distant mountains often typical of a Scottish scene, but uniquely different at the same time.

The ever-changing light plays across the landscape, casting shadows and highlights that accentuate the beauty of the surroundings, while distant rain clouds pass uninterrupted through the mountains, illuminating waiting rainbows for the right eyes to see. Whether bathed in the soft glow of dawn or illuminated by the fiery hues of sunset, Luskentyre Beach offers moments of tranquility and awe-inspiring beauty.

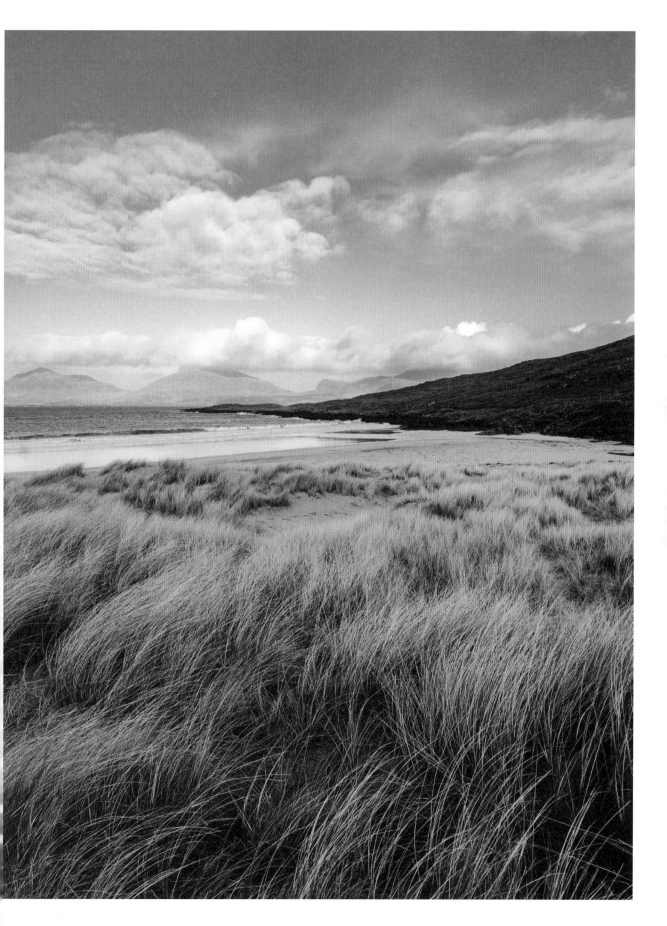

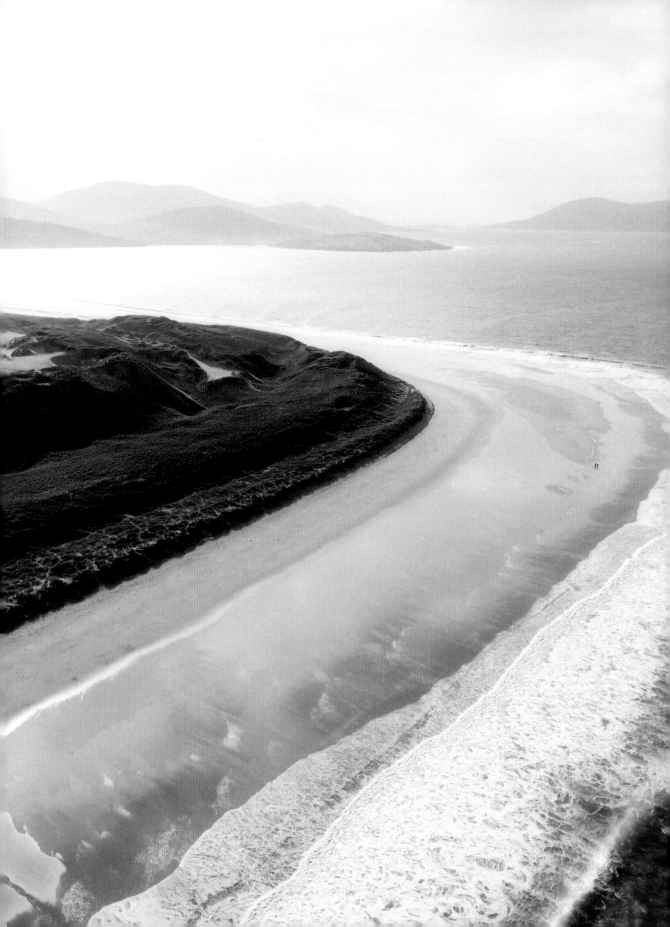

Luskentyre Beach offers moments of tranquility and awe-inspiring beauty.

Surrounded by unspoiled wilderness, Luskentyre Beach provides plenty of opportunities for exploration and outdoor adventure. Those that make it here can embark on leisurely walks along the shoreline, breathing in the salty sea air and listening to the soothing sound of waves breaking on the shore. Nearby trails wind through machair, a coastal grassland teeming with wildflowers and birdlife, offering glimpses of native flora and fauna in their natural habitat.

The history of Luskentyre is intertwined with the heritage of the Outer Hebrides, with evidence of humans dating back thousands of years. While the exact origins of the beach's name remain uncertain, it is believed to have Celtic roots, possibly derived from the Gaelic language, with the closest translation of 'lios-cinn-tir' (meaning 'headland fort') seeming the most accurate. Although there are no forts anywhere near the famous site, one wonders what may have come and gone without any record left to sate our imaginations.

CLOSE BY: SEILEBOST BEACH

Otherwise known as 'Oh wow, look at that!', Seilebost Beach may well be your first glimpse of what Harris has to offer. Located adjacent to Luskentyre Beach, Seilebost promises a similar tranquil retreat amidst the rugged beauty of Scotland's western coast. With its sweeping expanse of golden sands and panoramic views of Taransay Island, this picturesque beach invites all to unwind and reconnect with nature in a serene coastal setting. With a huge surface area at low tide, it's the perfect place for dogs (or kids) to run wild and explore all the nooks and crannies of this wondrous place.

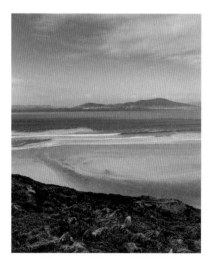

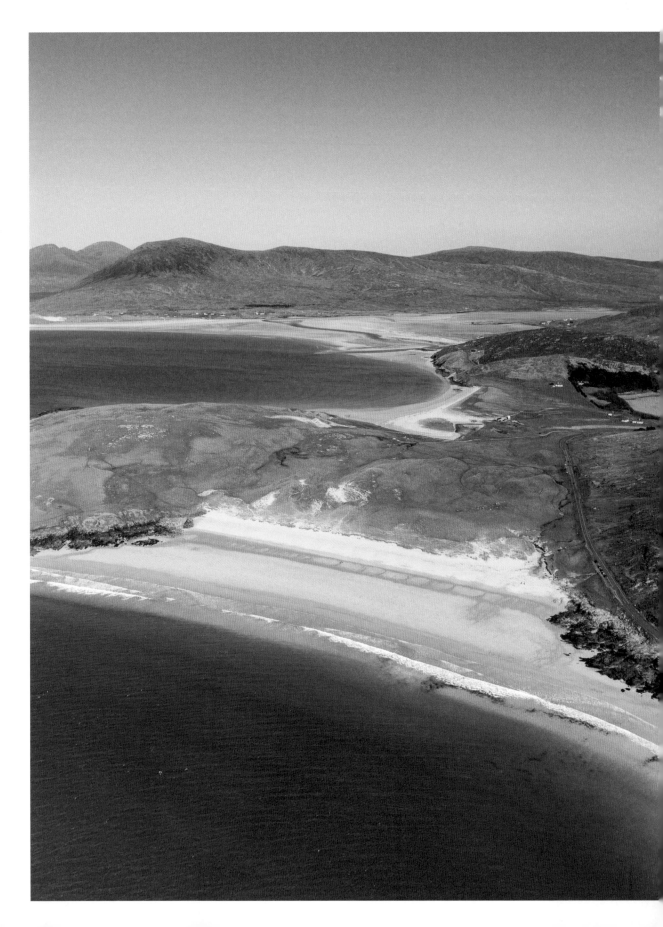

NISABOST BEACH

Island: Isle of Harris

Nisabost Beach is where the Atlantic's might meets the resilience of the Hebridean shore, a place of stark contrasts and sublime beauty. The white sands stretch forth, welcoming the caress of turquoise waves, while the ever-rugged outline of Harris's hills stands guard in the distance. It is a canvas on which the light plays, casting ever-changing shadows and hues that mesmerize all those who venture here.

The beach is a sanctuary of solitude, where the only sounds are the gentle washing of the sea and the soft call of seabirds walking in the wet sands and swimming in the gentle ebb and flow of the waves. With each tide, the landscape transforms, revealing hidden treasures and inviting the wanderer to lose themselves in the vastness of nature. It is a place that belongs to the elements, shaped by wind and water into a haven of peace and beauty.

Those that visit get to step into a world where time holds a different meaning, measured not in hours but in the rhythm of the sea and the dance of light across the dunes. It is a reminder of the transient yet timeless nature of beauty, offering a moment of connection with the wild heart of the Hebrides, where every grain of sand tells a story of the Earth's ancient song.

THE TEMPLE

Island: Isle of Harris

On the southwest coast of Harris, resting close to the village of Rodel, lies the remnants of a medieval temple. It is thought to be dedicated to Pope Clement I, considered one of the Apostolic Fathers, signifying his direct ties to Jesus's twelve apostles and his foundational role in early Christianity. Therefore, this site holds tales of the island's Christian past and the austere lives of its ancient inhabitants.

Dating possibly to the 15th century, the Temple's structure, though now a shell of its former self, showcases the architectural ambition of its era. Surviving arches and stonework offer glimpses into the craftsmanship and devotion that fueled its creation. Scenes carved into stones survive, hinting at the religious and communal life that once centered around this site.

The Temple itself provides a wonderful centrepiece to an area draped in natural beauty, and the walk to the ruins could not be more inspiring as you pass beaches large and small, grassy knolls looked after by local sheep and highland cows, and no signs of modern civilization.

The site remains a testament to the resilience of faith and the community it served, standing against the backdrop of Harris's ever-dramatic landscape. As the world changes all around it, the Temple has been in reverse, slowly being reclaimed by nature and becoming as part of the furniture as the rocky coastline or sandy dunes that surround it.

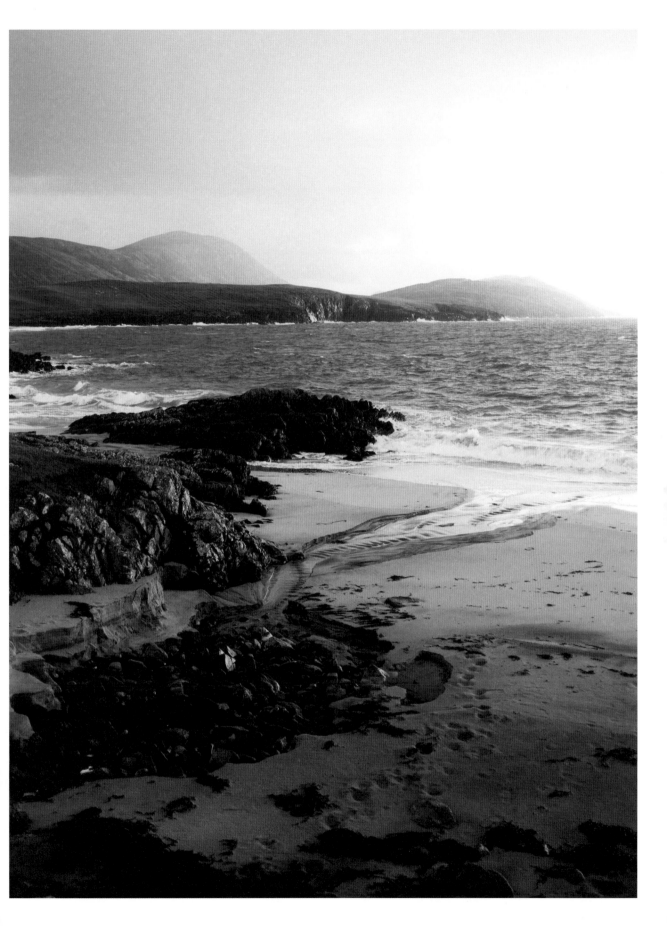

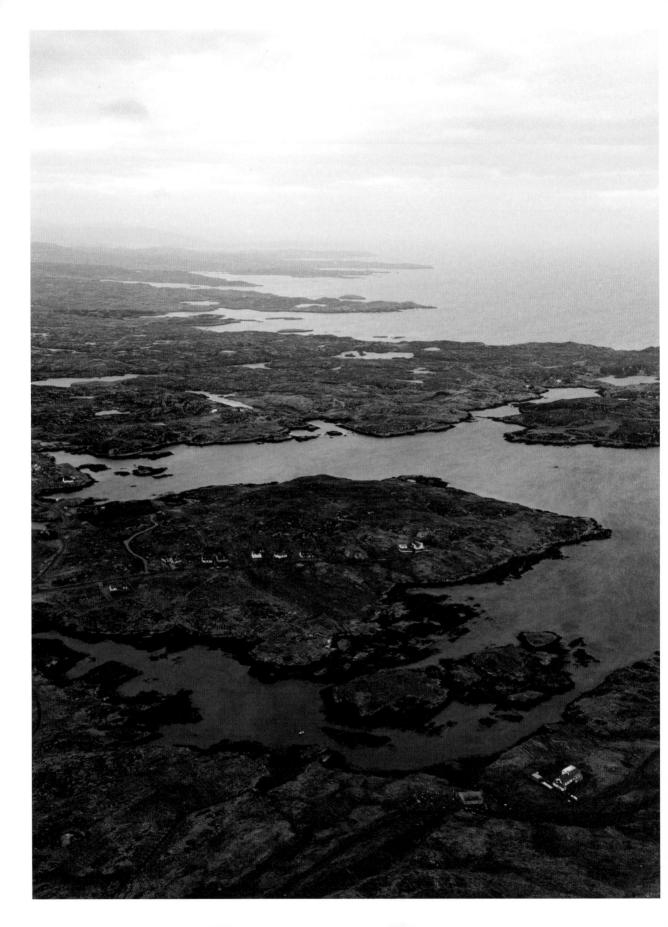

THE GOLDEN ROAD

Island: Isle of Harris

The Golden Road winds across the eastern reaches of Harris, marking a journey through a landscape that challenges the notion of beauty with its rough, undulating terrain. Here, the earth is a palette of heather, rock and water, each element sculpted by the relentless touch of weather and time. This path offers not just a route but a story of resilience and adaptation, where communities have carved out a niche in the midst of nature's grandeur. Artisans along the way share their crafts, each piece a display of the influence of this wild, untamed environment on the people that call it home.

The road itself is a contradiction, named for its perceived value rather than any precious metal. It's a treasure of a different kind, offering vistas that stretch the soul, from serene lochs nestled in the folds of the hills to expansive views of the Atlantic's distant horizon. The journey is punctuated by the work of those who draw inspiration from this place, their studios dotted like secrets along the winding way, inviting exploration and the chance to carry a piece of Harris's essence onward.

As you travel the snaking road, it becomes clear that this is a landscape of stories, each curve revealing a new chapter of natural beauty. It is a place where the sky looms large and the land speaks in tones of peat and stone, a constant reminder of the Earth's raw creativity. The road does not lead to gold but to something far more precious: an understanding of the symbiotic relationship between land and life in one of Scotland's most captivating corners.

As you travel the snaking road,
it becomes clear that this is a landscape
of stories, each curve revealing a new
chapter of natural beauty.

EACH-UISGE

The Each-uisge, known as a shapeshifting water horse, is a figure
of immense intrigue, distinguished from its relatively benign cousin,
the Kelpie, by its far more sinister demeanor. It is said to inhabit the
serene waters of the Highlands and Islands, preying on the unwary who
venture too close to the water's edge. Unlike the Kelpie, the Each-uisge's
reputation is marked by a penchant for malice, making it a far more
formidable beast.

According to legend, the creature often appears as a magnificent horse,
with a coat that shines under the moonlight and eyes that sparkle with
an otherworldly allure. This bewitching appearance is a trap, luring
the curious and the bold closer with visions of untold adventures and
treasures, only to drag them into the depths below.

The origins of the Each-uisge are thought to be deeply entwined with
ancient Celtic mythology, where horses were revered symbols of
strength, fertility and the abundance of nature. The Celts also held a
belief in beings capable of transforming their shape, interacting with
humans for good or for evil. The Each-uisge embodies this dual nature,
a majestic yet menacing figure that serves as a potent reminder of the
wild and unpredictable forces of nature.

As a cautionary tale, the Each-uisge reminded travellers of the dangers
hidden in plain sight and the wisdom of respecting the untamed
elements. The stories advised a keen awareness of the unusual,
especially near water, to avoid falling prey to the creature's deceit.

Today, the legend of the Each-uisge continues to enrich the folklore and
traditions of Scottish communities, casting a spell of wonder and caution
over the serene landscapes of the Highlands. While reports of actual
encounters are scarce, the legend persists, a testament to the enduring
power of storytelling and the human fascination with the mysteries that
lie just beyond the veil of the known world.

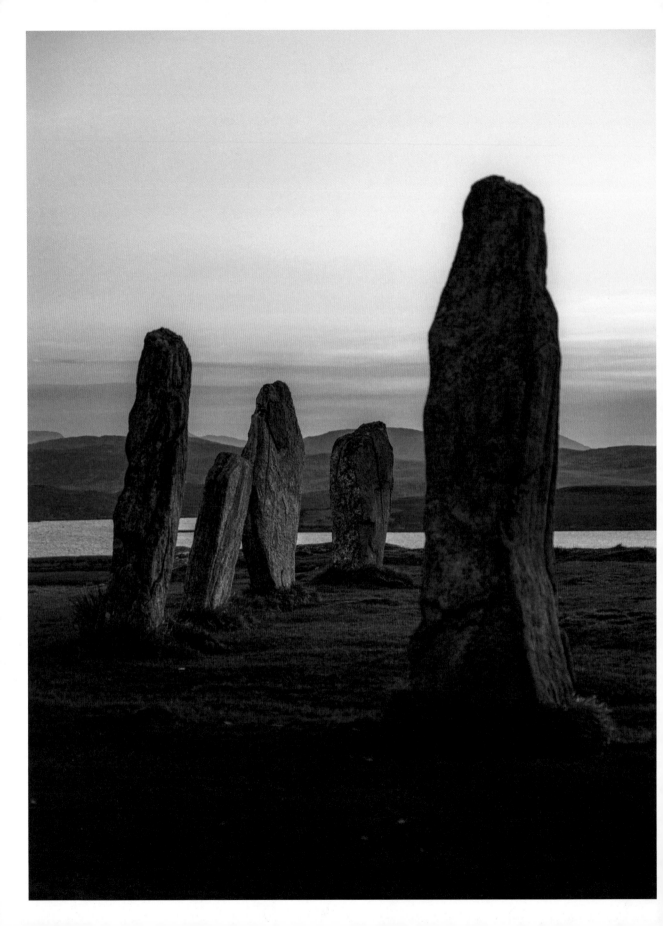

CALANAIS STANDING STONES

Island: Isle of Lewis

On the western coast of Lewis, tucked between the islands, lies an ancient marvel that has captivated the hearts and minds of explorers and scholars alike: the Calanais Standing Stones – a circle of towering rocks surrounded by avenues and other structures. These Neolithic monuments, standing proud for over 5,000 years, tell a tale of mystery and wonder that resonates through the ages.

The Calanais Standing Stones are believed to have been erected between 2900 BCE and 2600 BCE. Though their exact purpose remains a subject of debate, it is widely theorized that they served as a sacred site for ceremonial rituals, perhaps linked to the celestial movements of the sun and moon, or the spiritual beliefs of ancient civilizations.

Among the stones, the 'Calanais I' monolith stands out, towering over the landscape at an impressive 4.8m (16ft). This central figure, along with the other stones meticulously arranged in a cruciform pattern, showcases the remarkable precision and ingenuity of the Neolithic builders. It's as if they were reaching out to the heavens, aligning their creation with the cosmic rhythms of the universe.

Through millennia of change, the Calanais Standing Stones have remained steadfast, silent witnesses to the ebb and flow of time. Today, they continue to draw inquisitive minds and curious souls from around the globe, inviting them to ponder the mysteries of our ancient past against the backdrop of the rugged Hebridean landscape.

The stones are not just a collection of rocks – they are a window into our shared history, a reminder of the wonders that lie beyond our understanding. As we explore the windswept landscapes of the Isle of Lewis, we are reminded of the timeless mysteries that began the shaping of our world.

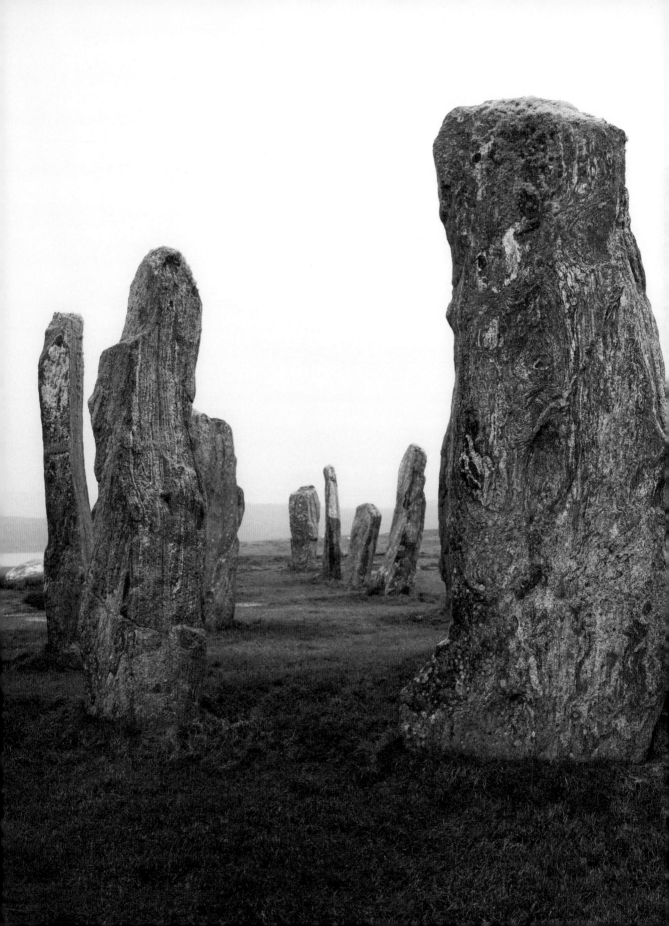

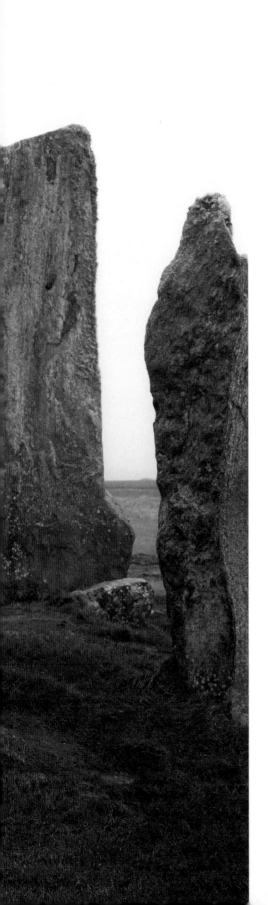
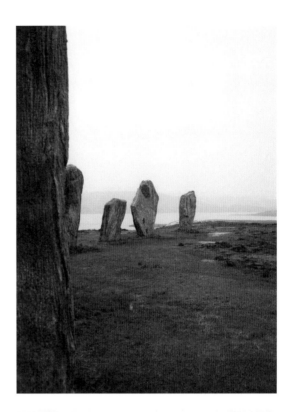
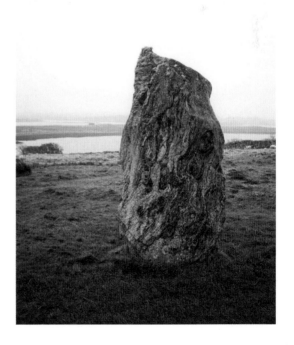

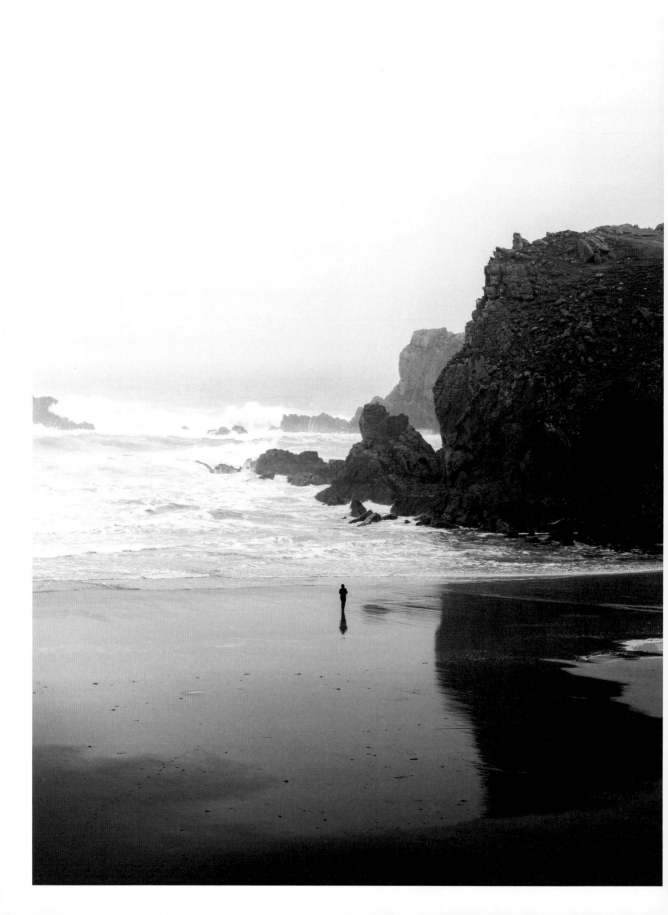

MANGERSTA BEACH

Island: Isle of Lewis

Along the rugged coastline of the Isle of Lewis, Mangersta Beach stands out as a breathtakingly beautiful, yet often underappreciated, corner of the world. Its vast sands and towering cliffs craft a landscape that feels both ancient and untouched.

On days when the air is calm, the fine sand drifts gently through the grasses and the waves softly lap onto the shore, creating a scene of peaceful calm. When the weather turns fierce, the beach transforms as the wind whips across the land, carrying sand in all directions, while the sea's powerful waves crash against the cliffs like a wall of ocean, drenching the rocks with salty spray in a display of raw strength.

Mangersta's true essence is revealed through its natural beauty and the historical significance of its location, which echoes the island's narrative. The area around Mangersta and beyond has been shaped by centuries of human habitation, reflecting a deep connection to the natural environment. This part of Lewis has witnessed the comings and goings of Norse settlers, the establishment of Gaelic-speaking communities and the ebb and flow of economic fortunes tied to the sea.

Mangersta Beach's wild allure doesn't scream of its beauty, but rather waits patiently for onlookers to come to terms with it exactly as it is. Here, amid the raw elements of wind, water and stone, we find a deeper appreciation for the rugged charm of Scotland's outer edges. It's a place where the natural world dominates and man has conceded, offering a unique perspective on the island's heritage and the timeless allure of its landscapes.

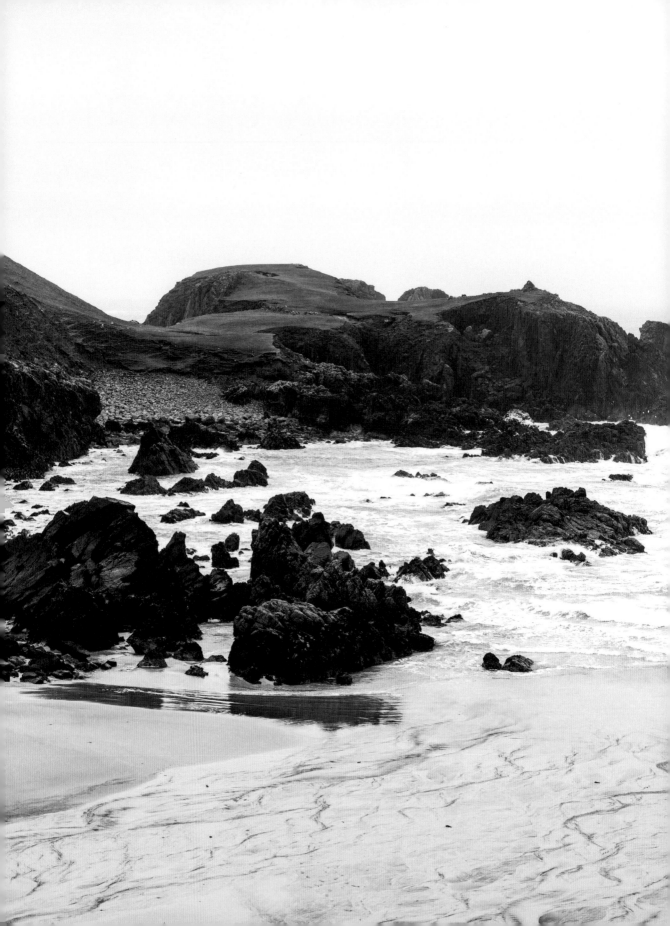

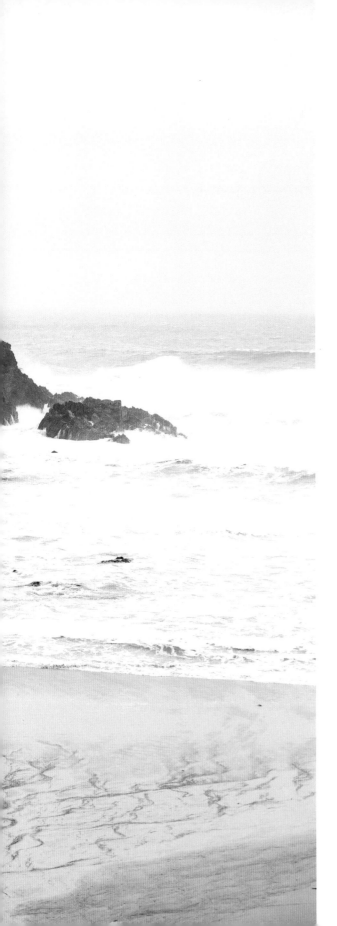

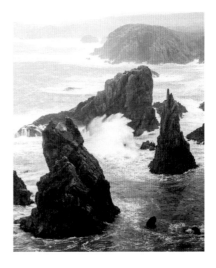

CLOSE BY:
MANGERSTA STACKS

Nothing quite prepares you for the sights and sounds that surround you as you approach the gigantic basin that holds the Mangersta Stacks. Standing on the western edge of the Isle of Lewis, amidst the cold waters of the North Atlantic, are a group of ancient sentinels, waiting almost peacefully to be woken by the furious ocean, which has been smashing against them for millennia.

The area is remote. But here they rest and wait: towering sea stacks, rising defiantly from the swirling currents as the wind blows from every direction.

The sense of how small we are is never more apparent. The sea moves and sways as one and the immovable stacks absorb each and every wave that powers into them. Take a moment to watch a wonder of nature unfold from a safe distance and relax in awe at the sheer power unfolding in front of you.

GEARRANNAN BLACKHOUSES

Island: Isle of Lewis

Situated on the west coast of Lewis, the Gearrannan Blackhouses offer a unique glimpse into Scotland's rural and cultural history. These traditional stone houses, with their distinctive thatched roofs, are evidence of the ingenuity and fortitude of the people who lived in this remote part of Scotland for centuries.

Constructed to withstand the harsh Atlantic climate, the blackhouses were designed with double stone walls and earthen floors, providing warmth and shelter for the inhabitants and their animals, who often shared the same space. This close-knit living arrangement reflected the communal lifestyle that was prevalent in the Scottish Highlands and Islands.

The village of Gearannan, now a carefully preserved museum, showcases what life was like in these blackhouses until the mid-20th century, when the last residents moved out. Visitors can explore the restored interiors of several houses, each furnished to reflect different periods of their use, offering insights into the daily lives, work and traditions of the Hebridean people.

Apart from their historical significance, these magnificent examples are set against the stunning backdrop of the wild Lewis landscape, with sweeping views of the Atlantic Ocean. The location not only highlights the natural beauty of the Outer Hebrides but also underscores the challenges faced by those who once lived there – isolated from the mainland, yet deeply connected to their environment.

Today, the Gearannan Blackhouses attract visitors from around the world, drawn by the opportunity to connect with Scotland's past and the chance to experience the enduring beauty of the Hebrides. The site also serves as a reminder of the importance of preserving cultural heritage, offering lessons in sustainability and the value of traditional ways of life in harmony with the natural world.

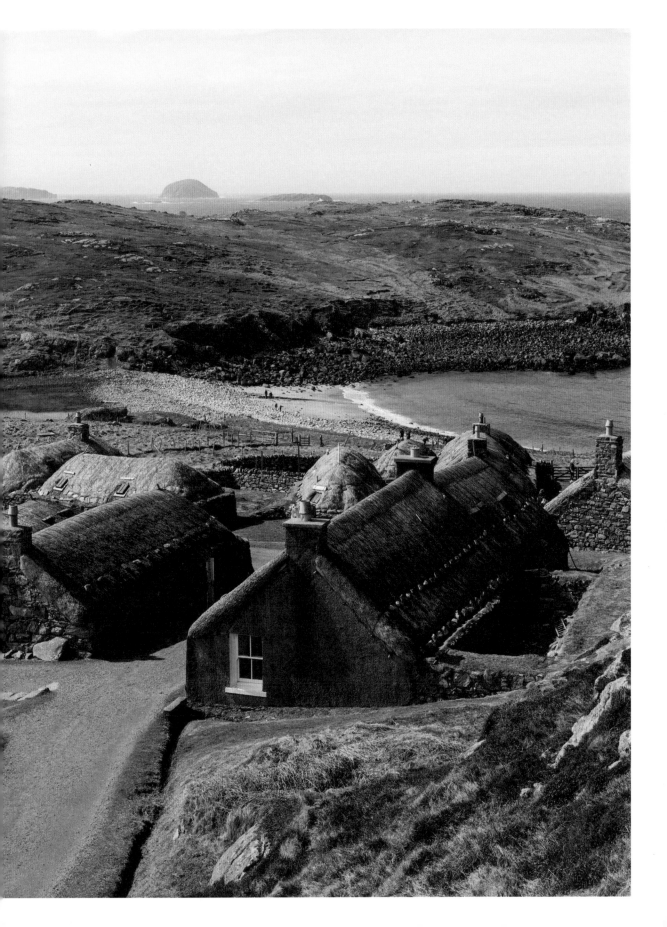

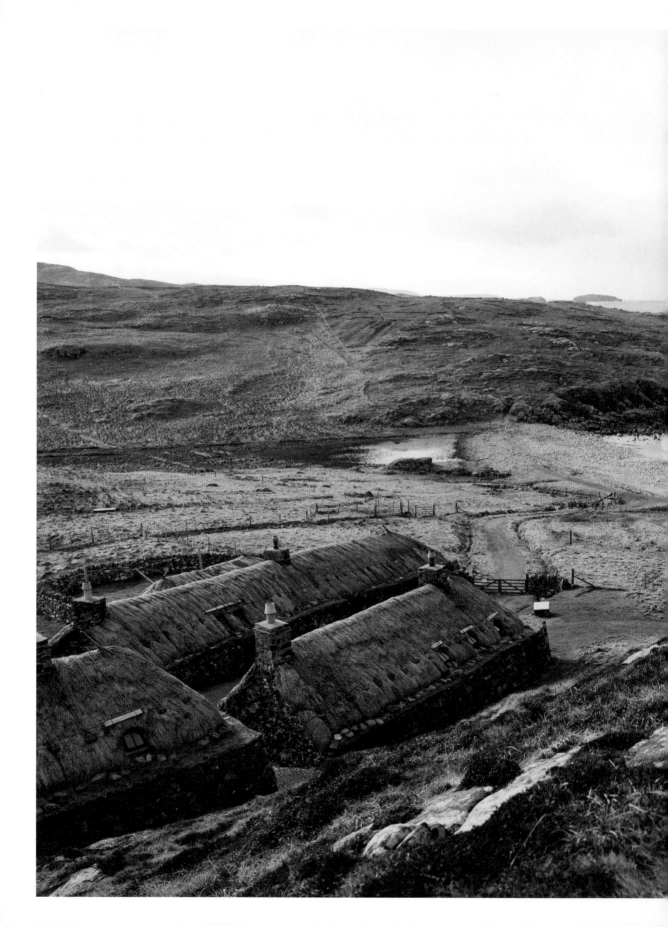

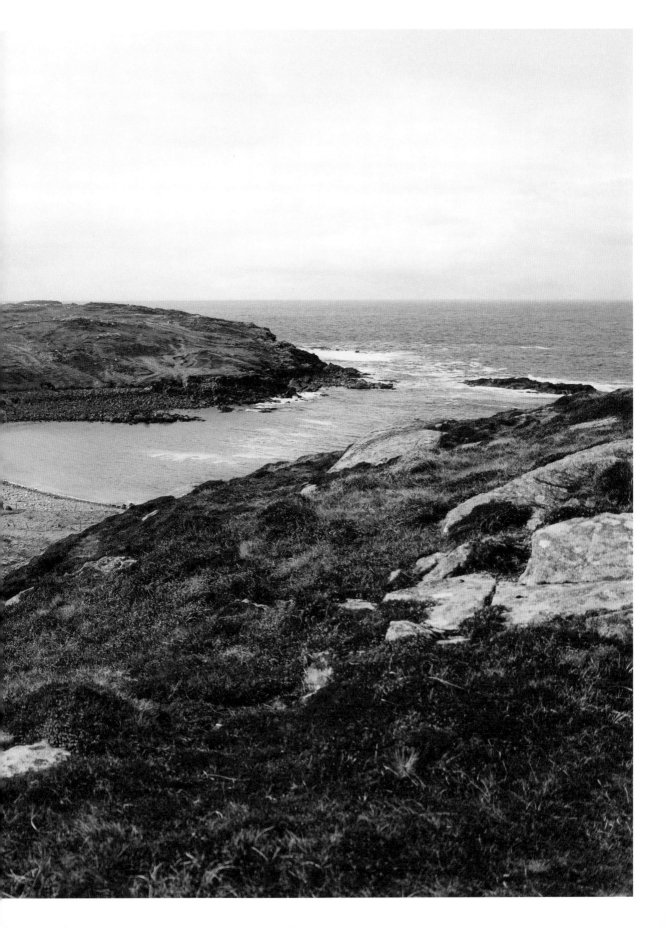

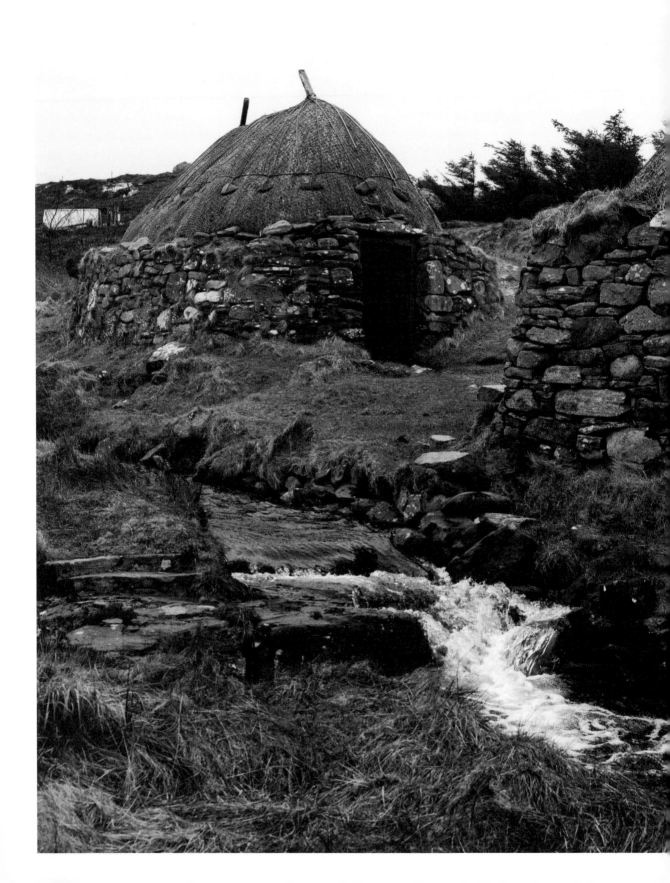

SHAWBOST NORSE MILL & KILN

Island: Isle of Lewis

Shawbost Norse Mill and Kiln stand as perfect, silent reminders of a bygone era. Dating back over a thousand years, these ancient structures offer a fascinating glimpse into the industrial practices of early Norse settlers in Scotland. More so than any other preserved piece of important history, these flawless examples are left to bear the brunt of countless seasons and live out their days just how they were intended, with only a little intervention for crucial repairs every half century.

Constructed around the 11th century during the Viking Age and in use right up until the 1930s, Shawbost Norse Mill and Kiln are among the best-preserved examples of Norse industrial architecture in Scotland. Built using local stone and traditional techniques, these structures are a testament to the resourcefulness of the early Norse inhabitants.

The mill, with its sturdy stone walls and waterwheel mechanism, was used to grind grain, essential for sustaining the growing Viking settlements in the region. Adjacent to it, the kiln provided a means of firing pottery and other clay goods, utilizing locally sourced materials to produce essential household items and tools.

Today, Shawbost Norse Mill and Kiln serves as a reminder of the enduring legacy of Norse culture in Scotland. Visitors have the opportunity to step back in time and explore the industrial practices of ancient civilizations as they wander amid the weathered stones and remnants of ancient machinery. We can reflect on the ingenuity of those who came before and appreciate the lasting impact they have left on the landscape and our understanding of history.

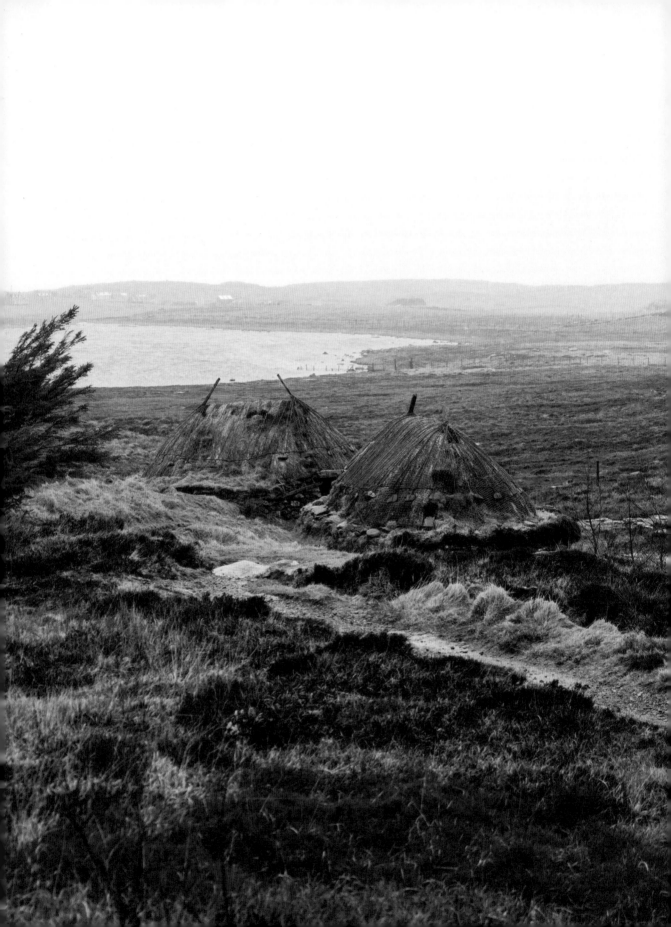

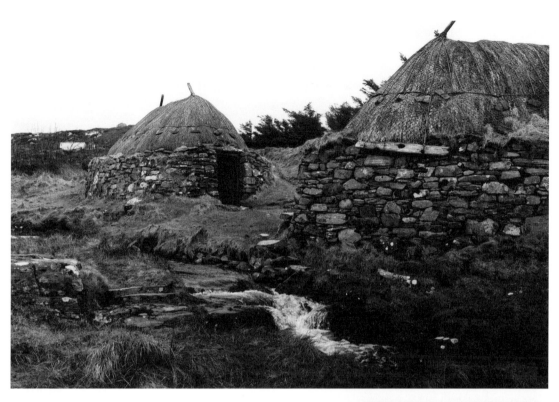

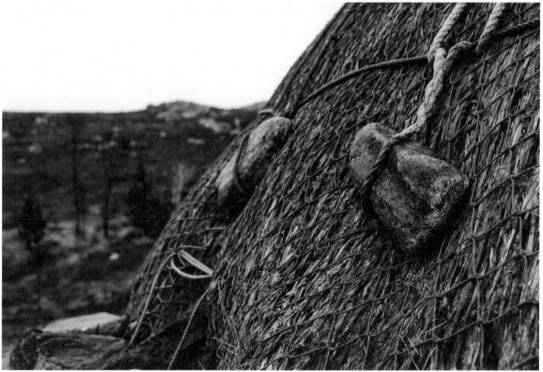

EOROPIE BEACH

Island: Isle of Lewis

Eoropie Beach is tucked away on the northern tip of the Isle of Lewis, the often brutal winds and violent waves crashing onto the spiked rocks surrounding the bay. Eoropie Beach is a testament to the raw, natural beauty that defines the Hebridean islands, completely untamed and free to do as it wills.

Eoropie's position within the Outer Hebrides means that it is steeped in the rich cultural tapestry of Gaelic tradition, with the human history of the islands echoed in the nearby standing stones and ancient ruins. The community around Eoropie maintains a strong connection to their heritage, with Gaelic still spoken by many, and the rhythms of island life influenced by the seasons and the sea.

Beyond its physical beauty, Eoropie offers a sense of peace and a connection to the elemental forces that have shaped the Hebrides over millennia. Whether it's watching the sunset paint the sky in hues of gold and pink, feeling the power of the Atlantic winds or simply walking along the water's edge, Eoropie Beach is a place few forget. It embodies the spirit of the Outer Hebrides – wild, welcoming and deeply woven with the threads of natural history.

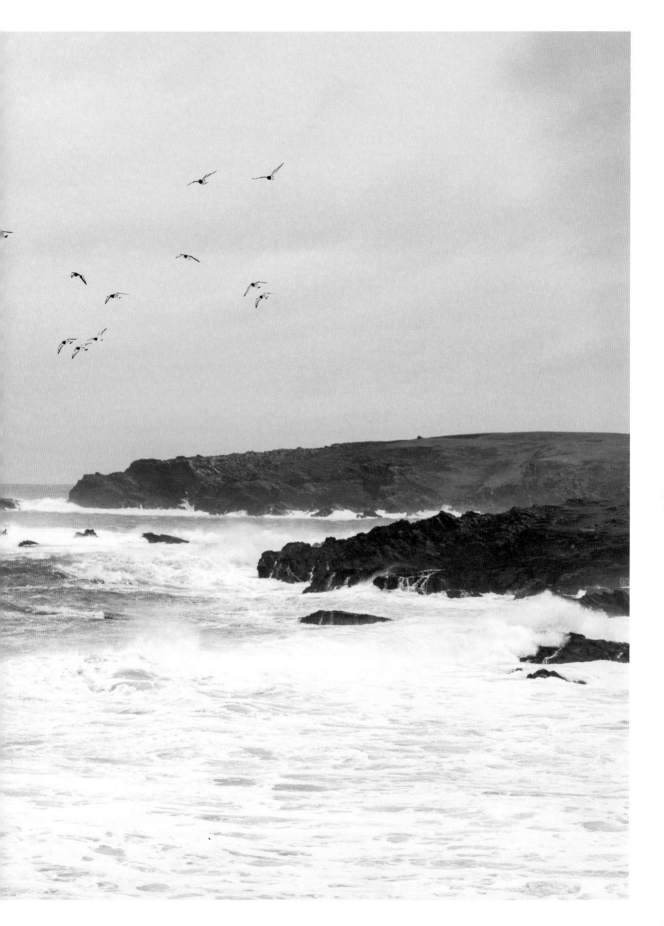

BUTT OF LEWIS LIGHTHOUSE

Island: Isle of Lewis

At the northernmost point of the Isle of Lewis in the Outer Hebrides, the Butt of Lewis Lighthouse and its adjacent cliffs stand resilient against the relentless North Atlantic. This rugged landscape, marked by sheer cliffs and the steadfast lighthouse, showcases nature's unbridled force and the straightforward human response to it through architecture designed to endure.

Constructed in the early 20th century, the lighthouse serves as a crucial navigational aid, its bright red tower a beacon for mariners braving the perilous waters around the island. Night after night, its light cuts through the darkness, a solitary signal of safety in the midst of the sea's unpredictability.

The cliffs surrounding the Butt of Lewis attest to centuries of natural warfare, shaped as they are by the ceaseless assault of wind and waves. Standing atop these cliffs, one is met with the raw edge of the world, where the ocean stretches to the horizon in a display of nature's vastness and power.

This area is more than picturesque; it's a reminder of the continuous challenge of navigating these waters. Here, on the edge of the Scottish Isles, the elements and human ingenuity collide. For visitors, it's a chance to witness the stark beauty and the enduring qualities of a landscape and a lighthouse that have faced down the North Atlantic for generations. This is not a scene of delicate beauty but a brutally rugged testament to survival and persistence in one of Scotland's most remote corners.

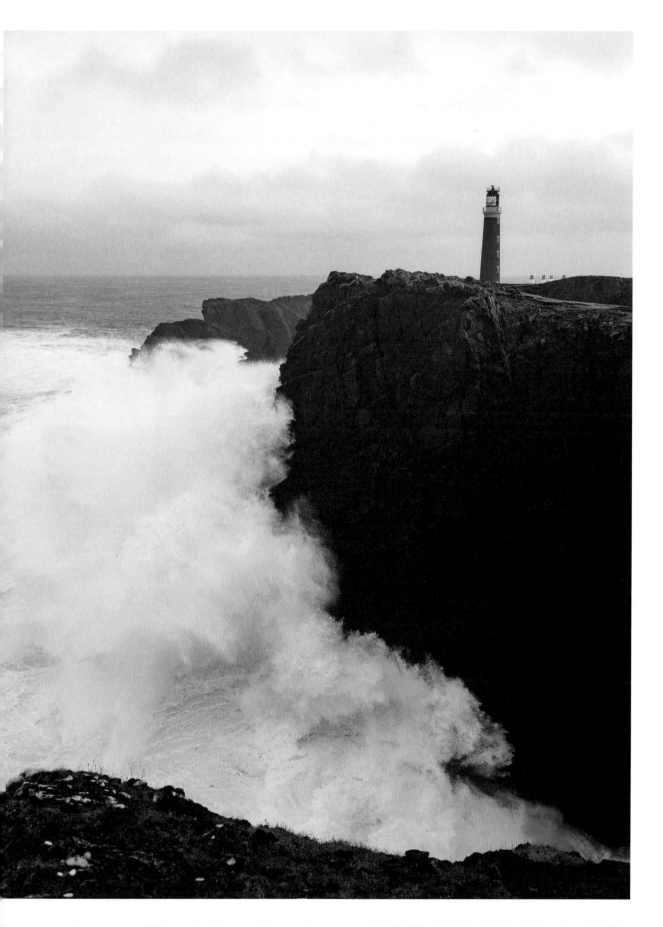

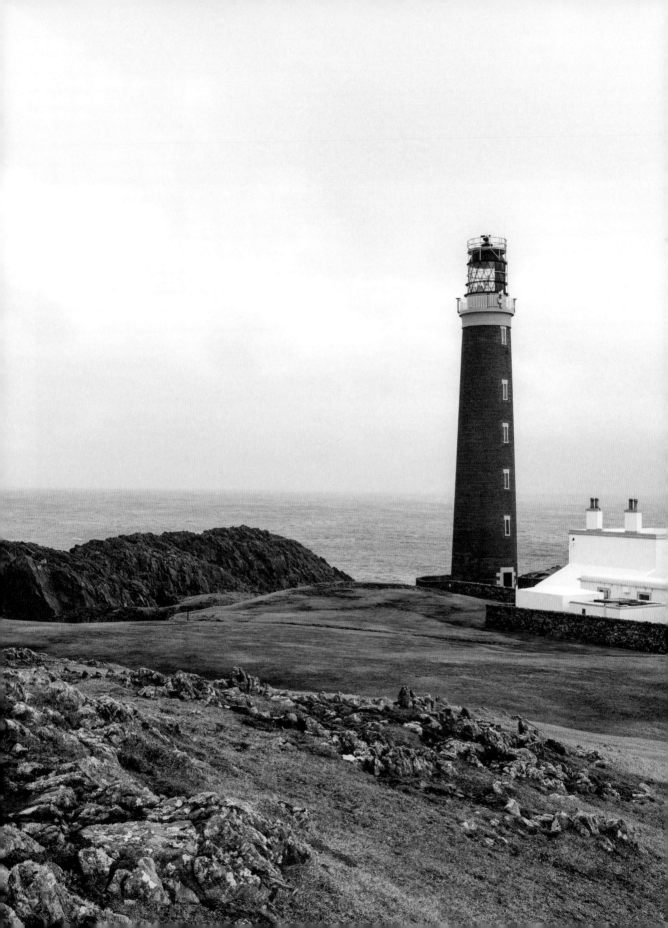

This is not a scene of delicate beauty but a brutally rugged testament to survival and persistence in one of Scotland's most remote corners.

THE BLUE MEN OF MINCH

In the waters between the Outer Hebrides and mainland Scotland lies a stretch of sea known as the Minch. Amid the swirling currents and shifting tides, lurk the enigmatic figures of Scottish folklore: the Blue Men of Minch.

According to legend, these mysterious beings are said to inhabit the depths of the Minch, where they roam the waves in search of unsuspecting sailors to lure to their watery realm. Described as half-men, half-fish, with skin as blue as the sea itself, the Blue Men are said to possess supernatural powers, capable of conjuring storms and wreaking havoc on passing ships.

One tale tells of a brave fisherman who encountered the Blue Men during a stormy night at sea. As he battled the fierce winds and crashing waves, he heard a haunting melody rising from the depths – a siren song that drew him ever closer to danger. Suddenly, a trio of Blue Men emerged from the waves, their piercing blue eyes fixed on him with an otherworldly gaze. But the fisherman, undaunted by their supernatural presence, sang a song of his own – a powerful incantation passed down through generations of seafarers. Miraculously, the Blue Men were overcome by the fisherman's song, and they vanished beneath the waves, leaving him to sail safely home.

While reports of encounters with the Blue Men of Minch are rare, their presence continues to captivate the imagination of sailors and storytellers alike. Whether seen as guardians of the sea or harbingers of misfortune, these mystical mariners remain an enduring symbol of the untamed beauty of Scotland's coastal waters and the mysteries that surround the Outer Hebrides.

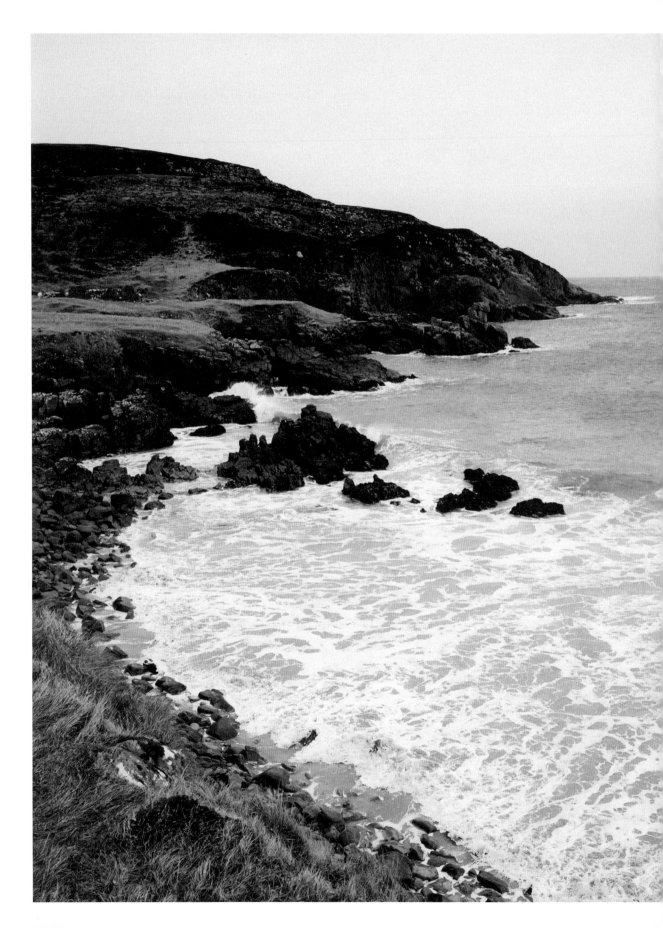

GARRY BEACH

Island: Isle of Lewis

Garry Beach on the Isle of Lewis is a stark reminder of nature's relentless artistry. This isn't just another picturesque shoreline, it's a landscape carved out by the sheer force of the elements, where the drama of Scottish geology plays out under an open sky.

The cliffs and sea stacks that define the coast here are a masterclass in erosion, shaped by centuries of Atlantic winds and waves. These formations stand as stories of the Earth's restless nature, with each layer of rock marking a period in the island's ancient history. It's a place where the past is visible, tangible and remarkably accessible.

Here the natural world thrives in what might seem like adversity. The plant life gripping the soil and the birds riding the sea breezes are incredible examples of adaptation and survival. The beach's ecosystem, shaped by the harsh Hebridean climate, showcases the resilience of life in extreme conditions.

Garry Beach is distinct in its raw beauty and the sense of wilderness it evokes. It doesn't coddle but rather challenges its visitors to appreciate the untamed and untainted. Here, the ocean doesn't gently lap but crashes; the wind doesn't whisper but howls, and the landscape doesn't invite but dares.

For those who venture to this part of the Isle of Lewis, Garry Beach offers not just a scenic view but a profound experience. It's an encounter with the primal forces of nature, where the stories of geological wonders and the spectacle of nature's persistence are on full display. This beach doesn't just entertain, it fascinates, educates and, most of all, it inspires.

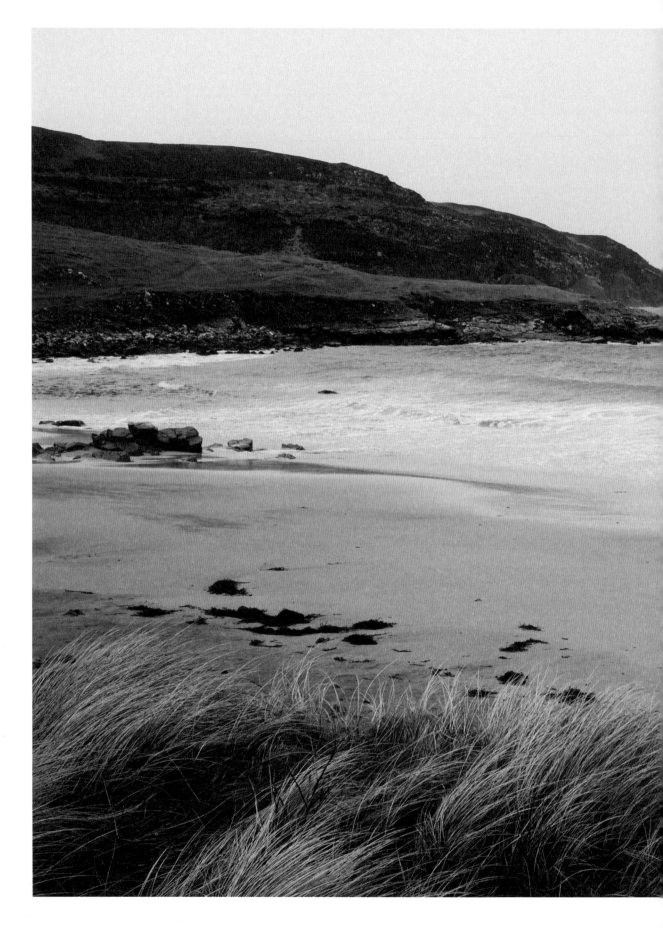

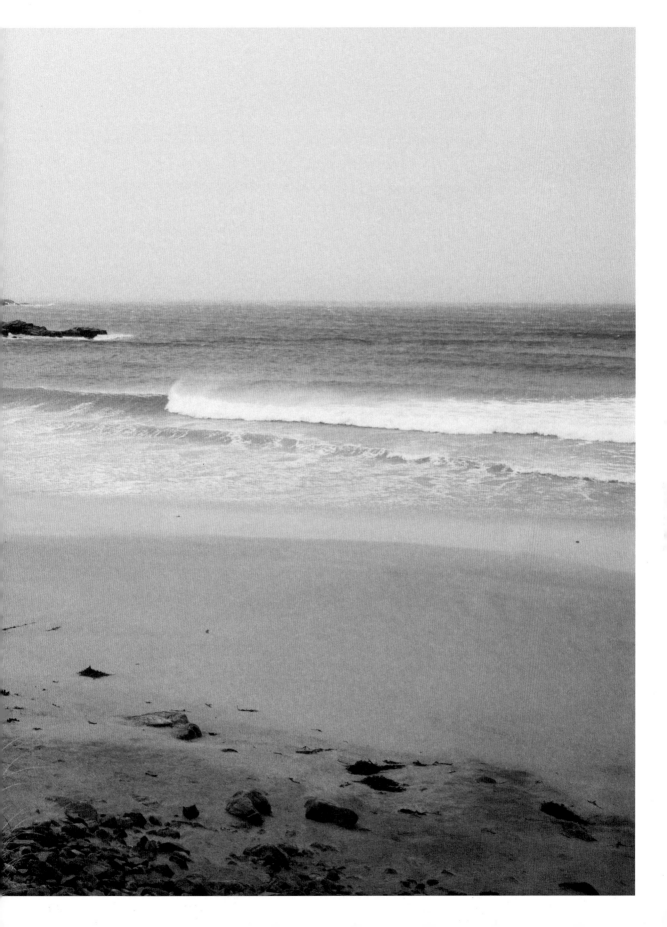

THE
HIGHLANDS

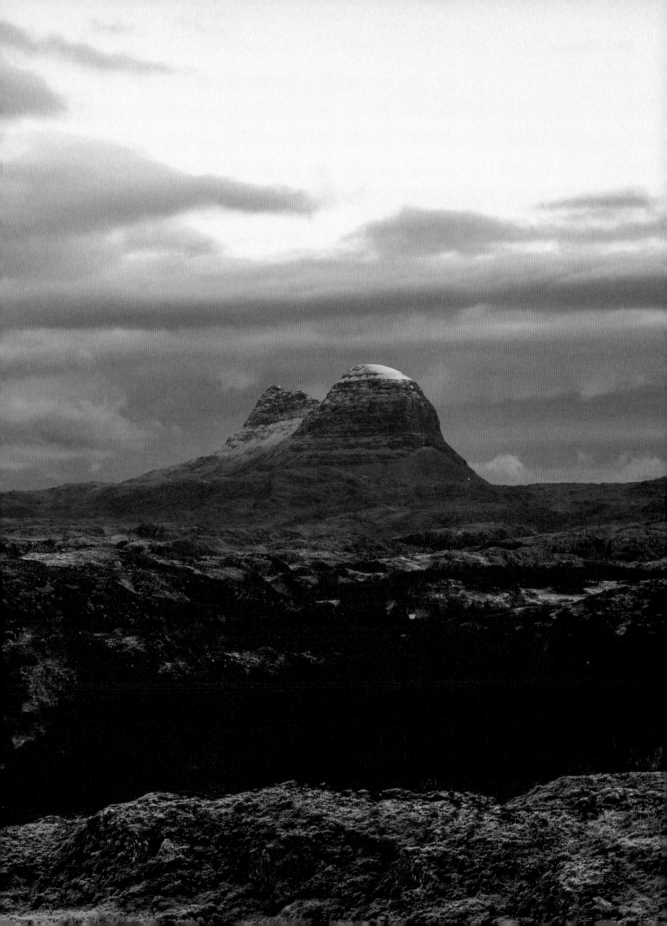

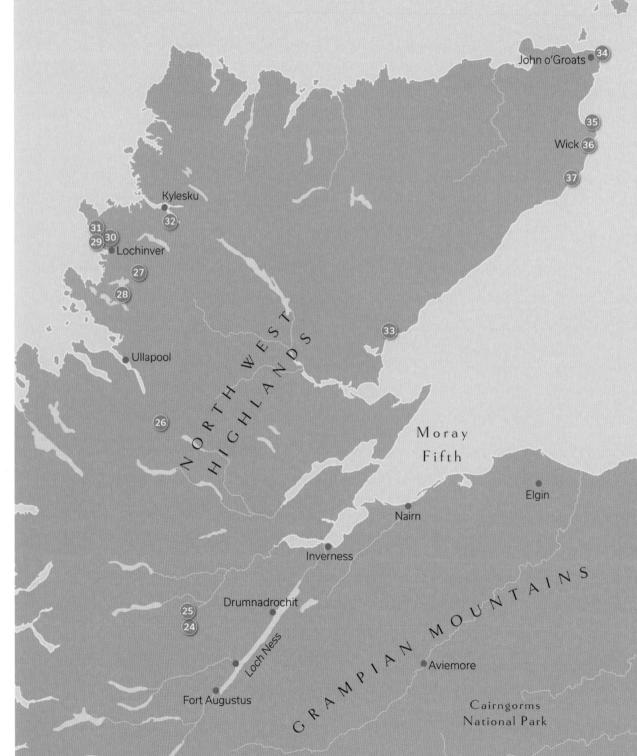

North Sea

Orkney
Islands

John o'Groats (34)

(35)

Wick (36)

(37)

Kylesku

(32)

(31)
(30)
(29)
Lochinver

(27)

(28)

(33)

Ullapool

NORTH WEST
HIGHLANDS

Moray
Fifth

Elgin

Nairn

(26)

Inverness

Drumnadrochit

(25)
(24)

Loch Ness

GRAMPIAN MOUNTAINS

Fort Augustus

Aviemore

Cairngorms
National Park

Stretching across the northern and western regions of Scotland, the Scottish Highlands encompass some of the most rugged and untamed landscapes in the country, covering 33 per cent of Scotland and accounting for almost 5,000km (3,100miles) of coastline. With some of the most remote and sparsely populated land in the country (around 8 persons per km^2). With a total of over 26,000km^2 (16,200miles2), it's safe to say a vast majority of it is left unseen by most.

The history of the Scottish Highlands is as ancient as it is storied, with evidence of human habitation dating back thousands of years. The Highland Clearances of the 18th and 19th centuries, during which many Highlanders were forcibly evicted from their land, remain a poignant chapter in the region's history.

The people of the Scottish Highlands are known for their fierce independence, strong sense of identity and deep connection to the land. Traditional Highland culture, including Scots Gaelic language, music and dance, continues to thrive in many communities. Clan loyalty remains strong, with tartan patterns and clan crests serving as symbols of pride and heritage.

Beyond its rich cultural heritage, the Scottish Highlands boast some of the most breathtaking scenery in the world. From the majestic peaks of Ben Nevis and the Cairngorms to the rugged coastlines of the Isle of Skye and the Northwest Highlands, the region offers endless opportunities for outdoor exploration. Visitors can hike through ancient forests, fish in crystal-clear lochs or simply soak in the tranquility of the natural surroundings.

24 Plodda Falls 25 Glen Affric 26 Corrieshalloch Gorge 27 Suilven 28 Stac Pollaidh
29 Achmelvich 30 Hermit's Castle 31 Clachtoll 32 Allt Chranaidh Falls
33 Golspie Burn and Waterfall 34 Duncansby Stacks 35 Castle Sinclair Girnigoe
36 Castle of Old Wick 37 Whaligoe Steps

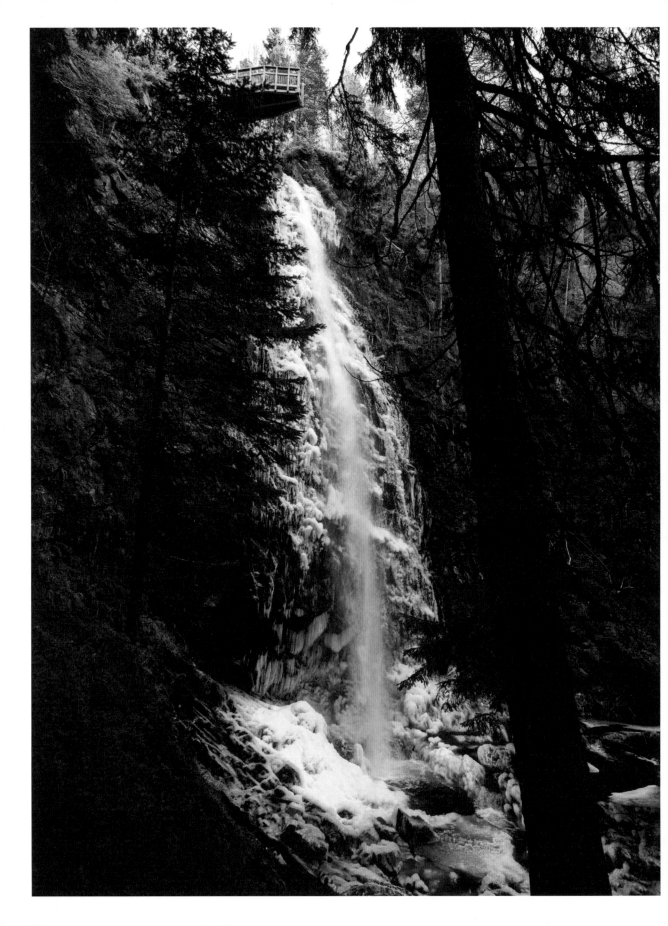

PLODDA FALLS

Nearby Town: Drumnadrochit

No matter which direction you come from, delving deep into the ancient Caledonian forest toward Plodda Falls is a worthy journey in itself. Acres of old farms, beautiful slow-flowing rivers and, if you're lucky, a little sunlight shining through the tops of some of our oldest living forest.

Located near the village of Tomich in Glen Affric, Plodda Falls offers a tranquil escape into the heart of Scotland's wilderness. The journey to reach the falls leads adventurers through enchanting forests filled with towering trees, moss-covered rocks and the soothing sounds of nature all around.

The highlight of the trail culminates in the awe-inspiring sight of the falls itself. The water crashes over the rocky precipice, creating a mesmerizing display of power and grace. The misty spray and thundering roar add an ethereal quality to the scene, casting a spell on all who stand in its presence.

The surrounding woodland, rich with diverse flora and fauna, provides a serene backdrop to the falls. Ancient trees, including Douglas firs and Scots pines, embellish the landscape, while the forest floor is adorned with ferns, mosses and wildflowers, creating a magical ambiance.

Acres of old farms, beautiful slow-
flowing rivers and, if you're lucky,
a little sunlight shining through the
tops of our oldest living forest.

Plodda Falls has been carefully developed for visitors, featuring well-
maintained paths and viewing platforms that offer unparalleled vantage
points to admire this natural wonder.

Interpretive signs along the trail provide insights into the ecology, geology
and history of the area, enhancing the overall experience.

Although the road itself can be a little bumpy at times, the short walk to
the falls is perfectly matched to the fairy-tale surroundings. Pine needles
scatter the floor as the echo of ferocious water gets closer and closer.
The expertly placed steps look as natural in the environment as the
plants, and the winding path eventually leads you to short plank hanging
over the 46m (150ft) drop to the wet rock waiting below. Thankfully the
entire thing is fantastically made and extremely safe, but it's fine to let out
a gasp or two.

Continue down the path for a viewpoint from ground level, looking up at
the falling water smashing into the rocks below. If you dare.

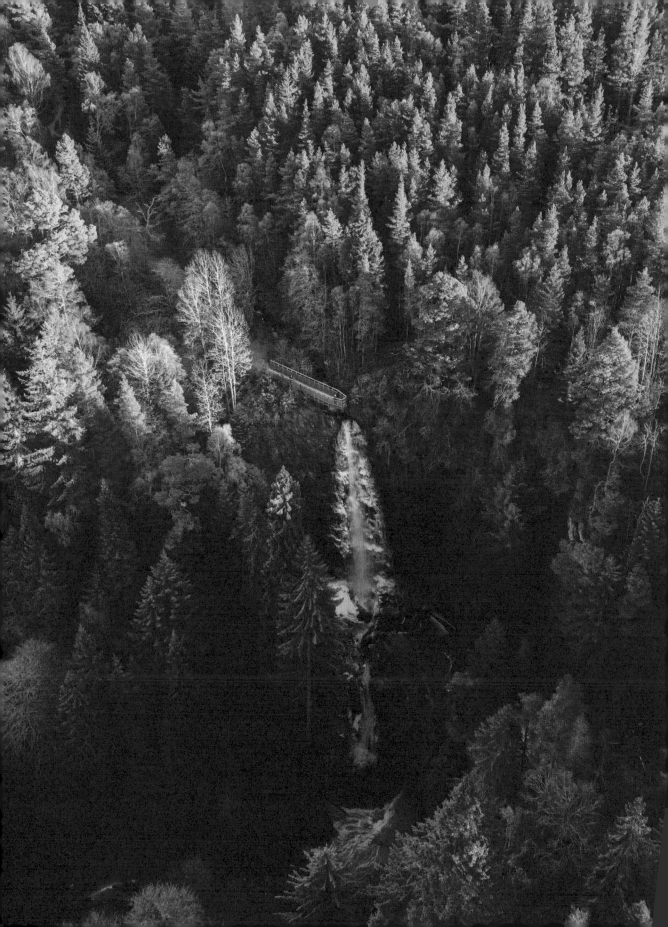

GLEN AFFRIC

Nearby Town: Drumnadrochit

Over thousands of years, Scotland has lost more than 95 per cent of its forests due to natural and unnatural changes in the climate and a lot of human intervention. The best example of how this piece of land used to look sits quietly between the Isle of Skye and the banks of Loch Ness.

Glen Affric hosts over 48km (30miles) of ancient Caledonian pinewoods, oak trees and a rich variety of flora that creates a sanctuary for wildlife, including red deer, golden eagles and the elusive Scottish wildcat. Delicately looked after by the Forestry Commission, the area is not often promoted as a place to travel, but there are enough facilities, roads and parking to host those willing to make the journey to experience nature truly at its best.

Littered with small farms and homes, the winding roads take you past fast-flowing rivers and deep into forests filled with trees covered head-to-root in lichen. To reach the main vantage point, walk up a steep hill from the car park for around a 1km (0.6mile); then the trees will part and the mountains either side will lead your eye to the gorgeous loch sitting silently below, framed by the very trees that surround you.

GHILLIE DHU

In the forest lurks a mysterious figure of Scottish folklore known as the Ghillie Dhu. Wrapped in a cloak of moss and leaves, with eyes like pools of darkness, the Ghillie Dhu is a guardian spirit of the wilderness, both feared and revered by those who dwell near its domain.

According to legend, the Ghillie Dhu is a solitary creature, seldom seen by mortals except under the cover of twilight or amidst the whispering branches of the forest. It is said to possess the ability to blend seamlessly with its surroundings, becoming one with the dense foliage and hidden glens that it calls home.

But, despite its elusive nature, the Ghillie Dhu is not a malevolent being. On the contrary, it is said to harbour a deep love for the natural world and all its inhabitants. In times of need, the Ghillie Dhu may emerge from the shadows to offer aid and protection to lost travellers or wayward wanderers.

Yet woe betide those who show disrespect for the forest or seek to exploit its riches for their own gain, for the Ghillie Dhu is also a vengeful spirit. It is said to cast curses upon those who desecrate its sacred groves or disturb the delicate balance of nature.

Throughout the ages, the legend of the Ghillie Dhu has inspired awe and reverence among the people of Scotland, serving as a reminder of the untamed beauty and hidden dangers of the wild. Even today, tales of encounters with this enigmatic forest spirit continue to echo through the mist-shrouded glens, weaving mystery and wonder that is as timeless as the ancient forests themselves.

CLOSE BY: DOG FALLS

Picking a walk in an area of unlimited natural beauty would seem like a fairly difficult task, but the 6km (4mile) trip past Dog Falls, over the wooden bridge and up the winding path to the viewpoint of the majestic Coire Loch definitely makes choosing a little easier.

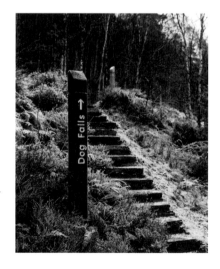

The path is clear and simple, and the views are consistently stunning, with misty mountains and tree tops looming over the loch, lichen draped over every tree, an abundance of heather and moss-covered rocks scattered around every foot of open ground. Keep your eyes out for roe deer, pine martens and the rare crossbill in the skies.

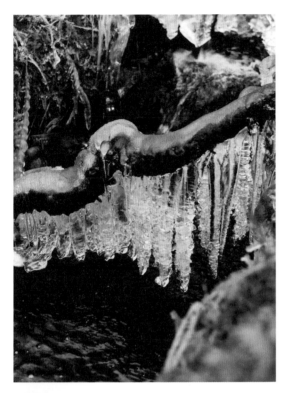

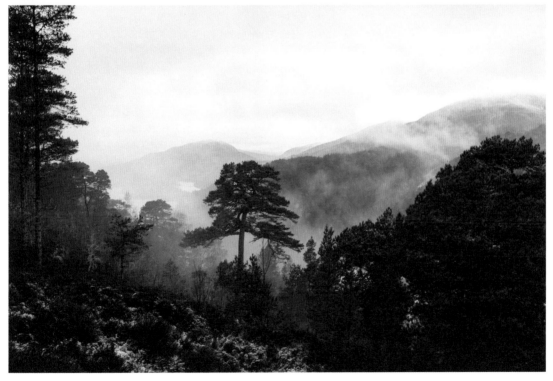

CORRIESHALLOCH GORGE

Nearby Town: Ullapool

Are you ever curious as to what could be hiding nearby, what we miss as we drive past a seemingly innocent patch of forest or through an unassuming valley? Perhaps there is a giant network of caves underfoot, a huge waterfall or a glorious view of a mountain peak around the corner... The Corrieshalloch Gorge is the perfect example of what could be waiting for you just out of sight.

Resting in an area that is never short of breathtaking views, and just a short walk from a new little car park, the well-maintained path takes you down through a forest of silver birch before revealing an incredible gorge carved out by the small stream of fast-flowing water below.

The gorge was formed during the Ice Age by glacial meltwaters and erosion, resulting in a deep, narrow chasm that stretches for around 1.5km (0.9miles). The force of the water carved the gorge through the hard rock, leaving behind sheer cliffs that plunge around 60m (200ft) to the river below.

Every season brings a new experience to this tiny part of the world. In the spring, fresh green leaves adorn the dense forest trees throughout the walk. Autumn illuminates the path with colours of gold and yellow as the mushrooms push their way to the surface. Winter blankets the area in snow and freezes over the smaller falls running through the gorge, creating countless icicles that hang from the rocks and moss.

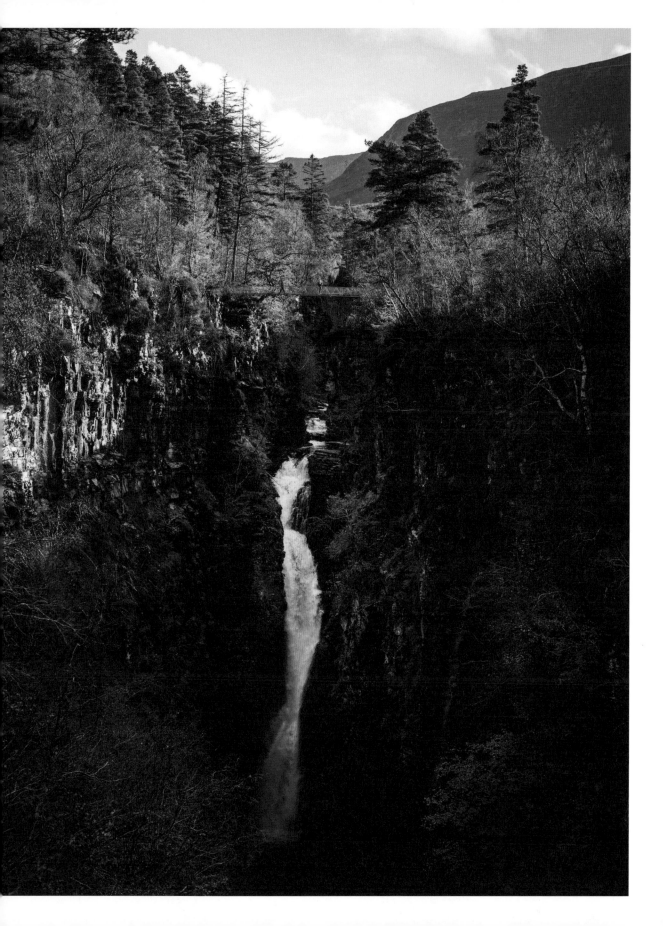

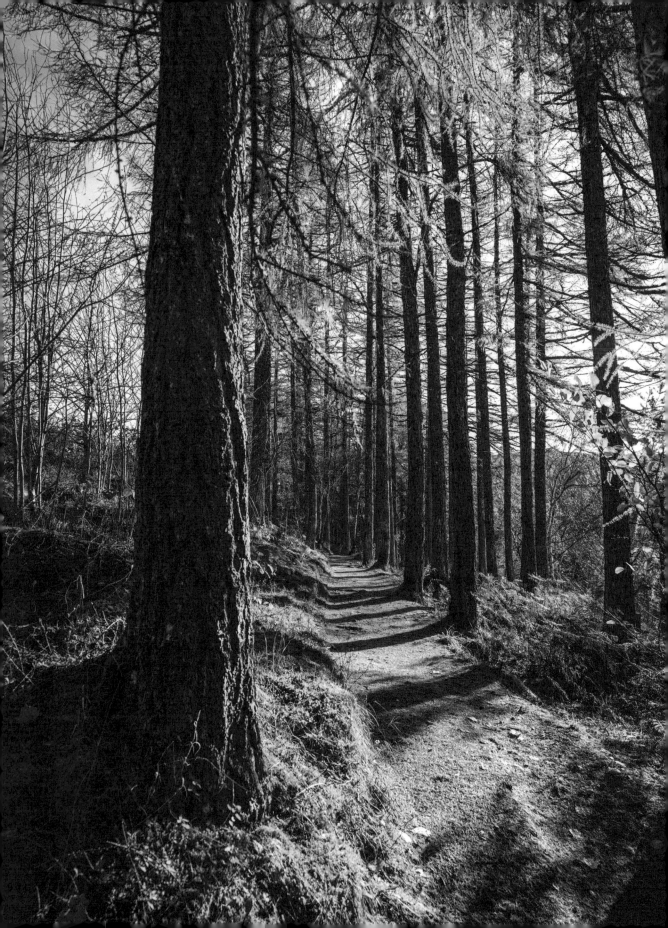

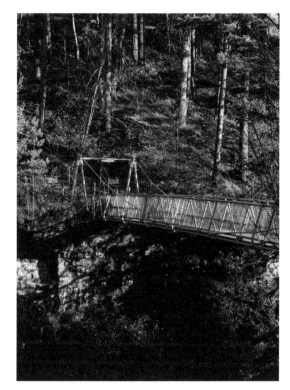

A wobbly (yet extremely secure) suspension bridge allows visitors a fantastic top-down view to the drop below, although those afraid of heights can make their way swiftly across before the swaying gets too much!

The bridge has historical significance: originally built in 1874, it was a testament to Victorian engineering and immediately turned the gorge into a popular attraction. The suspension bridge was refurbished in 1977 to the current model we see today.

A photogenic walk through the woodland takes you to the far end of the gorge. There you can walk out to the edge of the viewing platform and take in the beautiful sights upstream.

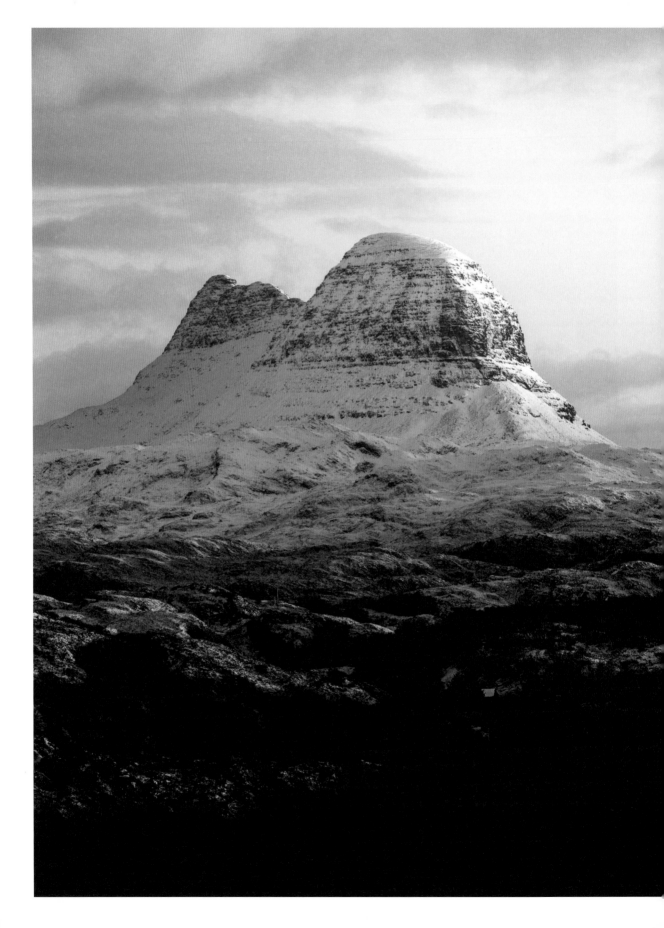

SUILVEN

Nearby Town: Lochinver

You'll see him for the first time and remember him forever. Suilven is a dominating force in Assynt, but standing just 731m (2,400ft) above sea level, he only just makes it into the Graham category of Scottish mountain. Nonetheless, his unique face, odd shape and perfect positioning make this mountain stand out in a region full to the brim with incredible giants. From the beaches of Achmelvich and Clachtoll, to the long winding road to Lairg, Suilven sits watching your every move as you clamber your way across his domain.

You would be forgiven for assuming this particular mountain is not for climbing; the unforgiving shape just doesn't look like it's for us mere humans to even attempt, at least not without the use of rope and vice-like fingers. But a long, slow and fairly flat walk from the north brings you right up to the belly of the beast, and all of a sudden he doesn't seem quite as terrifying.

Suilven is absolutely as unforgiving as he seems, but after reaching the craggy top, following an hour of rubble-filled scrambling, and gazing over the seemingly endless views as the sun drops in the sky, creating mile-long shadows on the hills, any thought of tired legs, sweaty backs or midge-bitten arms are a thing of the past, and the calm stillness of your surroundings is all that you feel.

You'll see him for the first time and remember him forever. Suilven is a dominating force in Assynt.

CLOSE BY:
SUILEAG BOTHY

Scottish bothies are a national treasure. Used and looked after by walkers for generations, these little cottages are as basic as they are fantastic, especially if you've been on your feet for a few days and a little shelter is needed!

Suileag is a prime example of a good old bothy: solid walls, a well-used fireplace and a place to pop your sleeping bag off the floor. A visit for the views is worth it alone.

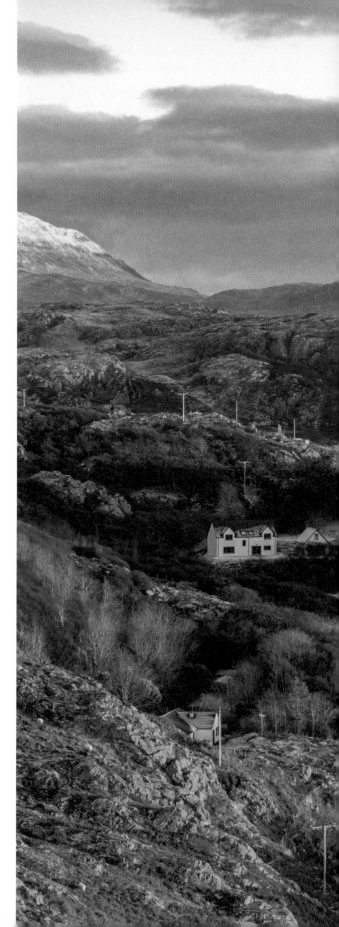

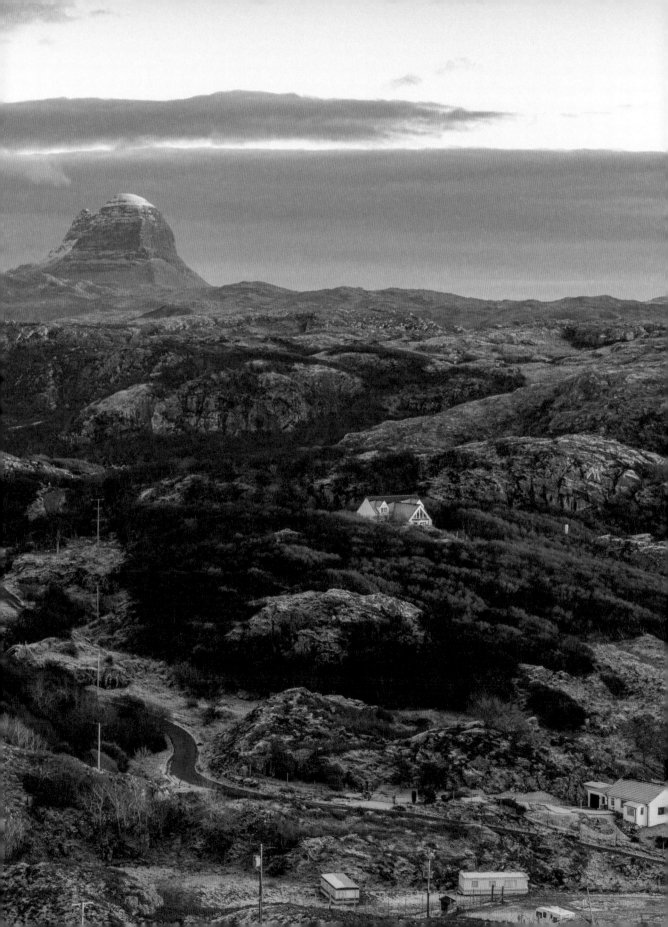

STAC POLLAIDH

Nearby Town: Lochinver

If I had to recommend just one walk of the multitudes in Coigach and Assynt, it would be Stac Pollaidh (Stac Polly). Its Gaelic name translates to 'Pinnacle Peak', accurately capturing its dramatic appearance and the sense of awe it evokes.

As you approach on the single-track road the views are immaculate, with Stac Pollaidh directly ahead, the Fiddler, Sgorr Tuath and Beinn an Eoin to the left and Cùl Beag watching from the side.

Stac Pollaidh stand 510m (1,670ft) tall and makes you work for it right from the get-go. Starting with a sharp incline through some dense forest and within the first 10 minutes you'll be looking out at gorgeous views of Loch Lurgainn below and Sgorr Tuath to the east.

The closer you get, the more apparent the unique features of this mountain become, with huge pillars of rock and Torridonian sandstone seemingly melting down from the top like wax. As you begin to circle around to the back of the mountain, the vastness of the Highlands starts to come into view. Suilven lies quietly in the background as countless mounds of earth, bodies of water and heather, gorse and plant life blanket the ground for hundreds of miles.

The main path follows rugged terrain, characterized by rocky outcrops and exposed ridges, and demands a degree of agility and sure-footedness from climbers. The ascent can take between one and three hours depending on the individual, with a short scramble up some steep rocks near the top that lead to a well-trodden peak with views unlike anywhere else on earth. The reward for this effort is the opportunity to witness the awe-inspiring beauty of the Scottish Highlands from a vantage point that feels both isolated and ethereal.

Whether conquering its peaks or admiring its silhouette from afar, Stac Pollaidh leaves a long-standing mark on all who are captivated by its presence.

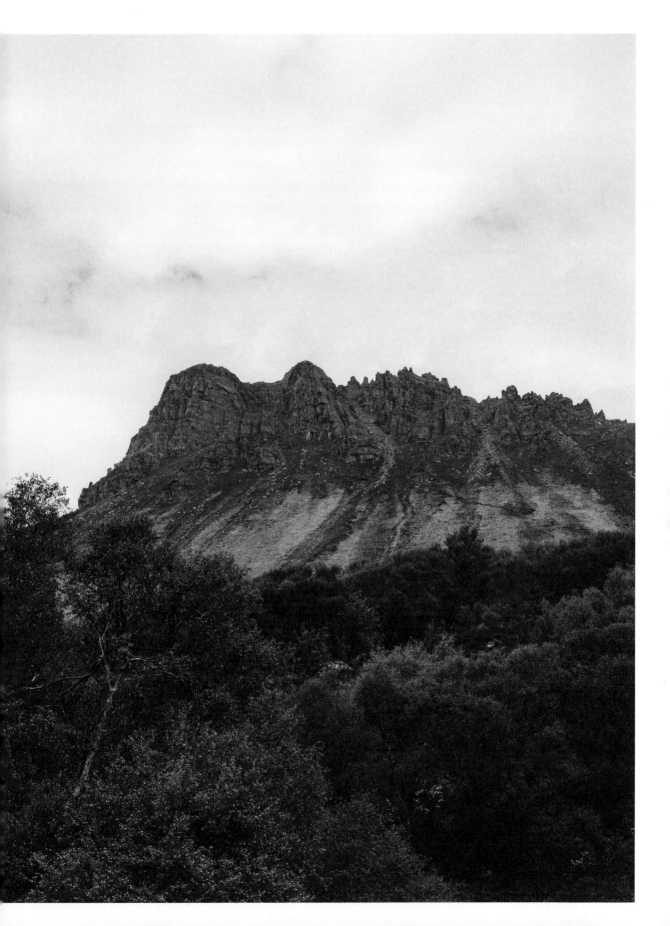

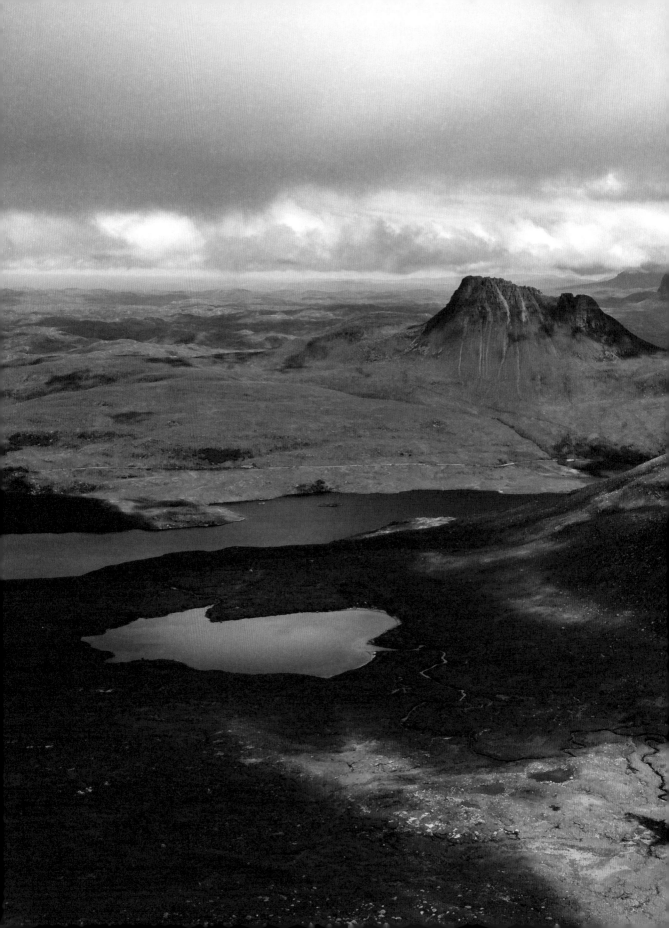

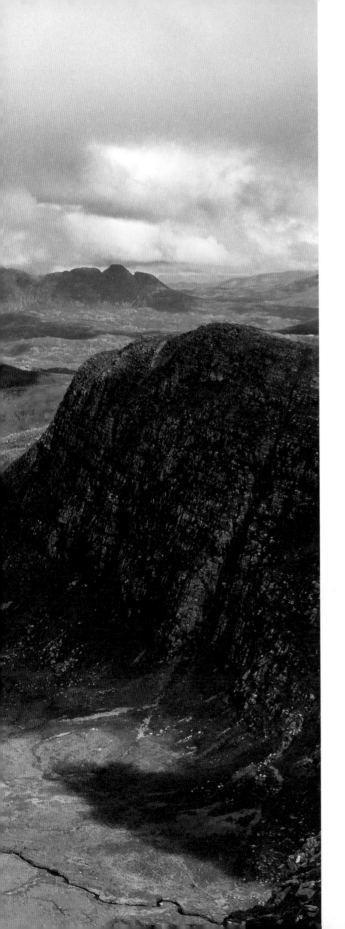

Stac Pollaidh leaves a long-standing mark on all who are captivated by its presence.

CLOSE BY:
THE FIDDLER

Those looking for something a little different won't go far wrong with the Fiddler. You'll find it in the Summer Isles, an archipelago lying in the mouth of Loch Broom and past the old crofts that have used the land for generations. The walk to the top is as ordinary as they come, but it's all in preparation for a dramatic finish as the land evens out and the entirety of the area is unveiled before you. With Stach Pollaidh in the distance and Suilven sitting calmly behind, it makes for a breathtaking view that is hard to beat.

ACHMELVICH

Nearby Town: Achmelvich

Year after year, Scotland's beaches are featured in top ten lists all over the world. The stunning beauty, remote location and breathtaking backdrops are enough to make them contenders, but time again the Caribbean-esque white sands and turquoise waters are what surprise people the most.

Achmelvich is a fantastic example of a Scottish beach, tucked away down a single-track road, a quick jaunt over grazing farmlands and a short climb over a few rocks. The fantastic blue waters still don't quite prepare you for the golden white sands surrounded by ancient highland stone.

A quick *dook* in the Atlantic can be just what's needed to escape the summer heat, but you'll likely find Scots in the water at most times of the year – those ladies swim clubs are braver than most of us!

Achmelvich is part of the Assynt-Coigach National Scenic Area, recognized for its outstanding natural beauty and protected to conserve the landscape and wildlife. It is home to birds, such as the penguin-like guillemots and the always popular puffin; marine life, with seals, dolphins and porpoise; as well as thousands of red deer, ever-curious otters, and an uncountable array of fish, insects and butterflies.

The beach and its surroundings have great cultural importance, with a history tied to traditional fishing communities; it's a place where visitors can appreciate the local heritage and way of life.

The surrounding landscape is a geologist's dream. Beautiful sandstone almost blended with limestone and ancient, three-billion-year-old Lewsian Gneiss. If you pay careful attention to the cracked and exposed rock you'll notice an almost marbled effect of grey, silver and pink.

The hills bump and roll over the horizon as the road twists and turns as though it was made by water. Tiny lochs appear and disappear as you make your way through a seemingly endless rollercoaster with sheep to your left, tiny croft houses to your right and suddenly, a vast, clear ocean pushing its way up on to the sands of Achmelvich.

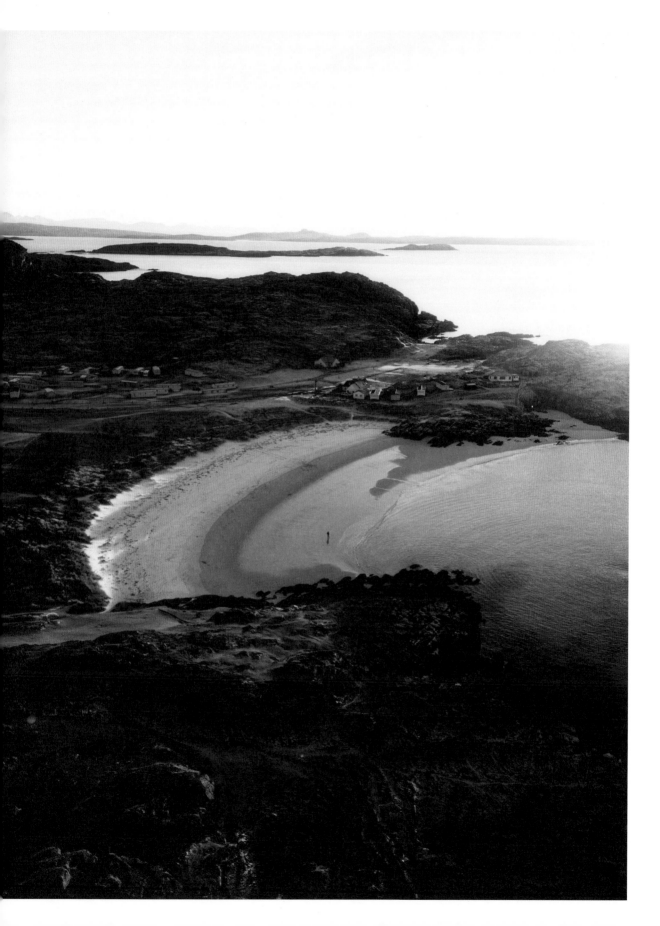

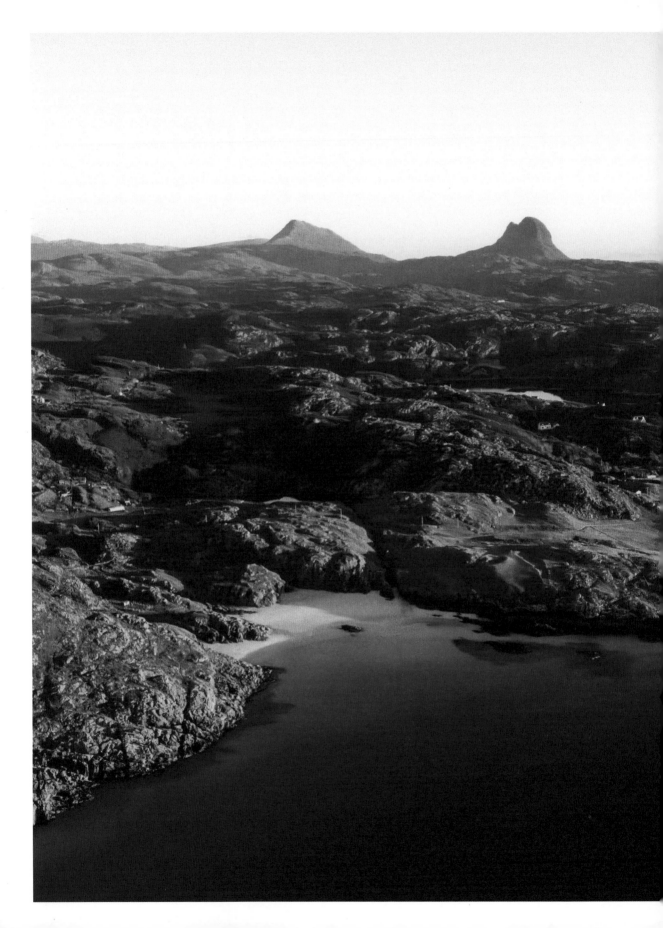

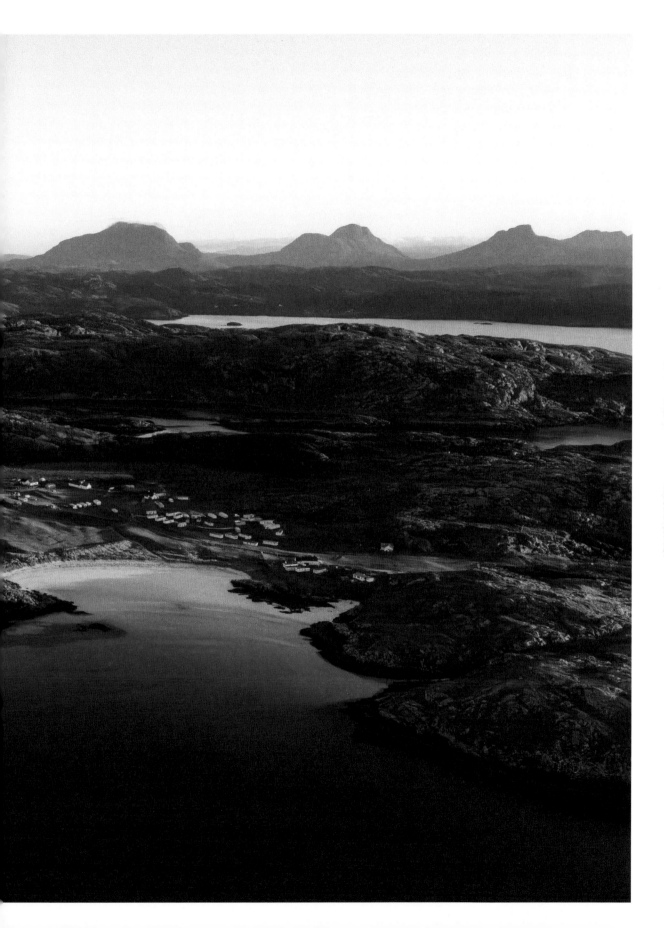

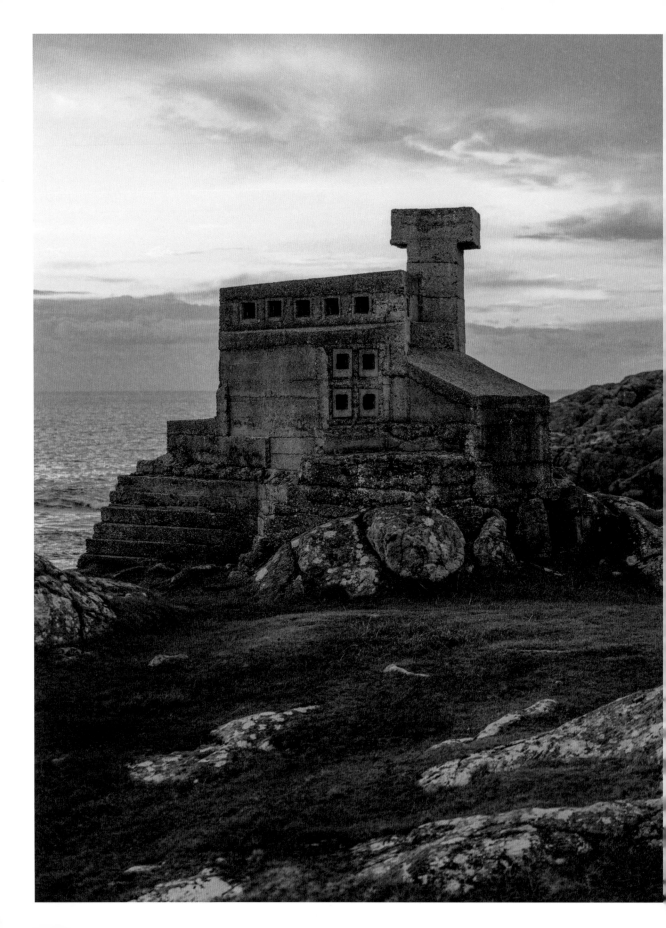

HERMIT'S CASTLE

Nearby Town: Achmelvich

Built in the 1950s by architect David Scott, Hermit's Castle was intended as a retreat – a place for seclusion and contemplation amid the serene Highland landscape. Its design, resembling a minimalist fortress, blends seamlessly with the natural surroundings, featuring stark lines and a compact layout that mirrors the rugged terrain. The castle itself is so small that you need to look carefully to even spot it among the rocks.

Despite its name, Hermit's Castle was never actually inhabited by a hermit. Instead, it was crafted as a holiday home, showcasing Scott's innovative architectural vision and appreciation for simplicity in design. Over the years, the castle has become a hidden gem for adventurers, hikers and those seeking a glimpse into Scotland's lesser-known architectural wonders.

Today, Hermit's Castle stands at the intersection of creativity and nature, inviting visitors to appreciate its unassuming beauty while marvelling at its captivating setting. It serves as a reminder of the enduring allure of solitude and the striking harmony between human design and the untamed Scottish landscape.

On a clear day you'll be able to see incredible views from Assynt behind you, the Outer Hebrides to your east, and to your south, the jagged mountains and extinct volcano of the Isle of Skye itself.

Sunset can make a perfect time to visit with the right conditions, especially in the colder months when the still, crisp air settles the clouds and the angle of the sun allows the colder crystals in the air to alight with colours of blue and purple.

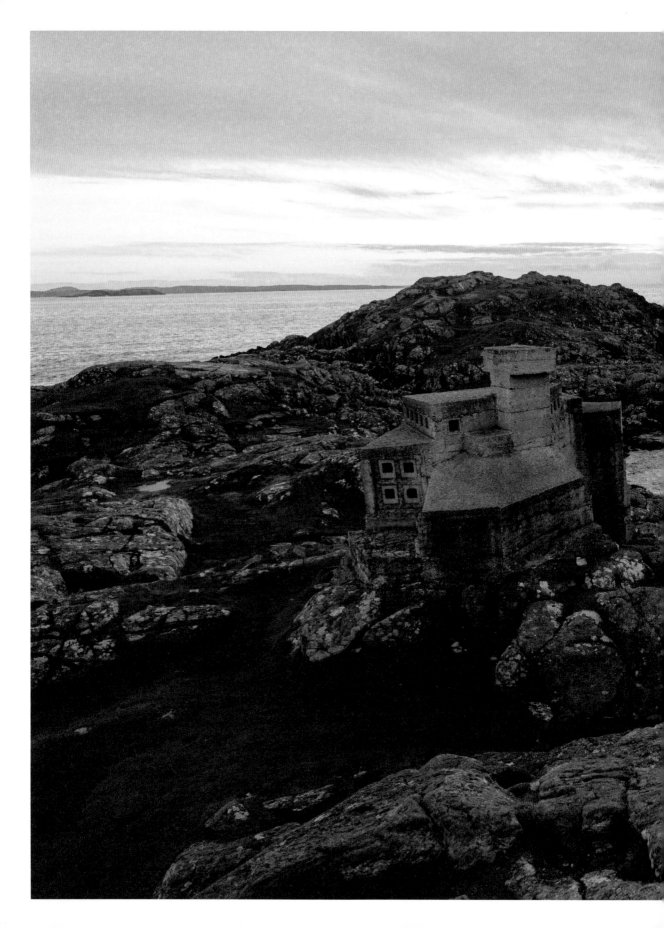

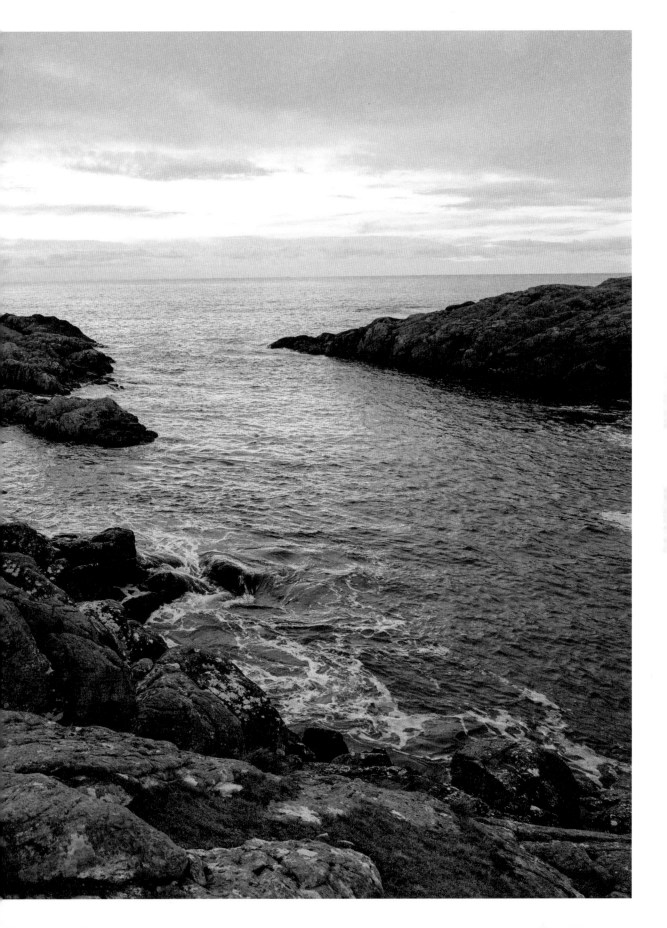

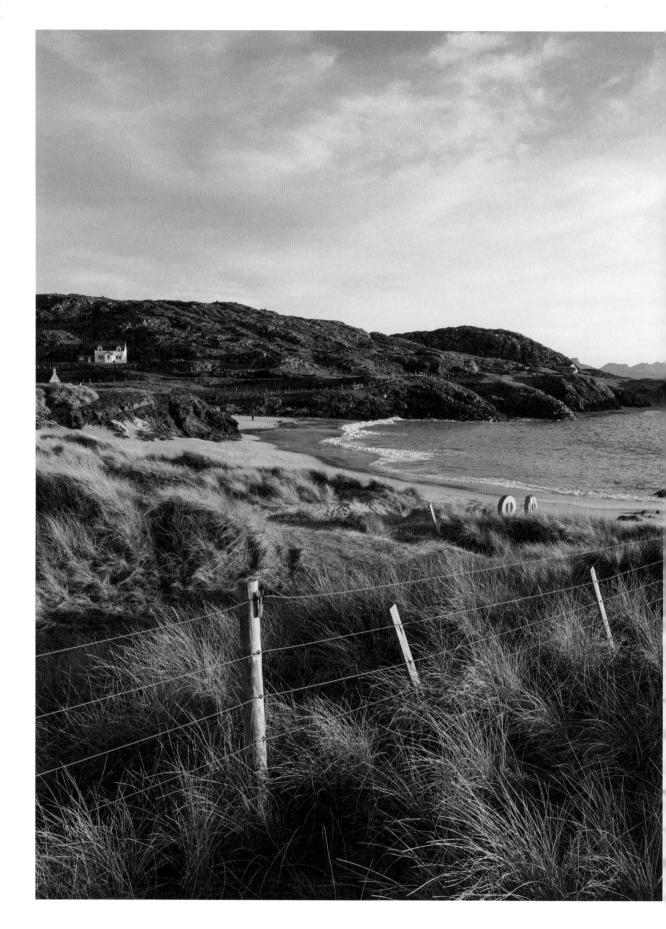

CLACHTOLL

Nearby Town: Lochinver

Steeped in natural beauty and offering a diverse range of activities, Clachtoll encapsulates the untamed allure of Scotland's coastline. It stands as a testament to the unspoiled wonders that await those who venture off the beaten path, inviting all who visit to bask in the tranquility and beauty of this particular coastal gem.

It has pristine sand and glass-green water, with pointed rock formations looking out toward the ocean. A quaint salmon bothy sits overlooking the beach that in summer will be filled with locals and tourists alike, often with a pie in hand from the famous larder, not too far away, in the village of Lochinver.

Clachtoll Beach is more than just a scenic spot, it's an adventurer's paradise. Kayakers, surfers and paddle boarders revel in the waves, while hikers explore the nearby trails that showcase the raw beauty of the region, taking in the views from the Highlands to the Islands and everything in between.

The beach's convenient facilities, including a campsite, toilets and ample parking, make it a welcoming destination for families and travellers seeking a comfortable and enjoyable coastal experience despite the remote location.

CLOSE BY:
CLASHNESSIE FALLS

As you drive around the winding roads of Assynt, you may catch a glimpse of a grand waterfall tucked away behind the homes of Clashnessie.

It's a little difficult to get to at times (and the local signs will certainly tell you which direction *not* to go), but if you follow the path from the top of the road you'll soon see the right signs to help you on your way. Walking over the hills, crossing the stepping stones and through a field of heather and bog, will lead you directly underneath the beautiful wide falls of Clashnessie.

On warmer days you'll often find some brave souls plunged into the small pool of water, getting battered by the gathering pace from the stream a few meters above. Legend says if you're invited in, you mustn't refuse.

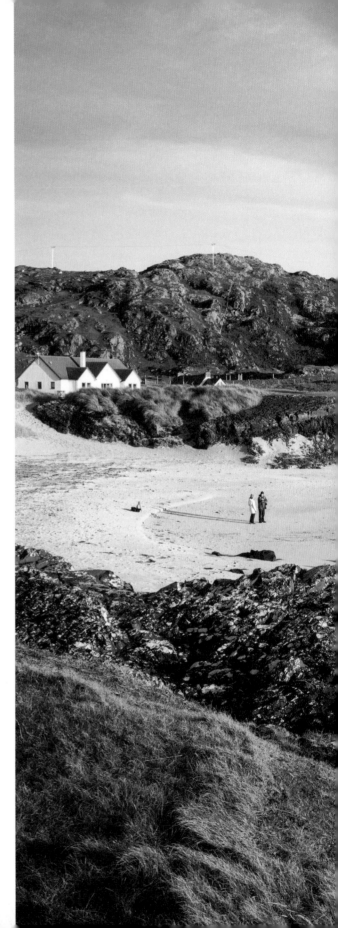

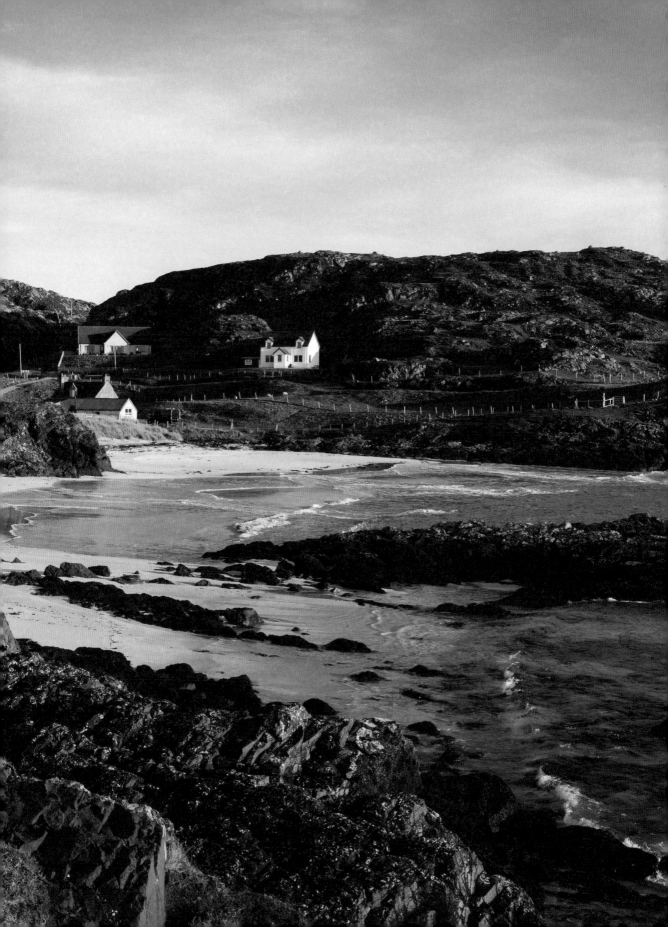

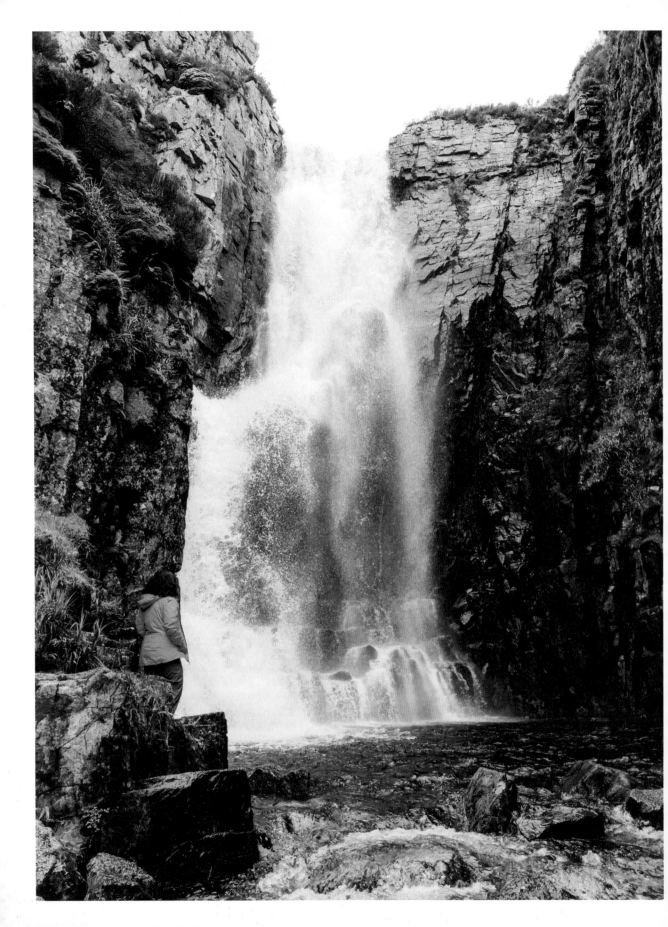

ALLT CHRANAIDH FALLS

Nearby Town: Kylesku

Allt Chranaidh Falls, also known as the Wailing Widow Falls, derive their name from an old folk tale. It's said that a young hunter was out looking for deer on a misty, rainy day. Due to the poor visibility, he did not see the top of the waterfall and he tragically fell from the top of the cliff. When his widowed mother learned of his untimely death, she visited the falls to weep and grieve. Overcome with distress at the loss of her son, she threw herself down into the dark waters.

Tall tales aside, the falls come from Loch na Gainmhich, loosely translated to 'Sandy Loch', overlooked by one of Assent's many rock-laden mountains and the northern foot of Glas Bheinn.

For the greatest adventure, start at the bottom of the small stream that runs from the loch and make your way into the crack of the mountain. As you navigate the uneasy path of boulders, heather and bog, the rock walls curve around to reveal the entire face of the falls. Continue upstream until you're face to face with all 30m (98ft) of roaring water flooding down to the rocks and pools below. It's a humbling sight, not to be missed.

CLOSE BY: KYLESKU BRIDGE

A bridge that crosses a loch may not seem noteworthy, but this architectural marvel sits proudly curving above Loch a' Chàirn Bhàin with the backdrop of some fantastic local peaks, views of Kylesku and Loch Gleann Dubh and – at the right time of year – a stop-worthy little seafood shack with lobster rolls that you'll want to get your hands on.

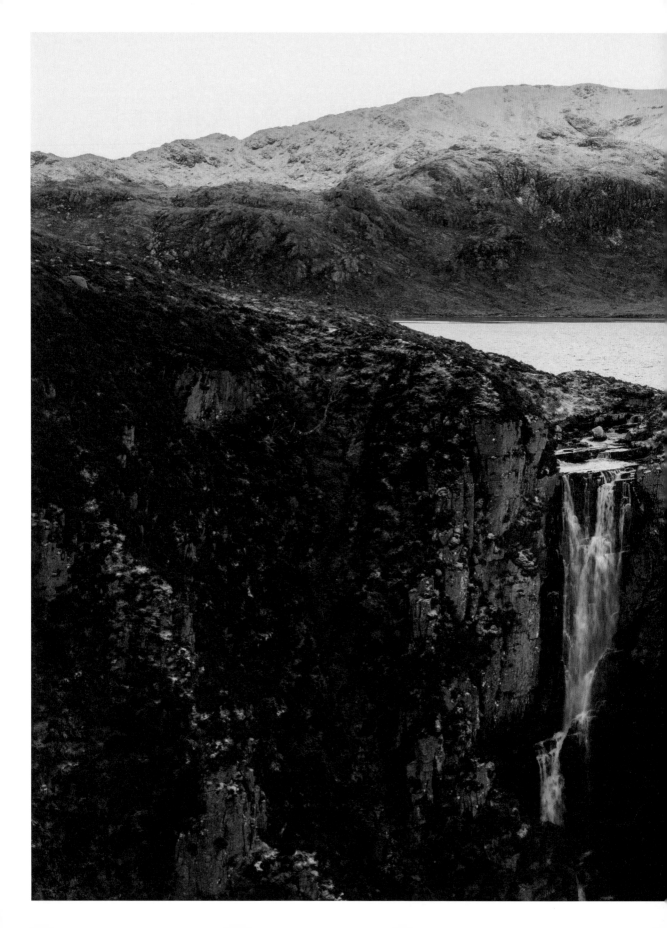

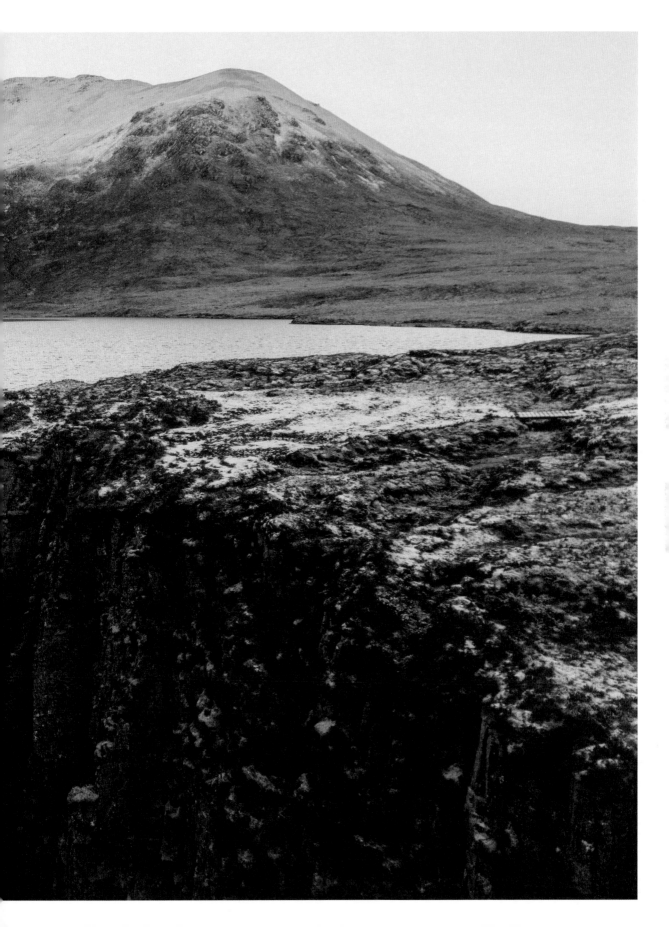

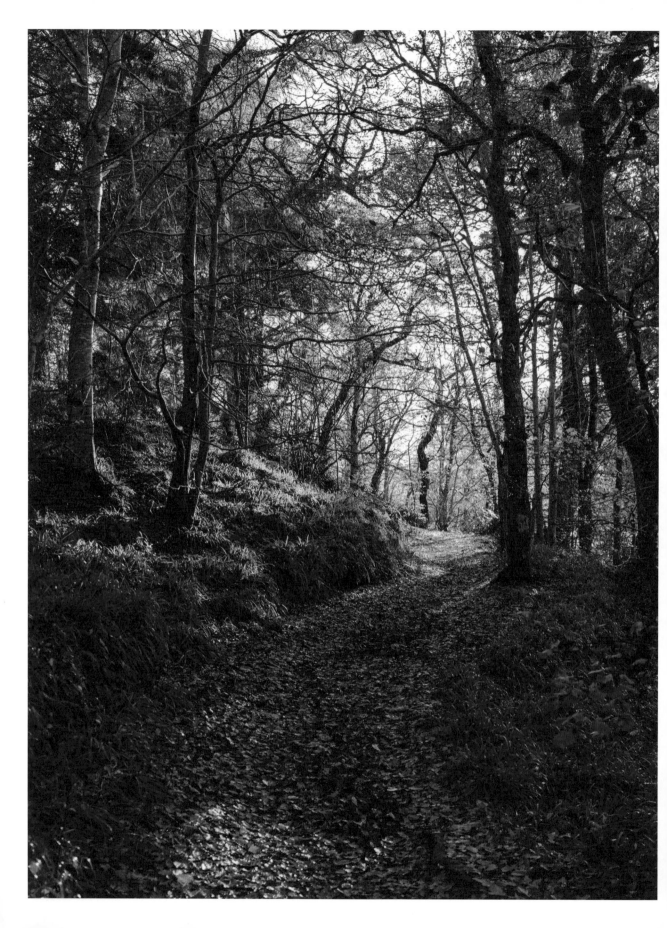

GOLSPIE BURN & WATERFALL

Nearby Town: Golspie

If you were told to picture a hidden Scottish glen during a slow autumn morning, the Golspie Burn and Waterfall would outshine your imagination. A quiet walk takes you down a well-made path as you skip your way past an abundance of trees, plants and animals, delving into the depths of the gorge. Little effort is required to reach the fierce river that runs at the bottom, and following it upstream just a little further reveals a short but heroic waterfall charging its way down a crooked formation of ancient rock.

Hopping over the wooden planks and walkways, which are overrun with wildflowers during the spring and summer months, and exploring amidst hanging moss growing over old trees, amplifies the feeling of being in an old Peter Pan movie.

However, in Scotland, mysterious legends are never far away. In the mist-shrouded valleys and along the winding shores of Scotland's lochs, tales of the Bean Nighe are whispered. Known as the washerwoman of the Highlands, a spectral figure is said to appear to those whose fates are sealed, her presence foretelling impending tragedy.

BEAN NIGHE

According to stories passed down through the generations, the Bean Nighe can be found near bodies of water, her ghostly form hunched over, endlessly washing the bloodstained clothes of those doomed to die. Her appearance is often accompanied by an eerie lament, haunting those unfortunate enough to glimpse her.

Though the origins of the Bean Nighe are shrouded in mystery, her legend endures as a potent symbol of death and the unknown. Some believe her to be a guardian of the Otherworld, guiding souls to their final resting place, while others fear her as an omen of doom.

Yet amidst the darkness of her legend, there are whispers of hope and redemption. It is said that those who encounter the Bean Nighe may receive her blessing, gaining insight into their own destiny or finding solace in the face of adversity.

Either way, the legend of the Bean Nighe is a reminder of the mysteries that lie beyond the veil of the mortal world.

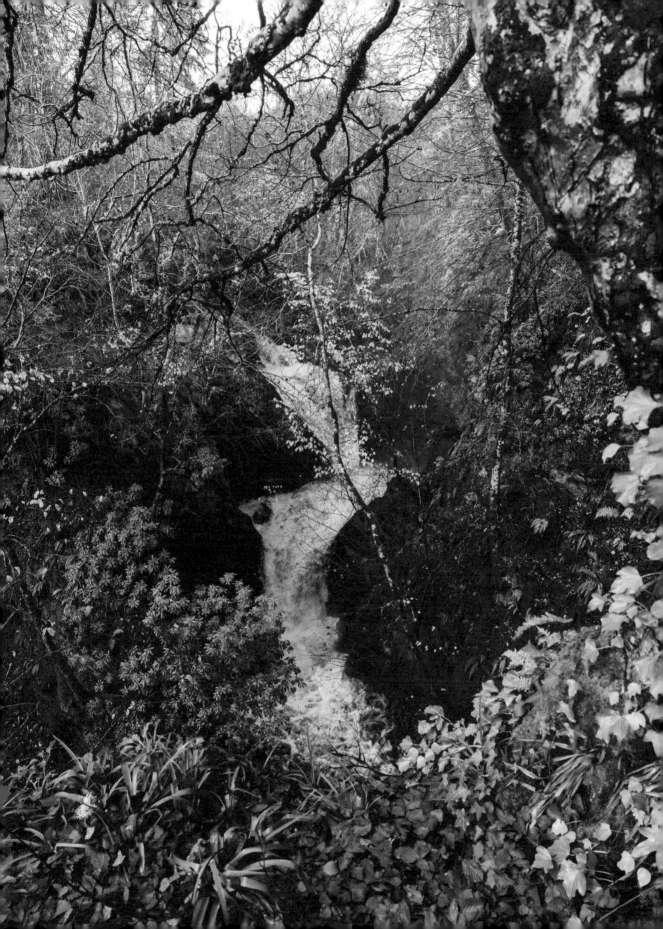

DUNCANSBY STACKS

Nearby Town: John o' Groats

The sea stacks at Duncansby – three giant triangular mountains – stand like glorious warships waiting to breach the cliff face as the endless sea batters against them.

Proudly positioned at Scotland's most north-easterly tip, a good couple of miles from John o' Groats, the dramatic walk along the unsuspecting grazing lands toward the cliff edge is breathtaking enough, before the peaks of the stacks start to pop out from the earth and bob around as you make your way toward them, trying to figure out what exactly it is your eyes are seeing.

Photo opportunities here are endless. The stacks provide a beautiful subject from any angle as you make your way along the coast and witness them change shape before you. Seal watching is always on the table here, although they will usually see you before you spot them, but they rarely scare at such a distance.

From mid-April until mid-August, you can find everyone's favourite bird nesting on the safe cliff edge to the north. The small but mighty puffins will be going about their daily business: building their nests, collecting twigs and taking turns to fly a few miles off shore to catch dinner for the family.

When you get the right kind of clear morning sky, nothing can beat the early morning light with views like these.

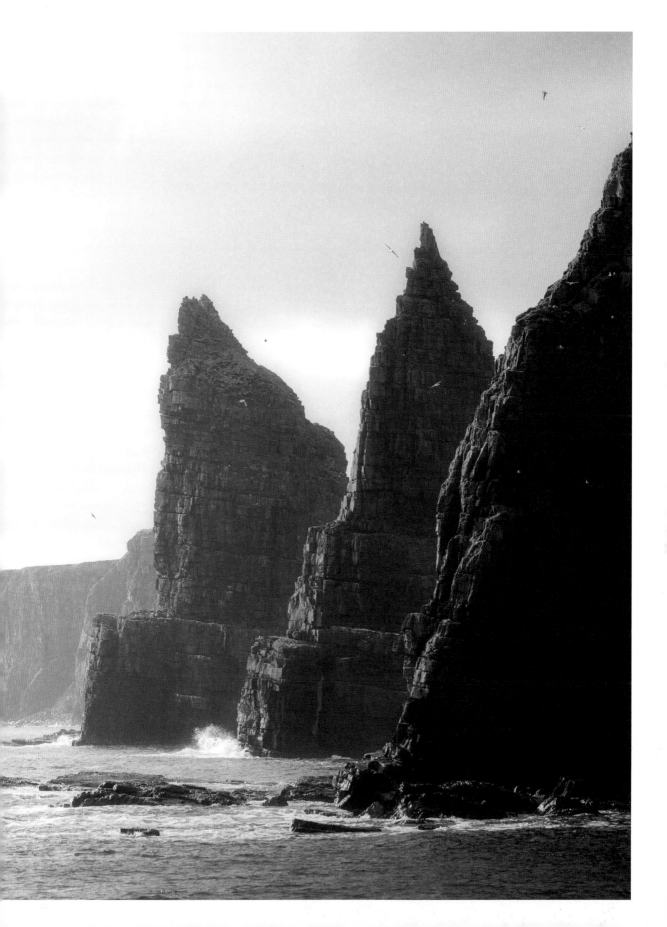

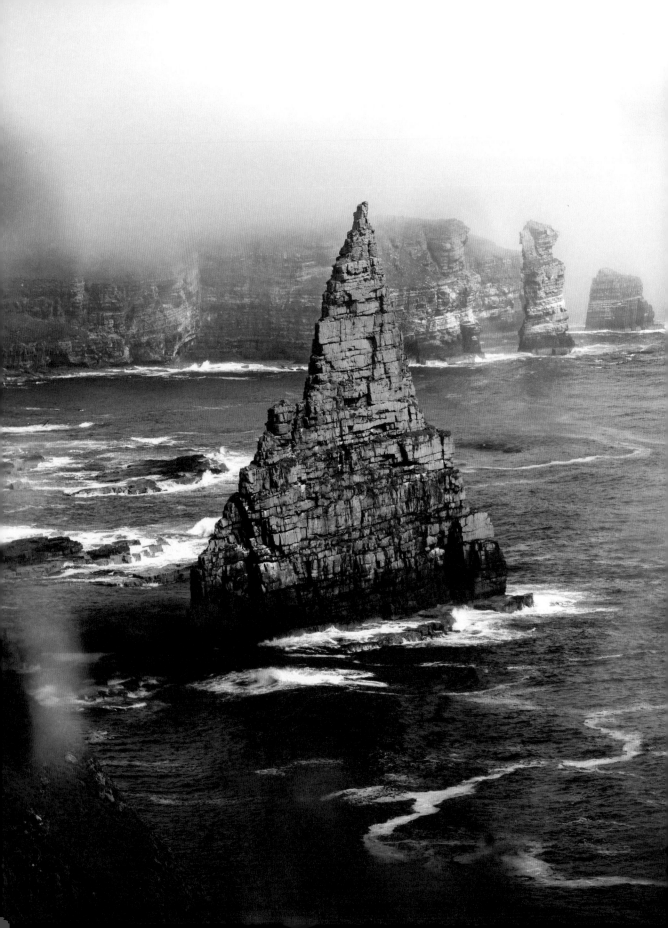

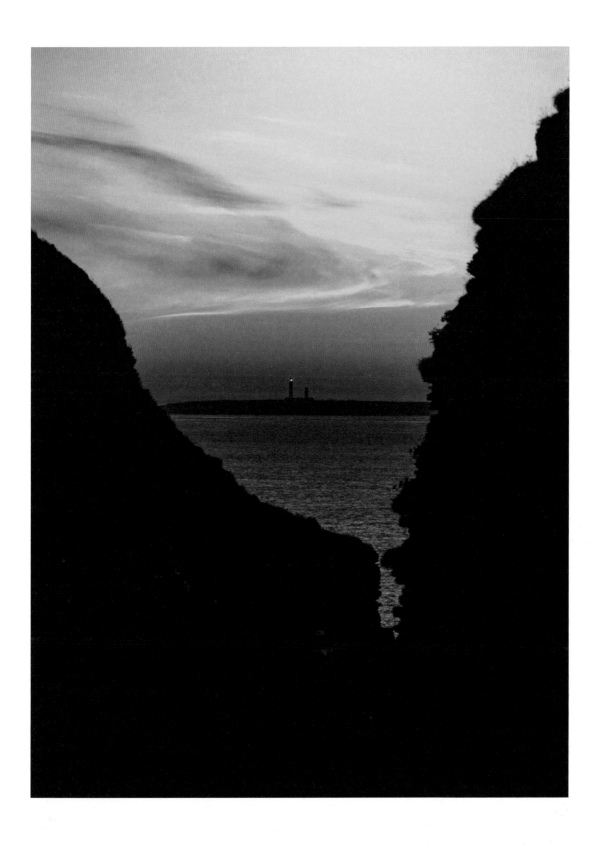

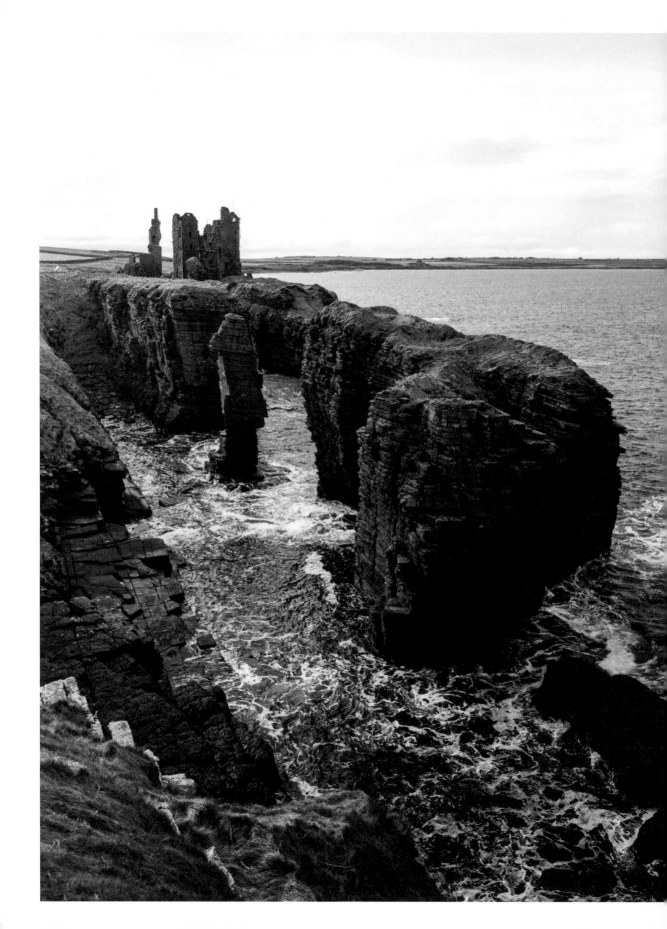

CASTLE SINCLAIR GIRNIGOE

Nearby Town: Wick

Steeped in history, you can see and feel the moment you make your approach to Castle Sinclair Girnigoe. It draws you in as your imagination runs wild with stories of medieval life, brutal conditions and invasions from near and far. While there is little left of the original structure, enough remains to paint a vivid picture of how life was.

The stories from Girnigoe are plentiful. In 1577, George Sinclair, 4th Earl of Caithness, imprisoned his son, John Sinclair, in the castle, on suspicion of rebelling against him. After seven years of imprisonment, the Earl killed his son by feeding him a diet of salted beef, with nothing to drink, so that he died of thirst.

George Sinclair requested the Scottish Parliament to change the name to Castle Sinclair, but because the names Castle Sinclair and Castle Girnigoe were both written down in 1700, the two names have been in use ever since, resulting in a rather confusing title.

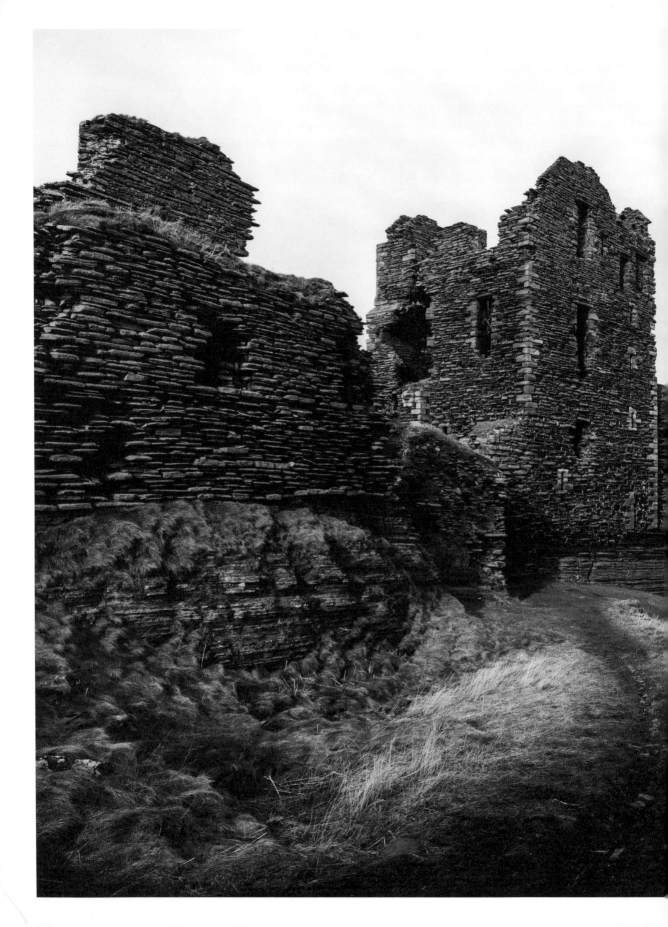

It draws you in as
your imagination
runs wild with stories
of medieval life,
brutal conditions
and invasions from
near and far.

CLOSE BY:
KEISS CASTLE

Keiss Castle sits rather precariously
on the edge of a cliff overlooking the
sea. As with many Scottish castles, the
current ruins were originally built atop
a much older building around the 16th
century. Upgrades, advancements and
more modern technology were used to
keep these important fortresses intact
against the weather, sea and invaders.
Five hundred years later their efforts
seem to have paid off!

The castle was built by our friend
George Sinclair (see page 161). Its tall
thin frame stands out among the jagged
cliff edge and, even on the roughest of
days, looks proud as it sits in silence in
its long-standing battle with time.

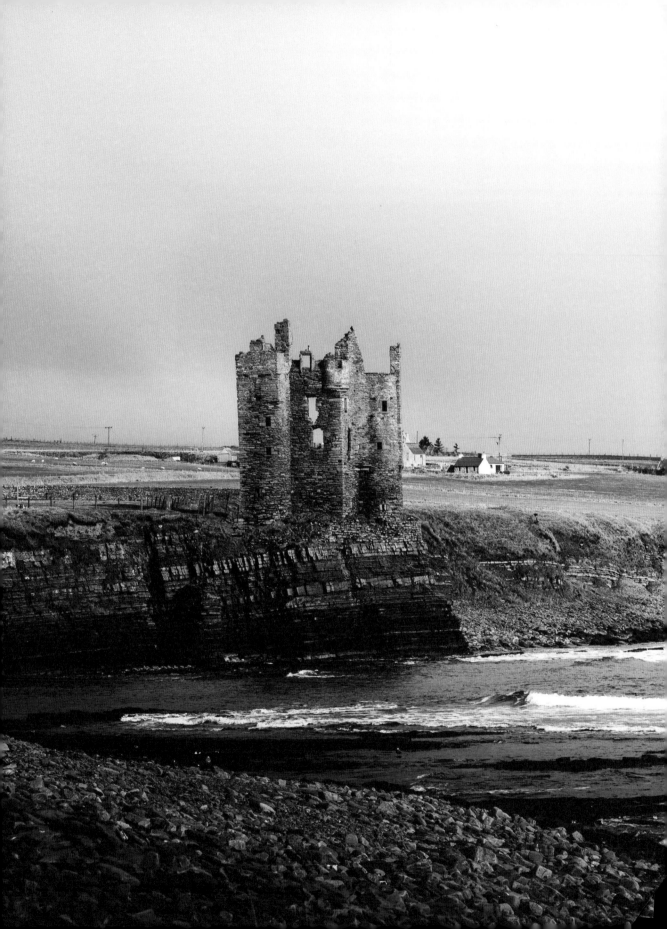

CASTLE OF OLD WICK

Nearby Town: Wick

The Castle of Old Wick is perched defiantly on the craggy cliffs of Caithness; it's a relic steeped in history and tales of a tumultuous past. Its weathered stones, dating back to the 12th century, cling to the coastline, bearing witness to centuries of territorial disputes and strategic positioning.

Approaching the castle unveils a commanding view of the North Sea crashing against the cliffs below. Legend has it that the castle was once a stronghold of the Norse earls, a strategic outpost guarding the northern reaches of Scotland against invading forces. Over time, it changed hands between Scottish clans amidst fierce territorial rivalries.

Exploring the ruins, you'll encounter the remains of the once formidable fortress – a maze of collapsed walls, worn battlements and remnants of defensive structures hinting at its past. The harsh coastal winds and relentless sea spray have weathered the castle, adding an eerie beauty to its desolate state.

Local tales speak of hidden tunnels beneath the castle and secret passages leading to the sea, used by smugglers and pirates during more turbulent times.

Today, the Castle of Old Wick stands as a haunting reminder of Scotland's rich heritage, inviting visitors to contemplate its storied past while soaking in the breathtaking views of the North Sea from its windswept vantage point. Its location served as a watchful eye over the surrounding waters, embodying the resilience of the people who once defended these ancient walls.

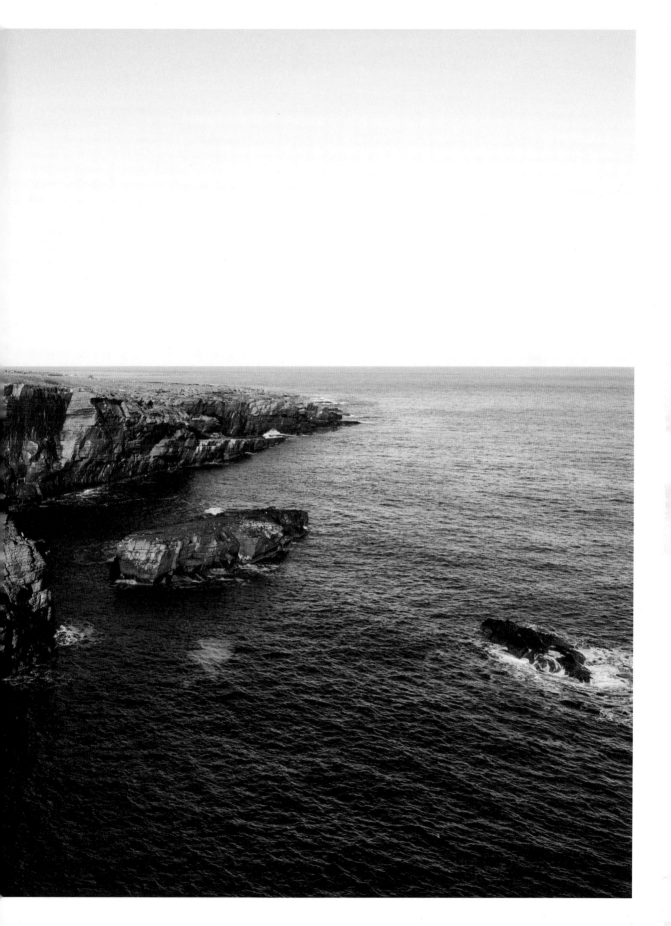

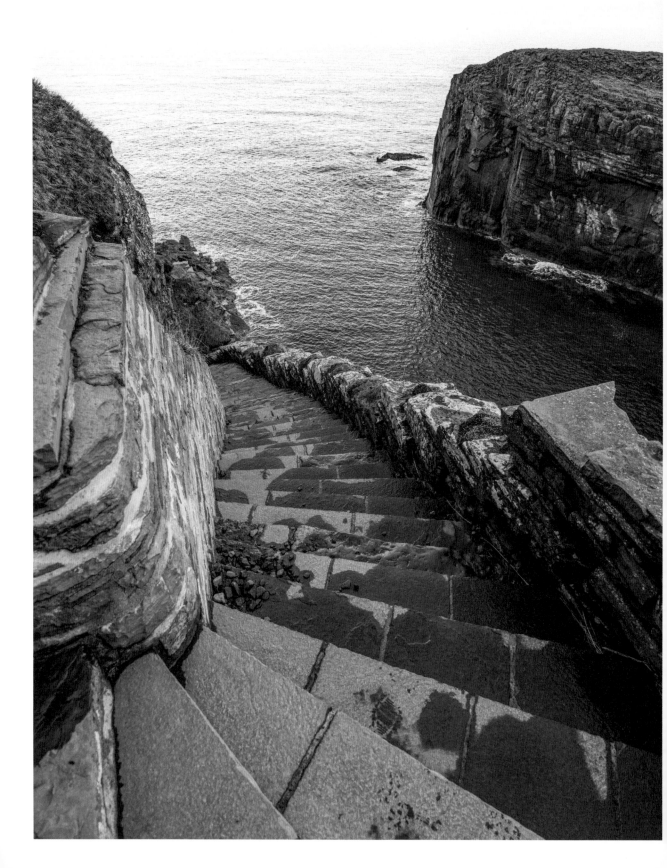

WHALIGOE STEPS

Nearby Town: Wick

The Whaligoe Steps are a remarkable feat of engineering and human determination. Carved into the steep cliff face, this staircase of 330 steps descends to a small, yet historically significant, natural harbour nestled between towering cliffs. The steps, which date back to the late 18th century, were primarily used by fishermen and fishwives to access the harbour below, where they would land and process their catch, notably herring.

The construction of the Whaligoe Steps is attributed to Captain David Brodie, who saw the potential for a landing spot in the sheltered cove beneath the cliffs. The laborious task of creating the steps from the rock was undertaken without the aid of modern machinery, showcasing the incredible perseverance and skill of the local people. Over the years, the steps have been maintained and restored, ensuring that this hidden gem of Scottish heritage remains accessible to those who seek to explore its depths.

The journey down the steps is a descent through time, offering breathtaking views of the brutal coastline and the turbulent North Sea. At the base, the old harbour, surrounded by cliffs on three sides, provides a tranquil haven, a stark contrast to the often wild conditions above. This secluded spot was once bustling with activity, as fishwives carried baskets of herring up the steps, destined for markets far and wide.

The steps serve not only as a physical pathway but as a momument to the resilience and ingenuity of the locals. For those who make the trek, the steps offer a unique perspective on Scotland's maritime history, set against the backdrop of its stunning natural beauty, which has barely changed in generations.

The Whaligoe Steps are more than just a historical curiosity; they are a symbol of the connection between the Scottish people and their environment. This site embodies the spirit of endurance, reflecting the challenges and triumphs of life along Scotland's coast. It's a place where history, culture and nature intertwine, leaving a lasting impression on all who venture down to the water's edge.

THE
EAST COAST

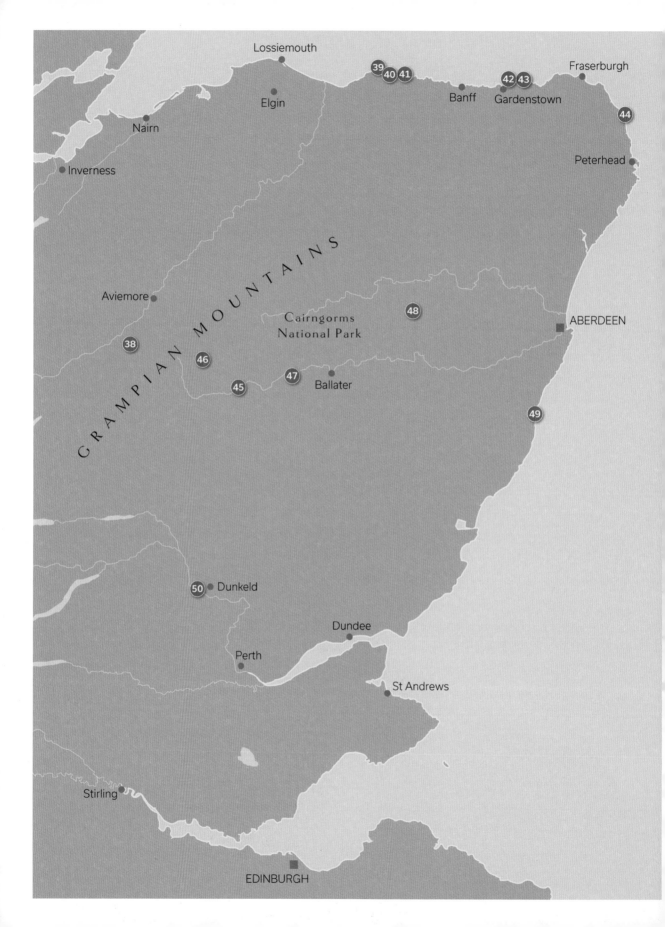

The East Coast, with its gentle beaches, rolling, colourful hills and historic harbours, presents a different kind of beauty than its western counterpart. It's a place where the past and present converge and where the echoes of history are felt just as strongly as the pulse of modern life.

The landscapes of the East Coast tell a story of centuries of human interaction: from ancient Picts who left their marks on stones, to medieval battles that shaped the nation, and the flourishing of Enlightenment ideas that spread from its cities. The ruins of castles stand solemnly along the coastline, silent witnesses to the ebb and flow of power, while lighthouses punctuate the shore, guiding seafarers home in a timeless pact between land and sea.

But it's not just the physical remnants of the past that imbue the East Coast with its unique character. The traditions of fishing and trade have left a mark on the culture here, creating communities with deep ties to the sea. Festivals celebrating maritime heritage, local cuisine featuring the bounty of the North Sea, and tales of seafarers and adventurers, contribute to a rich cultural experience that visitors can enjoy.

The East Coast is also a place of subtle magic; with the western part of the country soaking up all the bad weather, the light here plays off the North Sea in a myriad of colours, from early summer sunrises to incredible displays of green and pink light during an aurora borealis event (the Northern Lights). It's in the quiet moments over the sea, or in the tranquil beauty of a coastal garden, that the true spirit of the East Coast reveals itself, a spirit of history, dignity and a resourceful people.

38 Uath Lochan 39 Bow Fiddle Rock 40 Cullen 41 Findlater Castle 42 Crovie 43 Pennan
44 Rattray Head Lighthouse 45 Linn of Quoich 46 The Cairngorms 47 Prince Albert's Cairn
48 Craigievar Castle 49 Dunnottar Castle 50 The Hermitage

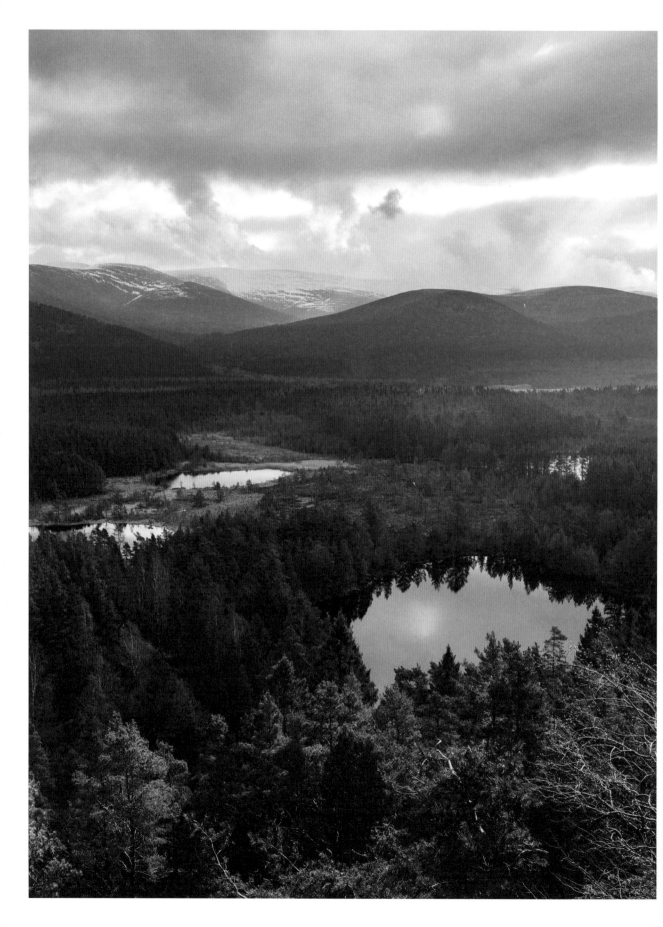

UATH LOCHANS

Nearby Town: Aviemore

Uath Lochans, nestled in the heart of the Cairngorms National Park, is a place of serene beauty and natural wonder. The series of small lochans, set against the backdrop of ancient Scots pines and the distant peaks of the Cairngorms, offer a snapshot of Scotland's wild heart. The tranquility of the water, mirroring the sky and surrounded by dense forest, creates a sense of isolation from the outside world, a retreat into nature's embrace.

The paths around Uath Lochans invite exploration, leading through a landscape that changes with the seasons, from the vibrant greens of spring and summer to the rich golds and russets of autumn. The area is a haven for wildlife, where red squirrels dart among the trees and ospreys can be seen diving for fish in the clear waters. It's a place where the cycle of life is evident in every leaf and ripple, a reminder of the interconnectedness of all things.

Visiting Uath Lochans is to experience the quiet majesty of the Scottish Highlands, where the landscape speaks of deep time and the enduring beauty of the natural world. It's a place for quiet contemplation, for walks that lead, not just through the forest, but into the depths of one's own thoughts. Here, in the stillness of the lochans, one finds a connection to the earth that is both humbling and uplifting, a reminder of the simple beauty that exists when land, water and sky converge.

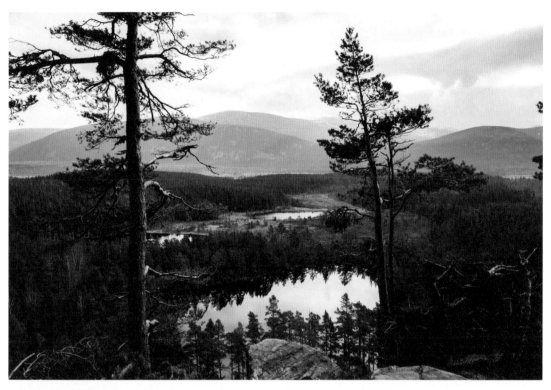

BOW FIDDLE ROCK

Nearby Town: Lossiemouth

With its distinctive arch rising from the sea, Bow Fiddle Rock is a natural sculpture crafted by the forces of erosion and time. This striking geological formation, located near Portknockie, is a testament to the power of the sea and the wind, which have shaped the quartzite rock into its current form. The rock's name derives from its resemblance to the tip of a fiddle bow, a poetic tribute to the artistry of nature's hand.

The spectacle of Bow Fiddle Rock is best appreciated at dawn or dusk, when the light casts shadows that accentuate its majestic form against the backdrop of the North Sea. It's a place that draws photographers, artists and nature enthusiasts, all seeking to capture the essence of this unique landmark. The surrounding coastline, with its jagged cliffs and hidden coves, offers the opportunity to explore and the chance to discover the diverse marine and bird life that call this area home, from seagulls, cormorants and razorbills to whales, dolphins and otters. Spending some time on a bench, with a local chippy in hand, watching them go about their day is time very well spent.

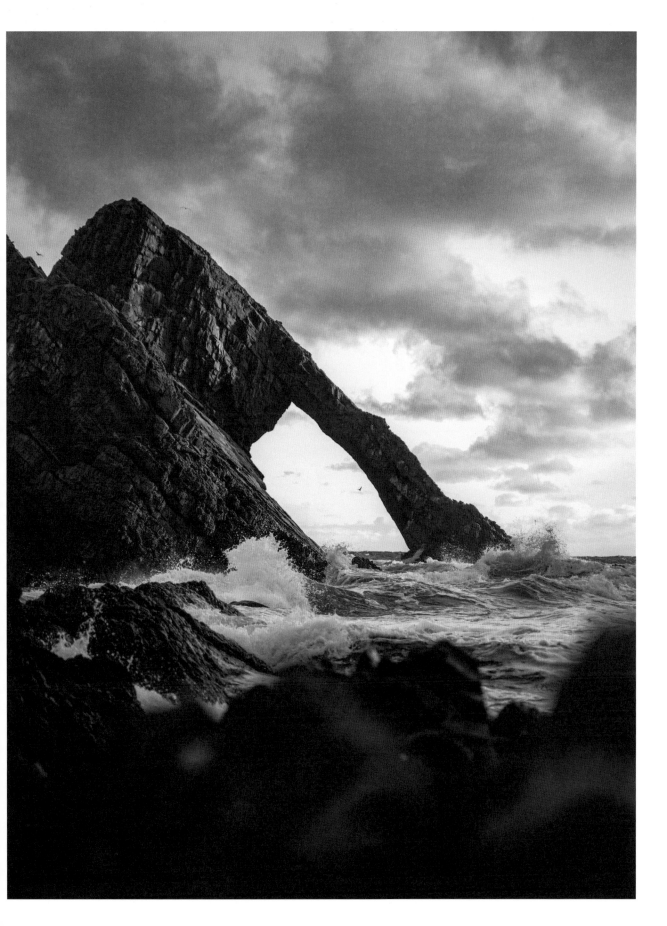

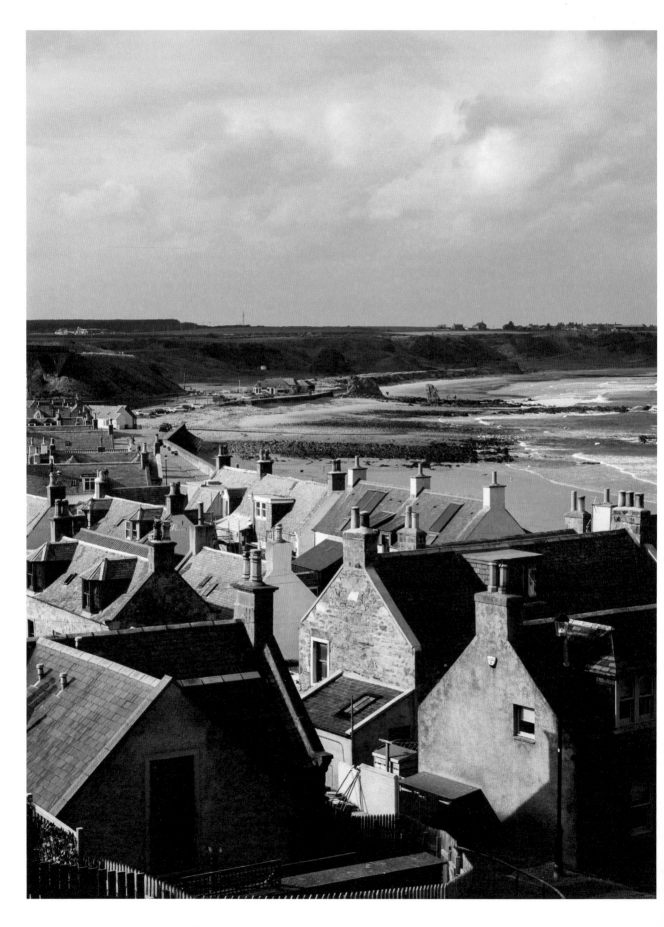

CULLEN

Nearby Town: Cullen

Cullen, known for its picturesque setting on the Moray Firth coast and its famous Cullen Skink soup, is a charming blend of natural beauty and culinary tradition. The town's historic buildings, winding streets and friendly atmosphere invite exploration, while the beach offers stunning views of the sea and a chance to experience the tranquility of the Scottish coastline. Cullen's viaduct – an impressive feat of engineering – arches over the town, adding to its scenic charm.

The culinary tradition of Cullen Skink, a hearty soup made from smoked haddock, potatoes and onions, demonstrates the town's connection to the sea and its long history of fishing. Sampling this local delicacy is not only a culinary experience but a dive into the cultural heritage of the region, where food and community are intimately linked. The town's eateries, from cozy cafes to traditional pubs, offer a warm welcome to those looking to savour the flavours of Scotland.

Visiting Cullen is to embrace the slower pace of life that characterizes Scotland's coastal towns. It's a place for leisurely walks along the shore, for conversations with locals who share tales of the town's history, and for moments of reflection on the beauty of the natural world. Cullen embodies the spirit of the Scottish coast, where the land meets the sea, and tradition mingles with the present to create a destination that captivates the heart and the palate.

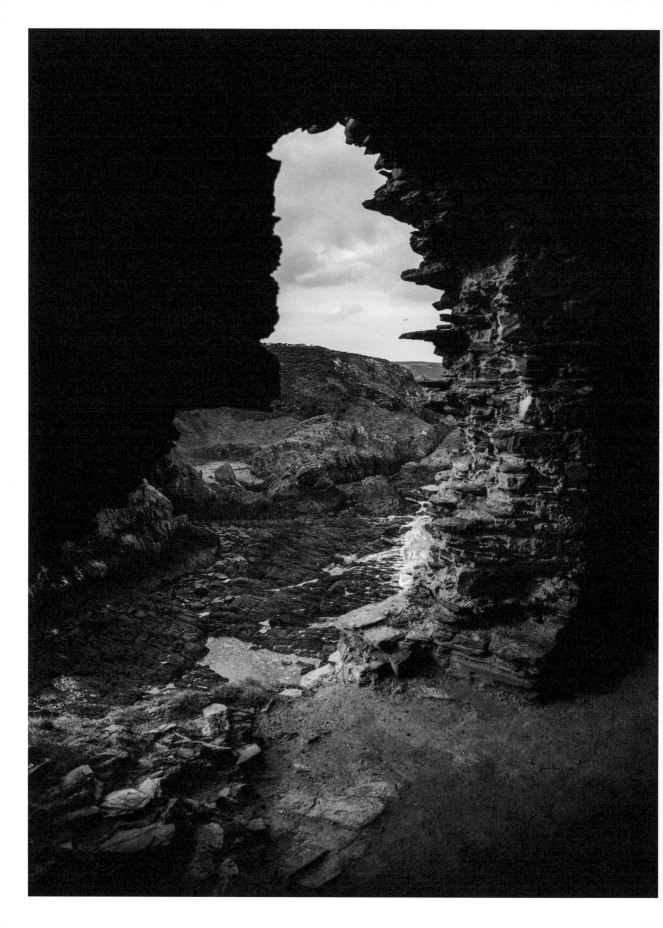

FINDLATER CASTLE

Nearby Town: Banff

Findlater Castle is the old seat of the Earls of Findlater and Seafield. Perched defiantly atop a craggy cliff, slowing being swallowed by the surrounding earth, it rests overlooking the tumultuous waves of the Moray Firth, shrouded in the mists of time, telling tales of a past long forgotten.

Built in the 13th century by the Ogilvie Clan, Findlater served as a bastion of defence against marauding invaders and rival clans vying for control of the coastline. Its strategic location provided an unparalleled vantage point, offering sweeping vistas of the surrounding seascape and ensuring the castle's formidable presence was felt far and wide.

But Findlater Castle is more than just a relic of the past – it's a chance to discover a place that was once a proud monument to many people for many centuries, people that lived, loved and died for this now empty shell. The panoramic views of the rugged coastline and the wild, untamed beauty of the sea remain unchanged, looking as stunning as they did hundreds of years ago, and will remain for hundreds more.

Scotland has many castles in almost every state of repair. But being able to explore a completely unrestricted view of Findlater, to touch the same piece of stone that was perfectly placed in that exact position 700 years ago, and to look out at a magnificent body of water that will remain there until the end of time, is a special thing, in a special place.

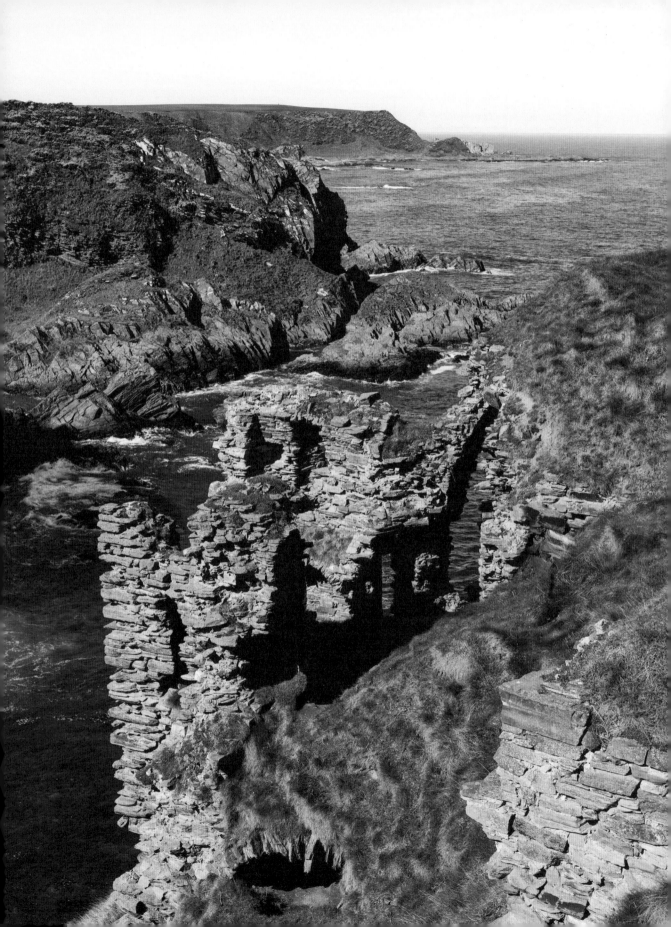

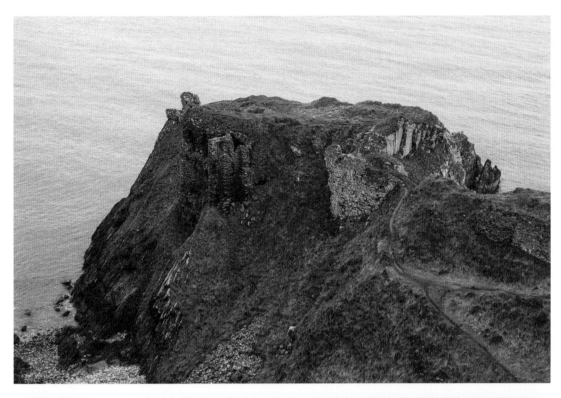

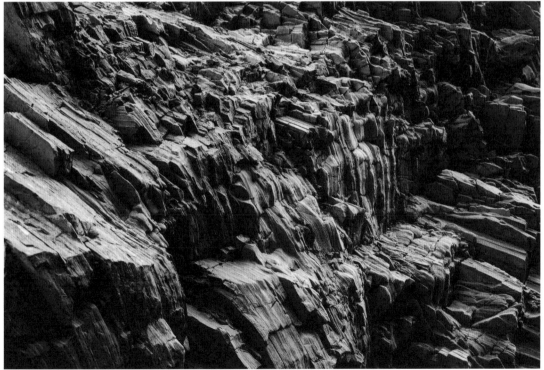

CROVIE

Nearby Town: Banff

Perched precariously at the edge of the sea, is a village frozen in time, offering a glimpse into a way of life governed by the constant rhythm of the tides. This tiny fishing hamlet, with its single row of houses clinging to the narrow strip between the cliffs and the water, speaks of a connection to the sea that is rare in the modern world. Accessible only by foot, Crovie offers an escape from the rush of contemporary life, a step back into a simpler time when communities were closely knit and the sea was both livelihood and lifeblood. To this day a communal wheelbarrow sits at the bottom of the cliff to help carry residents' shopping to their door, a perfect symbol of a tight-knit community, tradition and ingenuity.

The beauty of Crovie lies in its simplicity and its isolation. The sound of the waves against the shore, the call of seabirds overhead and the wind whispering through the gables of the cottages create a symphony of natural sounds, as the old-fashioned streetlights flicker on as the sun sets behind the distant horizon. It's a place where one can truly disconnect, where the vastness of the ocean and the closeness of the community remind us of the truly essential things in life.

Crovie's charm is its unchanged character, a nod to the endurance of its people and their way of life. It offers not just a picturesque setting but a perspective on a life led in harmony with the natural world. Here, against the backdrop of the sea and sky, one finds a peace and tranquility that is increasingly scarce, making Crovie a rare treasure along Scotland's coastline.

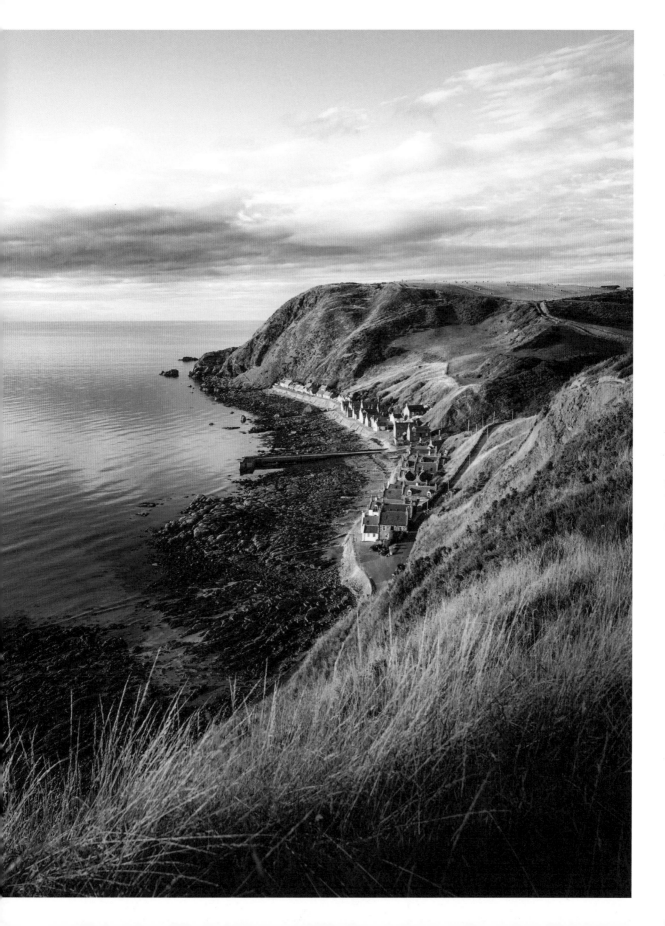

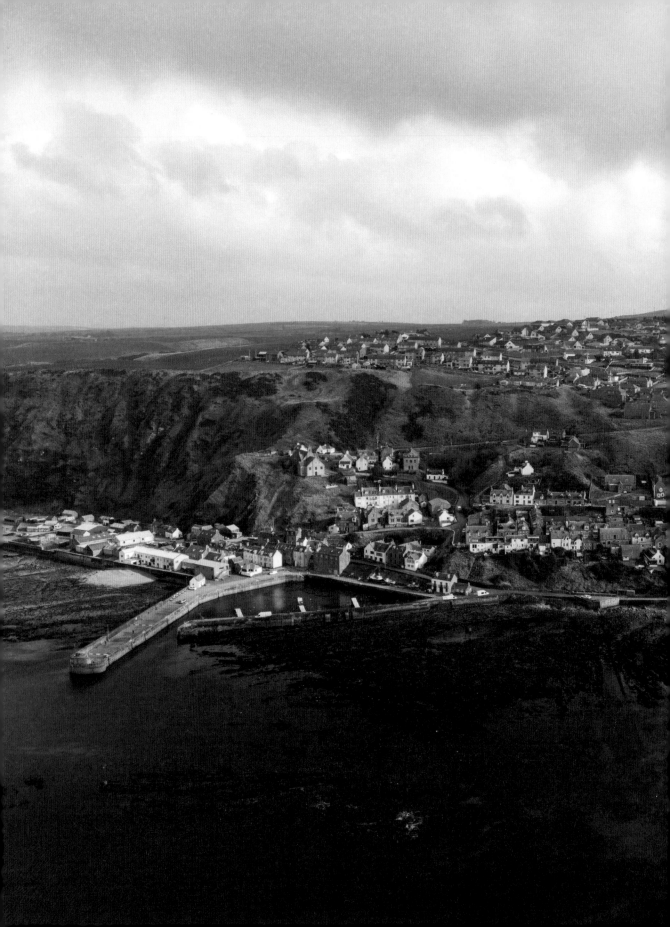

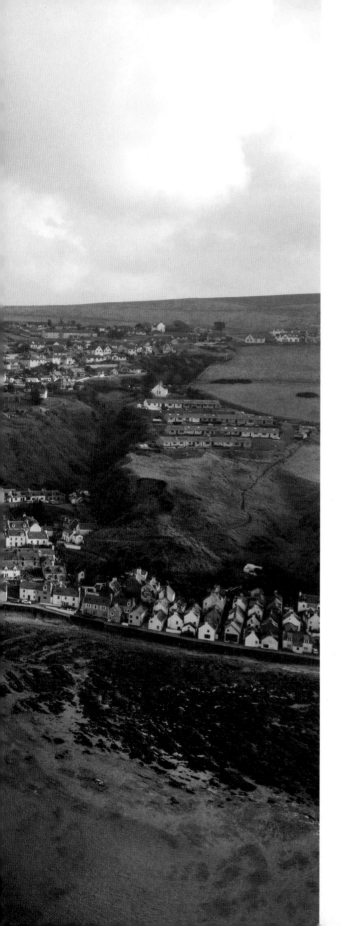

CLOSE BY: GARDENSTOWN

An idyllic coastal fishing village, Gardenstown offers a wealth of features squeezed into a very small space. Located along the rugged coastline of Aberdeenshire, it offers a unique blend of stunning natural beauty, rich history and tranquil ambiance. Founded in the 18th century by Alexander Garden as a fishing village, Gardenstown has retained much of its original charm and character. Its history is deeply intertwined with the sea, with generations of families relying on fishing as their primary livelihood.

Today, it's a place that attracts visitors looking for that old-time charm, where traditional houses seem to cascade down the cliff towards the harbor and the pace of life has refused to keep up with modern times. The town's narrow streets and historic buildings provide a glimpse into its past, while the surrounding landscape offers ample opportunities for outdoor activities. Hiking trails wind along the coast, offering breathtaking views of the Moray Firth, known for its dolphin and whale sightings. The nearby beach is a peaceful spot for walks, picnics and soaking in the serene beauty of the area. And the exquisite St John's Church, perched dramatically on the cliffs above the town, is another beautiful historical landmark worth visiting, offering panoramic views of the surrounding area.

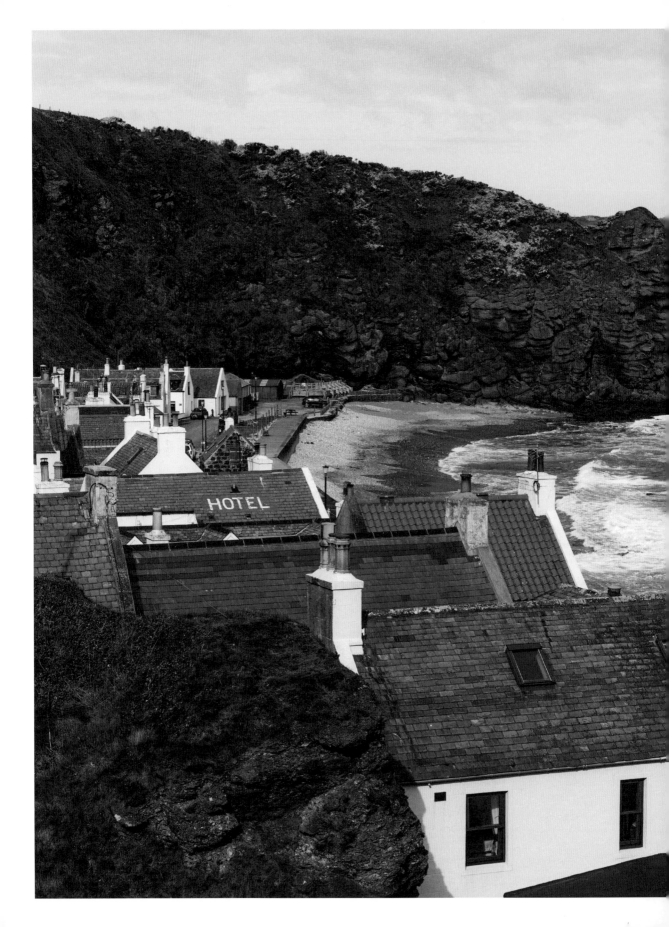

PENNAN

Nearby Town: Fraserburgh

A small coastal village in Aberdeenshire, Pennan captures the imagination with its charming setting along the shore. Famous for its appearance in the 1983 film *Local Hero*, this village has since become a beacon for visitors seeking the tranquility and beauty of the Scottish coast.

The village is characterized by a single row of traditional houses that line the waterfront, offering stunning views of the North Sea. Pennan's quaint harbor, with its small boats and pebbled beach, adds to the picturesque quality of the village, making it a favourite subject for photographers and artists alike.

Visitors to Pennan can enjoy leisurely walks along the shore, where the calming sound of waves and the fresh sea air provide a perfect backdrop for reflection. The village may be small, with a little coffee and cake shop for some local delights and an inn for those looking for an evening dram or warm bed, but its welcoming atmosphere and scenic beauty make it a memorable stop on any tour of the coastline.

For those interested in cinematic history, Pennan offers a tangible connection to *Local Hero*, with many locals happy to share stories about the village's time in the spotlight. Beyond its film fame, Pennan serves as a gateway to exploring the broader Aberdeenshire area, with its rich history, cultural sites and natural landscapes.

Pennan is a jewel of the Scottish coast, offering a peaceful retreat and a reminder of the simple beauty found in traditional coastal living.

RATTRAY HEAD LIGHTHOUSE

Nearby Town: Peterhead

Rattray Head Lighthouse is a beacon on the north-eastern coast of Scotland, guiding mariners through the treacherous waters of the North Sea. Erected in 1895, it's an impressive structure that's not just a navigational aid but a symbol of human ingenuity and the enduring battle against the elements.

Positioned atop a small island accessible only at low tide, the lighthouse's isolation adds to its mystique. The tower stretches up 34m (112ft), its light casting over the sea to warn ships of the hidden dangers lurking beneath the waves. The construction of Rattray Head Lighthouse was a response to the numerous shipwrecks that had plagued the area, an indication of the challenging conditions faced by sailors navigating these shores.

The history of Rattray Head is rich with tales of survival and tragedy. The surrounding waters, known for their shifting sands and hidden reefs, have claimed many vessels over the centuries. Each shipwreck has its story, contributing to the lore of the area. While not steeped in the kind of folklore that involves mythical creatures or legends, the tales of Rattray Head are no less compelling, centred around human courage, loss and the relentless pursuit of safety at sea.

Today, Rattray Head Lighthouse is automated, like many modern lighthouses, but the legacy of its keepers and the lives saved by its beam endure. It remains a point of interest not only for its historical significance but also for the stunning views it offers of the surrounding landscape and the North Sea.

Visitors to Rattray Head can enjoy the serene beauty of the location, the rugged coastline and the chance to spot wildlife, including the seals and seabirds that make their home in this part of Scotland. The lighthouse, with its isolated charm and historical importance, continues to attract those fascinated by Scotland's maritime heritage and the timeless allure of its coastal landscapes.

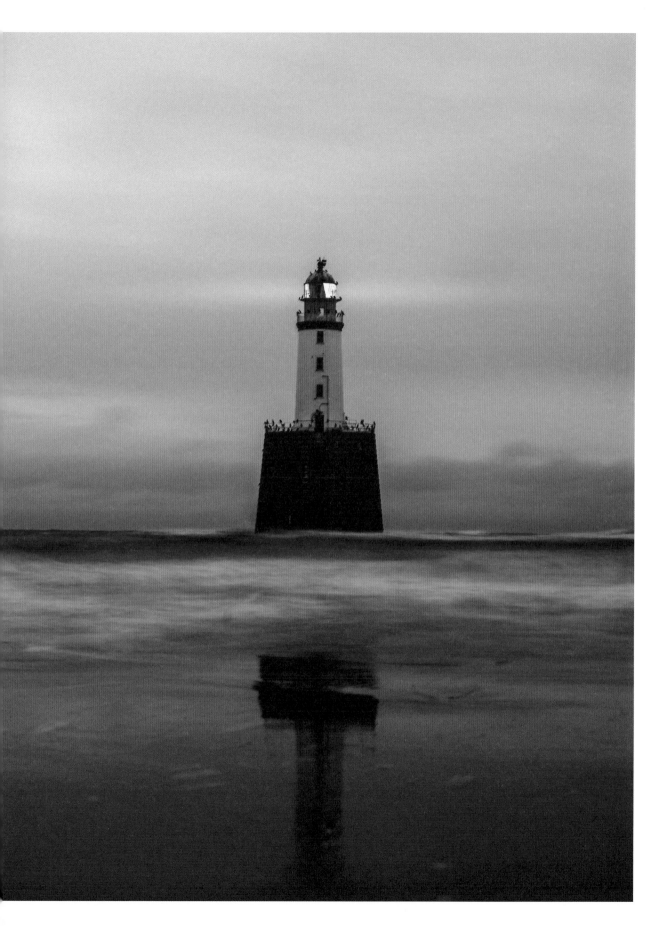

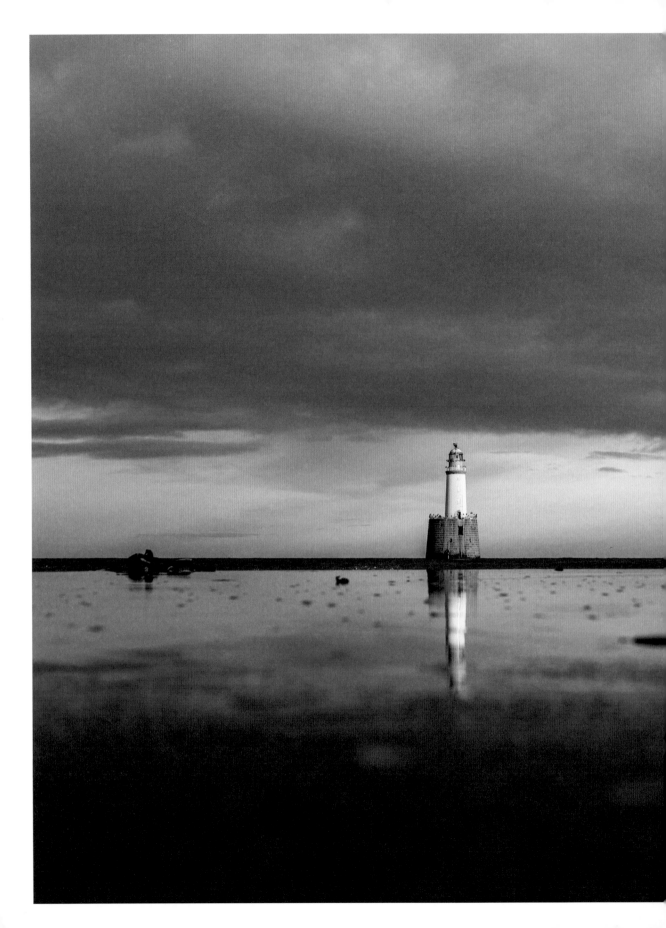

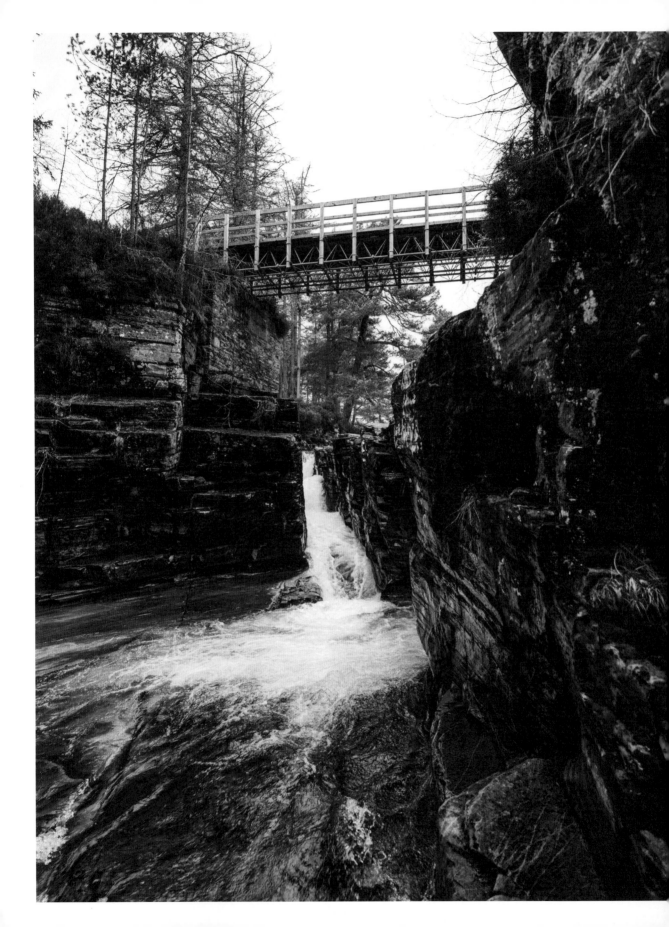

LINN OF QUOICH

Nearby Town: Ballater

In the heart of the Cairngorms National Park, the Linn of Quoich, also known as the Devil's Punch Bowl, presents a union of water and stone in a display of natural grandeur. The River Quoich, cascading through this pristine environment, has sculpted a remarkable basin from the granite, establishing a natural amphitheater.

The journey here weaves through old-growth forests and past vast mountain vistas, offering a trek that is as enriching as the destination itself. The trails meander through a landscape that embodies the wild heart of the Scottish Highlands, with the fragrance of pine and the melody of the river as your constant companions.

Legends speak of the devil himself visiting this spot on moonlit nights, using the bowl to concoct his wicked brews. The peculiar shape of the bowl, with its seemingly carved sides, is – according to myth – the result of the devil's own handiwork, a centrepiece to the supernatural events that have transpired here. These tales, whether believed or taken as part of the region's rich history of stories, adds an enchantment to the linn, making it not just a natural wonder but a focal point of Highland mystery.

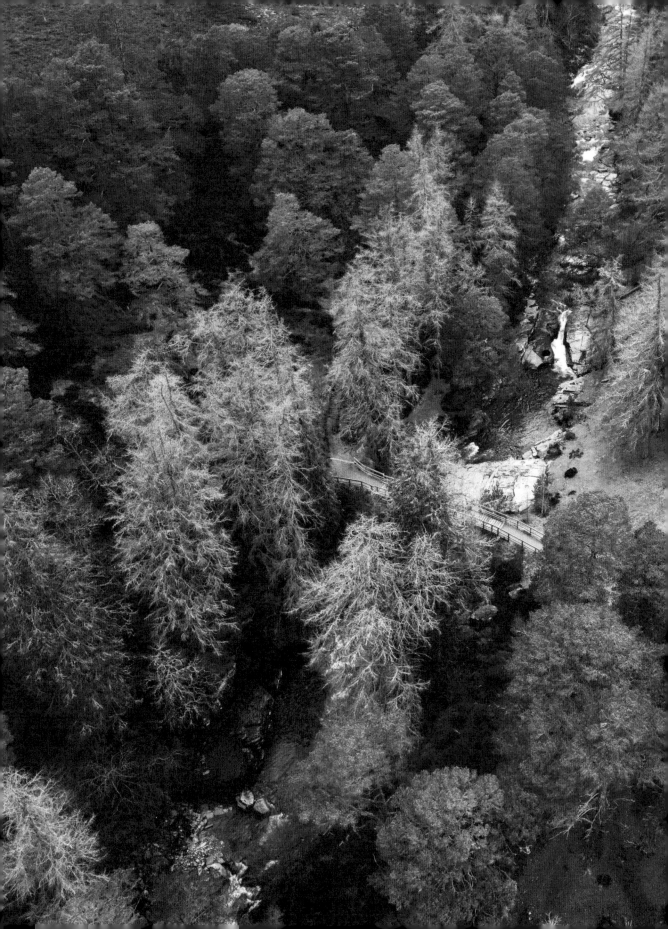

THE CAIRNGORMS

Nearby Town: Aviemore

A majestic mountain range at the heart of the Scottish Highlands, the Cairngorms form the centrepiece of one of Britain's largest national parks. Established in 2003, it is a landscape of unparalleled natural beauty and diversity, characterized by rolling hills of heather, ancient forests of firs, cascading rivers and forever tranquil lochs.

This vast and varied terrain is not only a haven for wildlife, including some of Britain's rarest species – among them golden eagles, Scottish wildcats, capercaillie (the world's largest grouse), ptarmigans, ospreys and pine martens – but also a playground for outdoor enthusiasts. From hiking and mountain biking on its extensive network of trails, to skiing and snowboarding on its snow-capped slopes, the Cairngorms offer year-round adventures. The park is also home to several scenic villages and towns, each with its own unique charm and history, serving as gateways to the natural wonders beyond.

The Cairngorms are renowned for their ecological significance. The ancient Caledonian Forest – remnants of a vast woodland that once covered much of Scotland – provides a critical habitat for wildlife such as red squirrels, golden eagles and capercaillie. The area's unique geology, climate and altitude have created a mosaic of habitats, from heather-clad moorlands to icy mountain plateaus, each supporting a diverse array of flora and fauna.

It's a place where the air is fresh, the vistas are expansive and the connection to nature is immediate and profound.

Conservation efforts within the park focus on protecting these natural resources while also accommodating and educating visitors. Initiatives aimed at restoring native woodland, peatlands and other habitats are critical to maintaining the ecological balance and ensuring the park remains a bastion of biodiversity.

The Cairngorms also hold a rich cultural heritage, with archaeological sites that tell the story of human activity in the Highlands dating back thousands of years. Castles and historic landmarks dot the landscape, reminders of Scotland's turbulent past and the strategic importance of this region through the centuries.

For those drawn to the beauty and serenity of the natural world, the Cairngorms National Park offers an escape into one of the UK's last great wildernesses. It's a place where the air is fresh, the vistas are expansive and the connection to nature is immediate and profound. Here, amidst the grandeur of the Scottish Highlands, the spirit of adventure is alive, and the rhythm of the natural world continues unabated, a timeless allure for all who visit.

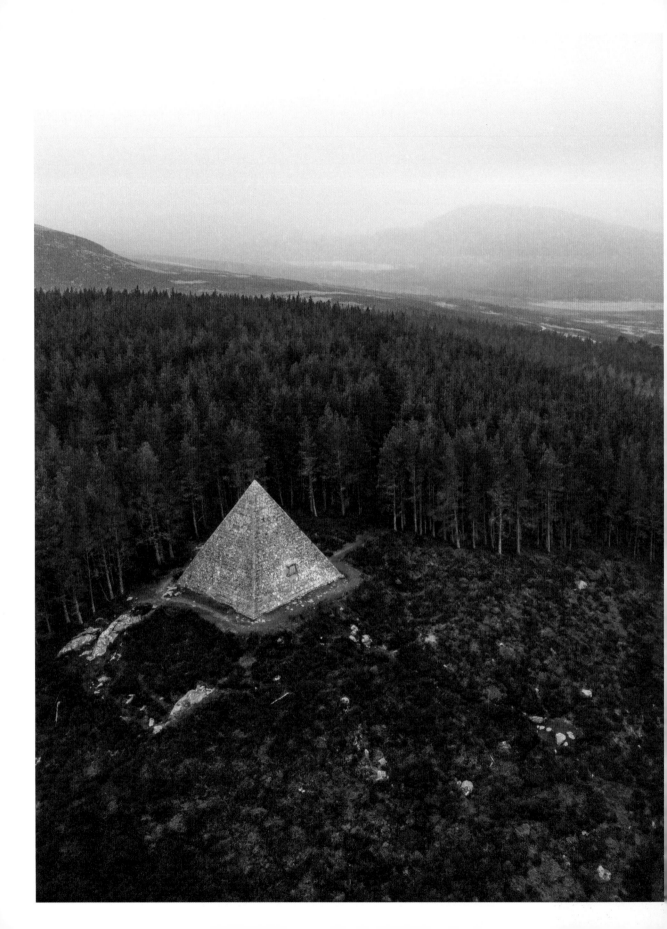

PRINCE ALBERT'S CAIRN

Nearby Town: Ballater

Prince Albert's Cairn stands as a solemn tribute, in the heart of Balmoral Estate, to the enduring love of Queen Victoria for her consort, Prince Albert. Erected after his death in 1861, this large pyramidical cairn is one of several memorials scattered across the estate, each marking a moment or memory shared by the royal couple. The cairn's location offers a vantage point that commands views of the surrounding Scottish Highlands, a landscape that captivated both Victoria and Albert during their lifetimes.

The walk to Prince Albert's Cairn is as much about the journey through the natural beauty of Balmoral as it is about reaching the monument itself. The paths wind through ancient forests and open moorland, leading visitors across a landscape that is both wild and managed, a reflection of the balance between nature and the human touch. The cairn itself, though a symbol of personal loss, also speaks to the public and historical significance of Albert's contributions to British society and the deep personal connection he shared with Victoria.

Visiting Prince Albert's Cairn offers a moment of reflection on the nature of love, loss and legacy. It's a place that transcends its immediate memorial purpose, inviting visitors to connect with the broader narratives of history and the enduring beauty of the Scottish landscape. Here, amidst the tranquility of Balmoral, the cairn stands as a testament to a relationship that shaped an era and left a lasting mark on the land.

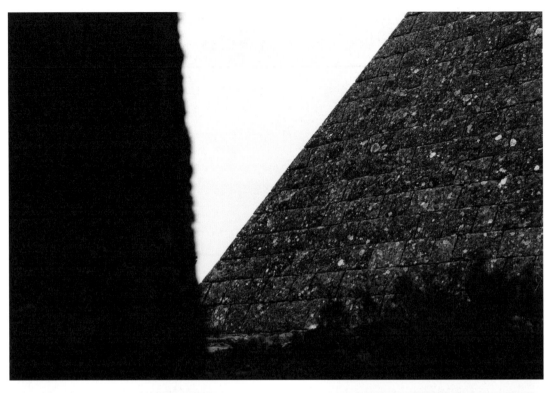

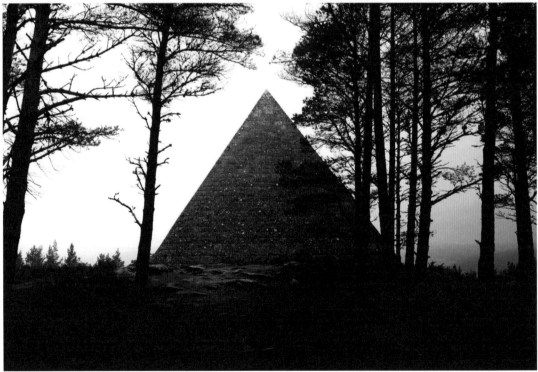

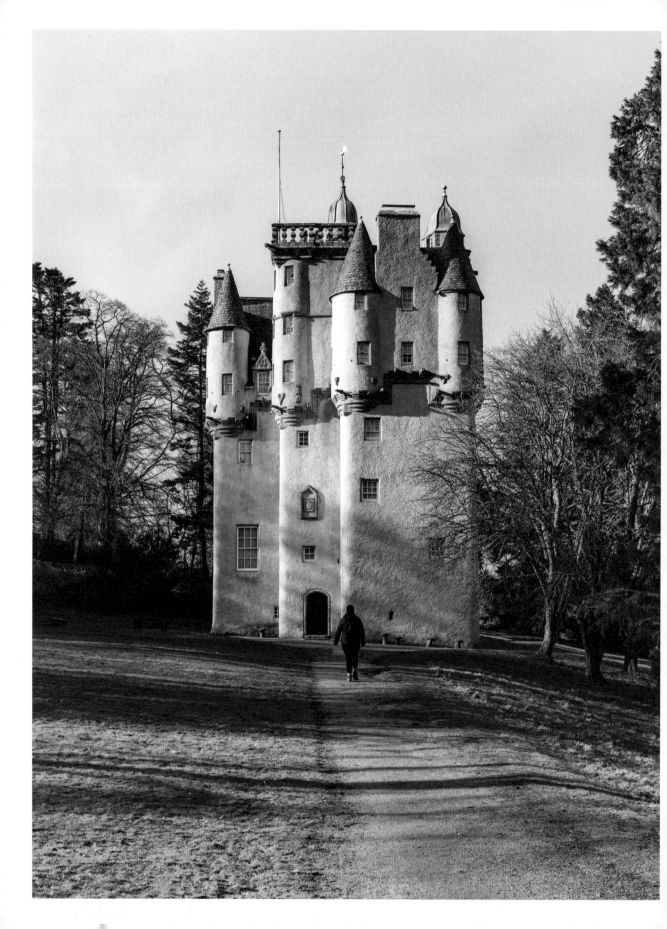

CRAIGIEVAR CASTLE

Nearby Town: Aberdeen

With its distinctive pink hue and fairy-tale turrets, Craigievar Castle seems lifted from the pages of a storybook; indeed, some say Walt Disney himself took inspiration from the castle when planning his own, now iconic, design. Squeezed into the rolling hills of Aberdeenshire, the castle is a fine example of Scottish Baronial architecture, its towers and crow-stepped gables evoking an era of romance. The surrounding estate, with its ancient woodlands and manicured gardens, offers a pastoral idyll that complements the castle's enchanting appearance.

The interior of Craigievar Castle is a journey through time, where each room tells a story of the families who have called this place home. From the original inhabitants, the Mortimer family, to the Forbes family, who took up residence in 1610 and held on to it for 370 years before giving the castle to the Scottish National Trust to be preserved as a historical museum. The collection of portraits, furniture and artefacts within its walls offer a glimpse into the life of the Scottish nobility, while the intricate plasterwork and wood carvings speak to the craftsmanship of bygone eras. It's a place where history feels alive, where the past mingles with the present in the quiet corridors and grand halls.

Exploring the castle and its grounds is to step into a world where fantasy and history merge. It's a place that inspires the imagination, inviting visitors to dream of knights and legends against a backdrop of undeniable beauty. The castle, with its whimsical appearance and storied past, shows the enduring appeal of Scotland's heritage, a reminder of the tales of valor and romance that are woven into the fabric of the land that surrounds it.

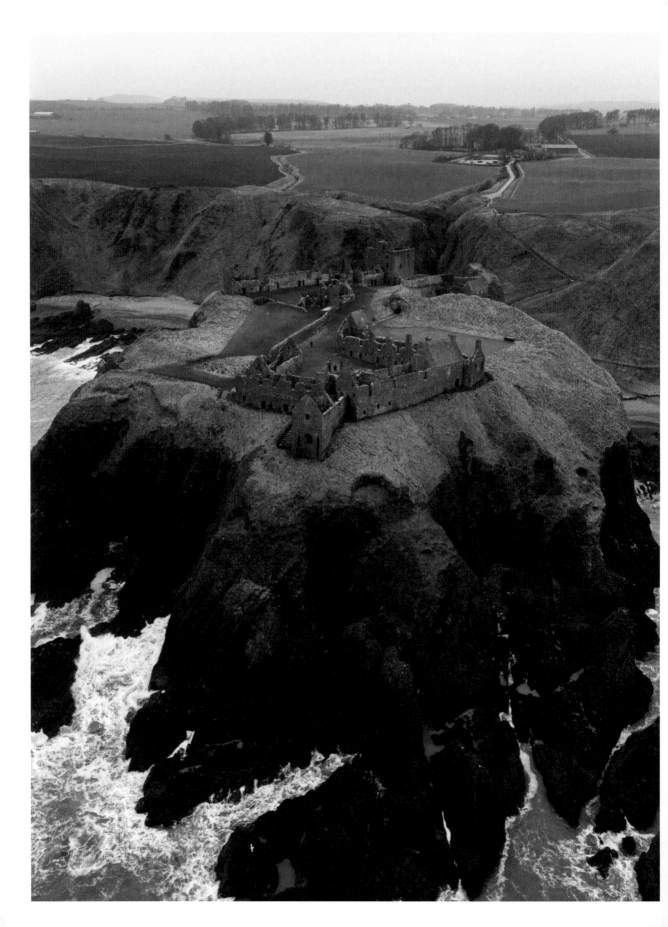

DUNNOTTAR CASTLE

Nearby Town: Aberdeen

Perched on a rocky headland along the north-eastern coast, Dunnottar Castle is a site of immense historical significance and visual splendour. This fortress, with its ruins dating back to the 15th and 16th centuries, tells the story of Scotland's past, marked by battles, sieges and royal visits, against the backdrop of the rugged Scottish landscape.

The origins of Dunnottar Castle stretch much further into history, with evidence suggesting the site was fortified as early as the Dark Ages. Its strategic position overlooking the North Sea made it a key military stronghold and a coveted prize for invaders and Scottish kings alike. Throughout its storied history, Dunnottar has played a pivotal role in several key historical events, including serving as a hiding place for the Scottish Crown Jewels during the invasion of Oliver Cromwell's army in the 17th century.

The castle's architecture attests to its strategic importance, with its formidable walls and gates designed to withstand long sieges. Despite the passage of time and the castle's ruinous state, visitors can still grasp the scale and the defensive capabilities of this once impregnable fortress.

The castle's dramatic location and haunting ruins also make it a source of inspiration for artists, writers and filmmakers, drawn to its beauty and its aura of mystery.

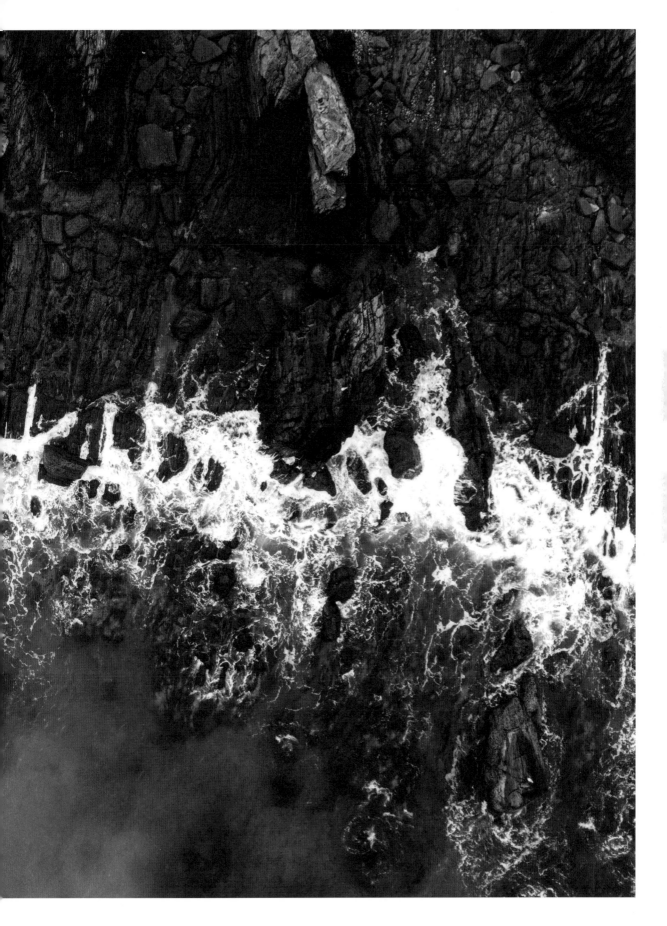

THE HERMITAGE

Nearby Town: Dunkeld

Tucked into the woodland marvel of Dunkeld, the Hermitage offers a retreat into a place where the wonder of Scotland's natural world is on full display. Here, the River Braan carves its way through the soft landscape, culminating in the dramatic cascade of the incredible Black Linn Falls. The contrast of the crashing water and immovable rock are staples here as you make your way upstream through countless old-growth trees, shrubs and flowers, in a setting the best painters would find hard to imagine.

The Hermitage itself, conceived as a folly in the 18th century, stands as a monument to our desire to commune and connect with nature. Its paths lead through gigantic Douglas firs and along the rushing river, inviting you to discover its secrets and explore in your own mini adventure. It is a place of contemplation, where the majesty of the landscape inspires awe and a sense of connection to the animals, trees and water all around.

The Hermitage is a display of nature's artistry, where the intricate dance of light and shadow across the water and woodland creates a constantly evolving spectacle; beams of light pass through gaps in the canopy like nature's church, as a choir of gentle wind blows through vibrant pines and the mists rising from the waterfall create a gentle halation all around you. It is a sanctuary where the hustle of modern life fades into the background, replaced by the timeless sounds of the natural world. Here, the beauty of the Scottish Highlands is revealed in its most raw and powerful form, offering a refuge for the spirit and a feast for the senses.

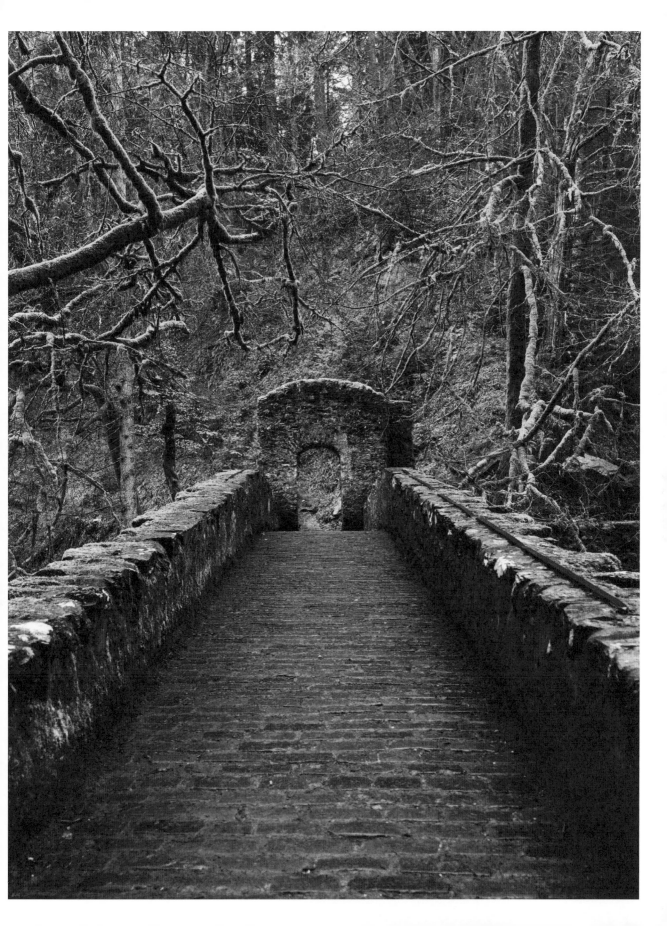

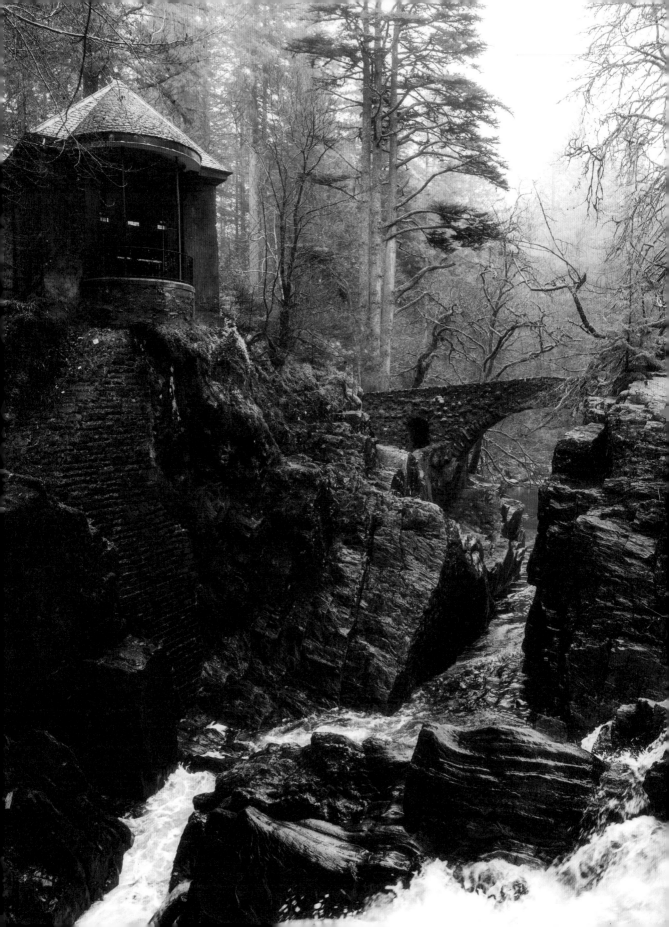

It is a sanctuary where the hustle of modern life fades into the background, replaced by the timeless sounds of the natural world.

GLAMIS CASTLE AND THE STORY OF LADY JANET DOUGLAS

Near the Hermitage lies Glamis Castle, the ancestral home of Lady Janet Douglas. Also known as Lady Glamis, she remains a poignant figure in Scottish history, emblematic of the political intrigue and personal tragedies of the 16th century. Born into the powerful Douglas family, her life took a tragic turn when she was accused of witchcraft and conspiracy against King James V of Scotland. The accusations were likely spurred by the king's animosity towards the Douglas Clan, a common practice in an era where charges of witchcraft were often used to settle scores or eliminate rivals.

In 1537, despite little evidence and the questionable legitimacy of the charges against her, Lady Janet was found guilty and sentenced to death by burning at the stake, a stark example of the perilous nature of the Scottish nobility during this tumultuous period. Her execution left an indelible mark on the history of Glamis Castle, the Douglas family and Scotland's judicial and societal norms.

In the centuries since her death, Lady Janet's story has transcended the historical record to become part of Scotland's rich folklore. Glamis Castle, her ancestral home, is said to be haunted by her spirit. Visitors and staff have reported sightings and experiences that suggest her presence, from unexplained sounds to fleeting visions of a figure that many believe to be Lady Janet herself.

Today, Lady Janet Douglas is remembered not only for the tragic circumstances of her life and death, but also as a symbol of the injustices wrought by fear, superstition and political machinations in Scotland's past. The folklore surrounding her ghost at Glamis Castle serves as a modern-day reminder of her story, keeping her memory alive in both historical accounts and the tales that continue to captivate the imagination of visitors to this day.

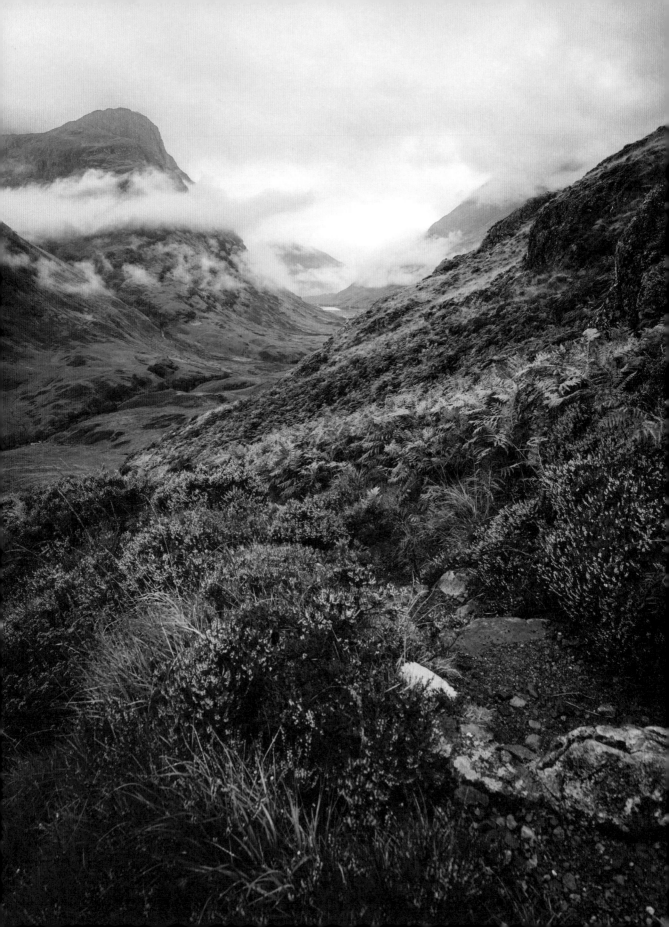

AFTERWORD

As a tour guide, I'm fortunate to spend my days exploring the beautifully diverse country I've always called home. With this, my first book, I hope I've been able to stir in you the same deep sense of wonder and affection it inspires in me. Each photograph, each word, was chosen to celebrate Scotland's majestic landscapes, the stories they hold and how I see them through my eyes.

The creation of this book has been a voyage of discovery, not just through Scotland's physical spaces but also through my own memories of these sights and stories. It's a journey I've been fortunate enough not to embark upon alone. Being able to look back on all the efforts of others and the impact they've had on me, I'm very thankful for being able to gather those experiences, thoughts and feelings together and attempt to put them into this collection of words and images.

The tales and scenes within these pages are a drop of Scotland's full story. For those who feel the call of the wild glens, the serene lochs and the towering peaks, I extend an invitation to join me in experiencing the magic of Scotland first-hand. Come and enjoy the heart of the unseen, the stories untold and the landscapes uncharted, treading paths less known and uncovering the secrets that Scotland tells to all those willing to listen.

To Scotland, to the journey and to all who travel in search of beauty and connection in all forms, thank you for sharing this path with me.

Bryan Millar Walker
Scottish Tour Guide

Bryan grew up in Glasgow and spent the majority of his childhood exploring the length and breadth of Scotland. He now designs and leads cutom tours of Scotland.

www.distinct.scot
@bryanmillarwalker on Instagram,
Facebook, TikTok and YouTube

INDEX

A

Aberdeen 211, 213
Achmelvich 136, 141
Allt Chranaidh Falls 149
Ardnamurchan 65
Assynt 129–30, 146
Aviemore 177, 202–5

B

Ballater 207
Balmoral Estate 207
Banff 185, 188
beaches
 Achmelvich 136
 Clachtoll 145
 Eoropie Beach 101
 Garry Beach 109
 Mangersta Beach 89–91
 Nisabost Beach 77
 Seilebost Beach 75
Bean Nighe 154
Bearsden 21
Beltane 15
Ben Cruachan 33
Ben Nevis 57
Big Ears Cat 41
Black Linn Falls 216
Blue Men of Minch 107
bothies: Suileag Bothy 130
Bow Fiddle Rock 180
bridges
 Fairy Bridge 53
 Kylesku Bridge 149
Brodie, Captain David 171
Buachaille Etive Beag 38
Buachaille Etive Mòr 38, 42, 47
Burns Night 15
Butt of Lewis Lighthouse 104–7

C

Cairngorms National Park 177, 202–5
Caithness 167
Calanais Standing Stones 85
Caledonian forest 117, 121, 202–5
Campbell Clan 29
Campbell, Walter Douglas 33
Campbells of Glenorchy 29

Carnock Burn 24
castles
 Castle of Old Wick 167
 Castle Sinclair Girnigoe 161
 Castle Tioram 60
 Craigievar Castle 211
 Dunnottar Castle 213
 Findlater Castle 185
 Glamis Castle 219
 Hermit's Castle 141
 Keiss Castle 162
 Kilchurn Castle 29
churches and temples
 St Conan's Kirk 33
 The Temple 78
Clachtoll 145
clan rivalries 47–8
Clashnessie Falls 146
Coire Loch 122
Corrieshalloch Gorge 124–7
Craigievar Castle 211
Crovie 188
Cullen 183

D

Devil
 Devil's Pulpit 24
 Devil's Punch Bowl 199
 Devil's Staircase 48
 Whangie 21
Dog Falls 122
Douglas, Lady Janet 219
Drumnadrochit 117–18, 121–2
Duncansby Stacks 156
Dunkeld 216
Dunnottar Castle 213

E

Each-uisge 82
East Coast 174–5
Eoropie Beach 101

F

Fairy Bridge 53
fauna 12
Fiddler 135
Findlater Castle 185

Fingal 34
Finnich Glen 24
Fionn's Rock 34
flora 12
folklore and legends
 Bean Nighe 154
 Big Ears Cat 41
 Blue Men of Minch 107
 Devil 21, 24, 48, 199
 Each-uisge 82
 Ghillie Dhu 121–2
 witchcraft 21, 219
 Witches of Kilpatrick 21
Fort William 57
Fraserburgh 193

G

Garden, Alexander 191
Gardenstown 191
Garry Beach 109
Gearrannan Blackhouses 92
geological features, see also waterfalls
 Bow Fiddle Rock 180
 Corrieshalloch Gorge 124–7
 Devil's Pulpit 24
 Duncansby Stacks 156
 Linn of Quoich 199
 Mangersta Stacks 91
 Whangie 21
Ghillie Dhu 121–2
Glamis Castle 219
Glen Affric 117, 121–2
Glen Creran 53
Glen Etive 38
Glen Lyon and Fionn's Rock 34
Glen Nevis 57
Glencoe 38, 42, 47–8
Glencoe Massacre 47–8
Golden Road 81–2
Golspie 153
Golspie Burn and Waterfall 153
gorse 12

H

heather 12
Hebrides 70–1
Hermitage 216
Hermit's Castle 141

Highland Clearances 115
Highlands 114–15
Hogmanay 15

I

Inveraray 29
Isle of Harris 72–5, 77, 78, 81–2
Isle of Lewis 85, 89–91, 92, 97, 101,
 104–7, 109
Isle of Mull 67

J

James II of England 47–8
James V of Scotland 219
James VII of Scotland 47–8
John o' Groats 156

K

Keiss Castle 162
Kilchurn Castle 29
Kilpatrick Hills 21
Kylesku 149
Kylesku Bridge 149

L

lighthouses
 Butt of Lewis Lighthouse 104–7
 Rattray Head Lighthouse 194
Linn of Quoich 199
Local Hero (film) 193
Loch a' Chàirn Bhàin 149
Loch Awe 29, 33
Loch Etive 38
Loch Gleann Dubh 149
Loch Lurgainn 132–5
Loch Moidart 60
Loch na Gainmhich 149
Lochinver 129–30, 132–5, 145
Lossiemouth 180
Luskentyre Beach 72–5

M

MacDonald Clan 48
Macpherson, James 34
Mangersta Beach 89–91

Mangersta Stacks 91
midges 42
Milngavie 24
Minch 107
Moray Firth 183, 185, 191

N

New Year 15
Nisabost Beach 77
Norse buildings and culture 97

O

Oban 33
Ogilvie Clan 185
Ossianic poems 34
Outer Hebrides 70–1

P

Pennan 193
Peterhead 194
Plodda Falls 117–18
Portknockie 180
primroses 12
Prince Albert's Cairn 207

R

Rattray Head Lighthouse 194
River Braan 216
River Coupall 42
River Lyon 34
River Quoich 199
River Shiel 60

S

Samhain 15
Sanna Bay 65
Scott, David 141
Scott, Sir Walter 34
Scottish Highlands 114–15
Scottish Outdoor Access Code 8
Seilebost Beach 75
Sgorr Tuath 132–5
Shawbost Norse Mill and Kiln 97
Sinclair, George 161, 162
Skyfall (film) 38

St Andrew's Day 15
St Conan's Kirk 33
Stac Pollaidh 132–5
Steall Falls 57
Stirling 34
Suileag Bothy 130
Suilven 129–30
Summer Isles 135

T

Temple 78
thistles 12
Tobermory 67
Trossachs 21

U

Uath Lochans 177
Ullapool 124–7
Up Helly Aa 15

V

Victoria, Queen 207
Vikings 15

W

waterfalls
 Allt Chranaidh Falls 149
 Black Linn Falls 216
 Clashnessie Falls 146
 Dog Falls 122
 Golspie Burn and Waterfall 153
 Plodda Falls 117–18
 Steall Falls 57
West Coast 18–19
Whaligoe Steps 171
Whangie 21
Wick 161, 167, 171
wildlife 12
William of Orange 47–8
witchcraft 219
Witches of Kilpatrick 21

First published in Great Britain in 2024 by

Greenfinch
An imprint of Quercus Editions Ltd
Carmelite House
50 Victoria Embankment
London EC4Y 0DZ

An Hachette UK company

A CIP catalogue record for this book is
available from the British Library

HB ISBN 978-1-52943-755-3
Ebook ISBN 978-1-52943-756-0

10 9 8 7 6 5 4 3 2 1

Design by Sarah Pyke

Printed and bound in Germany by
Mohn Media

MIX
Paper | Supporting
responsible forestry
FSC® C011124
FSC
www.fsc.org

Papers used by Greenfinch are from
well-managed forests and other
responsible sources.

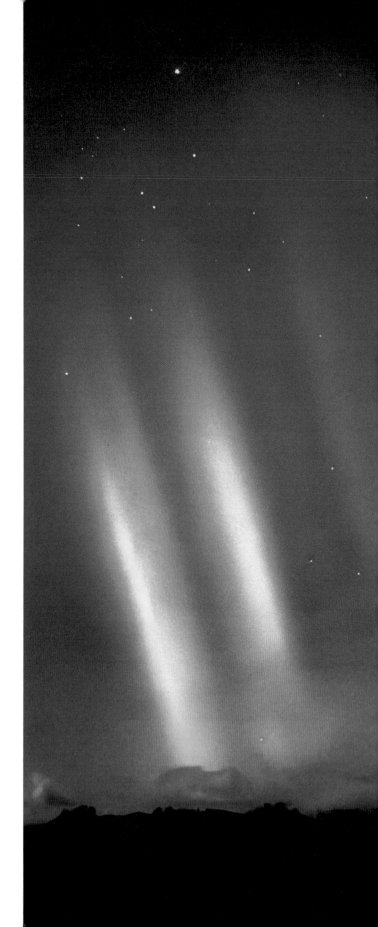